IN THIS HISTORICAL

NOTHING IS WRIT IN STONE

AND THE TYPOGRAPHER'S ART

REFLECTS ITS CONTINGENCY IN

A KALEIDOSCOPIC GLOBAL CUL-

TURE. DIGITIZED, SCRIBBLED,

SCRAMBLED TYPE DEPOS-

ES CHASTE VALUES OF

ORDER AND BEAUTY. YET

PERHAPS IN ITS "FALL"

IS THE SALVATION OF

GRAPHIC DESIGN PREPARED.

YOU ARE INVITED TO ENTER

YOUR MOST PROVOCATIVE

WORK IN THE 1995 TYPE DIREC-

TORS CLUB 42ND EXHIBITION.

QUALITY HOUSE OF GRAPHICS
47-47 VAN DAM STREET . LONG ISLAND CITY . NY . 11101
PHONE 718.784.7400 FAX 718.935.5179

THE TYPE DIRECTORS CLUB WISHES TO THANK
QUALITY HOUSE OF GRAPHICS FOR THEIR
CONTINUED GENEROSITY AND SUPPORT.

297
^{17"}
42"

Scott Wadler '95

James Wageman '88

Frank Wagner '94

Jurek Wajdowicz '80

Robert Wakeman '85

Garth Walker '92

Tat S. Wan '91

Xu Wang '93

Al Wasco '96

Janet Webb '91

Joy Weeng '93s

Kurt Weidemann '66

Seth Weine '95

Alex White '93

Gail Wiggin '90

Richard Wilde '93

James Williams '88

Carol Winer '94

Conny J. Winter '85

Fred Woodward '95

Masayuki Yamamoto '95

Shen-Hua Yen '95s

Teresa Yeung '94s

Doyald Young '96

Shawn Young '94

Susan Young '93

Hermann Zapf** '52

Azita Zarrabi '96

Maxim Zhukov '96

Roy Zucca '69

Robert Norton '92	Michael Rylander '93	Olaf Stein '96
Alexa Nosal '87	Gus Saelens '50	Charles Stewart '92
Robert O'Connor '92	David Saltman '66	Ted Stoik '95
Brian O'Neill '68	Nicole Salzano '95	Slavimir Stojanovic '95
Jack Odette '77	Richard Sasso '94	Sumner Stone '88
Michel Olivier '94	Irene Santoso '95s	William Streever '50
Manuel Ribera Ordax '95	Frank Sax '94	Ilene Strizver '88
Robert Overholtzer '94	John Sayles '95	Vance Studley '95
Toshi Ozone '95	Hermann J. Schlieper '87	Hansjorg Stulle '87
Bob Paganucci '85	Hermann Schmidt '83	Robert Sutton '95
Susan Panetta '95	Klaus Schmidt '59	Tony Sutton '93
Jim Parkinson '94	Markus Schmidt '93	Zempaku Suzuki '92
Christi Payne '96	Bertram Schmidt-Friderichs '89	Ken Sweeny '78
B. Martin Pedersen '85	Werner Schneider '87	Paul Sych '93
Daniel Pelavin '92	Geraldine Schoeller '96	Laurie Szujewska '95
Robert Peters '86	Eileen Hedy Schultz '85	Yukichi Takada '95
Peter Hans Pfaffmann '94	Eckehart Schumacher-Gebler '85	Gordon Tan '90
Roy Podorson '77	Christian Schwartz '95s	Sari Tanimura '95
William Porch '94	James Sebastian '95	William Taubin '56
Will Powers '89	Jessica Shatan '95	Jack Tauss '75
Vittorio Prina '88	Paul Shaw '87	Pat Taylor '85
Richard Puder '85	Philip Shore, Jr. '92	Anthony J. Teano '62
David Quay '80	Miki Shun-ichi '95	Mark Tenga '93
Erwin Raith '67	Robin Siegel '94	Regine Thienhaus '96
Diddo Ramm '95	Mark Simkins '92	Paula Thomson '91
Adeir Rampazzo '85	Scott Simmons '94	Bill Thorburn '95
Paul Rand** '86	Arlyn Simon '95	Fred Tieken '95
Hermann Rapp '87	Mondrey Sin '95	Eric Tilley '95
Karen Meyer Rappaport '95	Dwight D.A. Smith '92	Harry Title '93
Jo Anne Redwood '88	Felix Sockwell '95	Joseph Treacy '94
Hans Dieter Reichert '92	Silvestre Segarra Soler '95	Susan B. Trowbridge '82
Martha Rhodes '93	Martin Solomon '55	Michael Tutino '96
Robert Rindler '95	Jan Solpera '85	Lucile Tuttle-Smith '78
Nadine Robbins '95	Mark Solsburg '89	Kate Ulanov '95
Eva Roberts '95	Barbara Sommer '92	Edward Vadala '72
Nancy Romano '93s	Ronnie Tan Soo Chye '88	Diego Vainesman '91
Salvadore Romero '94	Bill Sosin '92	Mark van Bronkhorst '93
Edward Rondthaler* '47	Erik Spiekermann '88	JanVan Der Ploeg '52
Kurt Roscoe '93	Vic Spindler '73	Eliza van Gerbig '95
Robert M. Rose '75	Walter Stanton '58	Pamela Vassil '95
Dirk Rowntree '86	Rolf Staudt '84	James Velsor '96
Erkki Ruuhinen '86	Thomas Stecko '94	Thilo von Debschitz '95

295
17" 42"

Howard Glener '77

Tama Alexandrine Goen '96

Laurie Goldman '93s

Harriet Goren '94

Edward Gottschall '52

Rüdiger Götz '95

Norman Graber '69

Diana Graham '85

Austin Grandjean '59

Karen Greenberg '95

Kevin Greenblat '93s

Adam Greiss '89

Jeff Griffith '91

Rosanne Guararra '92

Olga Gutierrez de la Roza '95s

Einar Gylfason '95

Kurt Haiman '82

Brock Haldeman '95

Allan Haley '78

Tadanobu Hara '95

Sherri Harnick '83

John Harrison '91

Knut Hartmann '85

Nabeel Kamal Hassan '94

Bonnie Hazelton '75

Amy Hecht '95

Jeri Heiden '94

Frank Heine '96

Richard Henderson '92

Klaus Hesse '95

Jay Higgins '88

David High '96

Elise Hilpert '89

Drew Hodges '95

Michael Hodgson '89

Fritz Hofrichter '80

Alyce Hoggan '91

Cynthia Hollandsworth '91

Catherine Hollenbeck '93

Kevin Horvath '87

Gerard Huerta '85

David Hukari '95

Harvey Hunt '92

Donald Jackson** '78

Michael Jager '94

John Jamilkowski '89

Jovan Jelovac '96

Jon Jicha '87

John Kallio '96

Iskra Johnson '94

Grace Jong '95

Karen Karabasz '95

Anita Karl '94

Karen Kassirer '93

Scott Kelly '84

Jeff Kennard '96

William McLean Kerr '95

Hermann Kilian '92

Rick King '93

William Kirchgessner '95

Zoltan Kiss '59

Don Kline '95

Robert C. Knecht '69

Cynthia Knox '95

Nana Kobayashi '94

Seiko Kohjima '95s

Steve Kopec '74

Andrej Krátky '93

Bernhard J. Kress '63

Madhu Krishna '91

Pat Krugman '91

Ralf Kunz '93

Mara Kurtz '89

Sasha Kurtz '91

Gerry L'Orange '91

Raymond F. Laccetti '87

Julia Katja Lachnik '94s

John Langdon '93

Guenter Gerhard Lange '83

Judith Kazdym Leeds '83

David Lemon '95

Olaf Leu '65

Jeffery Level '88

Ginny Lindzey '94a

Wally Littman '60

Kaming Liu '95s

John Howland Lord** '47

Alexander Luckow '94

Gregg Lukasiewicz '90

Burns Magruder '93

Sol Malkoff '63

Daniela Mandil '95

Marilyn Marcus '79

David Marino '94s

Adolfo Martinez '86

Rogério Martins '91

Deborah Masel '94s

Les Mason '85

Andreas Maxbauer '95

Douglas May '92

Sherwood McBloom '96

Rod McDonald '95

Roland Mehler '92

Frédéric Metz '85

Michael Milley '94

John Milligan '78

Michael Miranda '84

Oswaldo Miranda (Miran) '78

Sotiris Mitroussis '94

Sakol Mongkolkasetari '95

James Montalbano '93

Richard Moore '82

Tadashi Morisaki '95

Minoru Morita '75

Gerald Moscato '93

Tobias Moss* '47

Richard Mullen '82

Joachim Müller-Lance '95

Antonio Muñoz '90

Keith Murgatroyd '78

Brendan Murphy '95

Jerry King Musser '88

Alexander Musson '93

Louis A. Musto '65

Cristina Newman '93

Julie Nigohosian '94

Colleen Abrams '95

Jim Aitchison '93

Victor Ang '91

Martyn Anstice '92

Hal Apple '94

Herman Aronson '92

Marcela Augustowsky '95

Jaques Bagios '95

Peter Bain '86

Patt Baldino '95

Bruce Balkin '93

Stephen Banham '95

Maria Helena Ferreira Braga
 Barbosa '93s

Nancy Bauch '95

Gerd Baumann '95

Clarence Baylis '74

M. Pascal Béjean '95

Felix Beltran '88

Ed Benguiat '64

Jesse Berger '92

Anna Berkenbusch '89

Peter Bertolami '69

Klaus Bietz '93

Roger Black '80

Anthony Bloch '88

Holly Block '95

Susan Cotler Block '89

Karlheinz Boelling '86

Garrett Boge '83

John Bonadies '95

Patricia Bradbury '93

Bud Braman '90

Risa Brand '94

Jason Brightman '95s

Ed Brodsky '80

Kathie Brown '84

Bill Bundzak '64

Queenie Burns '94

Elizabeth Butler '94s

David Byun '95s

Jason Calfo '88

Evan Camp '95

Ronn Campisi '88

Matthew Carter '88

Ken Cato '88

Petra Cerne '94s

Theseus Chan '94

Herman Chandra '94s

Len Cheeseman '93

Kai-Yan Choi '90

Traci Churchill '95

Travis Cliett '53

Mahlon A. Cline* '48

Tom Cocozza '76

Lisa Cohen '93

Angelo Colella '90

Ed Colker '83

Paul Correia '93

Freeman Craw* '47

Bart Crosby '95

Jennifer Crupi '94s

David Cundy '85

Rick Cusick '89

Luiz Dalomba '94

Susan Darbyshire '87

Lisa David '95s

Don Davidson '93

Richard Dawson '93

Carol DeBlasio 94s

Matej Decko '93

Robert Defrin '69

Josanne De Natale '86

G. de Pinel '95

Luiz Henrique de Silva Cruz '95

Ernst Dernehl '87

Pere Romero Diaz '95s

Claude Dieterich '84

Tom Dolle '95

Jonathan Doney '96

Lou Dorfsman '54

Anthony Douglas '94

Kyle Dreier '94

John Dreyfus** '68

Christopher Dubber '85

Herman Dyal '95

Lutz Dziarnowski '92

Rick Eiber '85

Friedrich Eisenmenger '93

Khaled Ibrahim El-Sawaf '95

Dr. Elsi Vassdal Ellis '93

Garry Emery '93

Nick Ericson '92

Joseph Michael Essex '78

Leslie Evans '92

Florence Everett '89

Peter Fahrni '93

Simon Fairweather '96

Chen Fang '95

David Farey '93

Michael Farmer '94

Gene Federico** '91

Finner Malmquist Fiton '96

Simon Fitton '94

Kristine Fitzgerald '90

Mona Fitzgerald '91

Yvonne Fitzner '87

Norbert Florendo '84

Gonçalo Fonseca '93

Wayne Ford '96

Alex Fornari '94

Tony Forster '88

Thomas Fowler '93

Carol Freed '87

Adrian Frutiger** '67

Partick Fultz '87

Gene Gable '95

Christof Gassner '90

David Gatti '81

Jeremy Gee '92

Ginger Geist '95

Robyn Gill-Attaway '93

Lou Glassheim* '47

293

17" / 42"

ENGLAND

David Farey

HouseStyle

50-54 Clerkenwell Road

London EC1M 5PS

FRANCE

Christopher Dubber

Signum Art

94, Avenue Victor Hugo

94100 Saint Maur Des Fosses

GERMANY

Bertram Schmidt-Friderichs

Universitatsdruckerei und Verlag

H. Schmidt GmbH & Co.

Robert Koch Strasse 8

Postfach 42 07 28

55129 Mainz Hechtsheim

JAPAN

Japan Typography Association

4-8-15 Yushima Bunkyo-ku

Tokyo 113

TYPE DIRECTORS CLUB

60 East 42nd Street

Suite 721

New York, NY 10165

212-983-6042

FAX: 212-983-6043

E-mail: typeclub@aol.com

http.//users.aol.com.//typeclub

For membership information

please contact the Type Directors Club offices.

MEXICO

Prof. Felix Beltran

Apartado de Correos

M 10733 Mexico 06000

REPUBLIC OF SINGAPORE

Gordon Tan

Gordon Tan Academy

#3 Jaian Pisang

Singapore 0719

SOUTH AMERICA

Diego Vainesman

160 East 26 Street

New York, NY 10010

SWEDEN

Ernst Dernehl

Dernehl & Son Designers

Box 8073

S-10420 Stockholm

Carol Wahler, Executive Director

TYPE DIRECTORS CLUB PRESIDENTS

Frank Powers, 1946, 1947

Milton Zudeck, 1948

Alfred Dickman, 1949

Joseph Weiler, 1950

James Secrest, 1951, 1952, 1953

Gustave Saelens, 1954, 1955

Arthur Lee, 1956, 1957

Martin Connell, 1958

James Secrest, 1959, 1960

Frank Powers, 1961, 1962

Milton Zudeck, 1963, 1964

Gene Ettenberg, 1965, 1966

Edward Gottschall, 1967, 1968

Saadyah Maximon, 1969

Louis Lepis, 1970, 1971

Gerard O'Neill, 1972, 1973

Zoltan Kiss, 1974, 1975

Roy Zucca, 1976, 1977

William Streever, 1978, 1979

Bonnie Hazelton, 1980, 1981

Jack George Tauss, 1982, 1983

Klaus F. Schmidt, 1984, 1985

John Luke, 1986, 1987

Jack Odette, 1988, 1989

Ed Benguiat, 1990, 1991

Allan Haley, 1992, 1993

B. Martin Pedersen, 1994, 1995

Mara Kurtz, 1996

TDC MEDAL RECIPIENTS

Hermann Zapf, 1967

R. Hunter Middleton, 1968

Frank Powers, 1971

Dr. Robert Leslie, 1972

Edward Rondthaler, 1975

Arnold Bank, 1979

Georg Trump, 1982

Paul Standard, 1983

Herb Lubalin, 1984 (posthumously)

Paul Rand, 1984

Aaron Burns, 1985

Bradbury Thompson, 1986

Adrian Frutiger, 1987

Freeman Craw, 1988

Ed Benguiat, 1989

Gene Federico, 1991

Lou Dorfsman, 1995

SPECIAL CITATIONS TO TDC MEMBERS

Edward Gottschall, 1955

Freeman Craw, 1968

James Secrest, 1974

Olaf Leu, 1984, 1990

William Streever, 1984

Klaus F. Schmidt, 1985

John Luke, 1987

Jack Odette, 1989

1996 SCHOLARSHIP RECIPIENTS

David Barrineau, Parsons School of Design

Lara Hovanesian, School of Visual Arts

Jeffrey Piazza, The Cooper Union

Hyewon Shin, Pratt Institute

TYPE

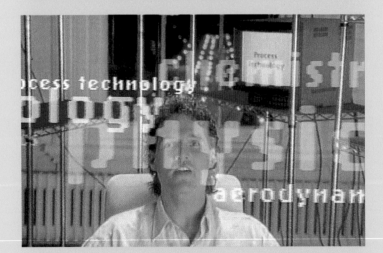

people
communicate
today
like computers

computers
will communicate
tomorrow
like people

process technology
aerodynan

Seagate's FY95 earnings
exceeded those of all
other independent disc-drive
manufacturers

287
17" | 42"

VIDEO

DESIGN
robert wong and
carina feldman
new york, new york

CREATIVE DIRECTION
kent hunter, aubrey
balkind, and robert
wong

STUDIO
frankfurt balkind
partners

CLIENT
seagate technology,
inc.

PRINCIPAL TYPE
oakland and univers
condensed

VIDEO

DESIGN
arturo aranda and
yoo mi lee
new york, new york

CREATIVE DIRECTION
andreas combuchen
and aubrey balkind

STUDIO
frankfurt balkind
partners

CLIENT
partnership for a
drug-free america

PRINCIPAL TYPE
bell gothic

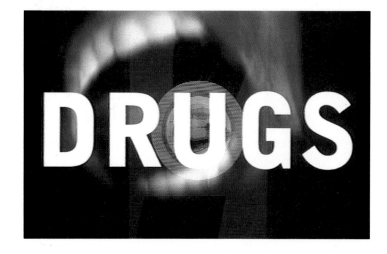

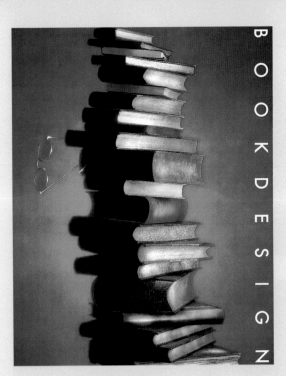

BOOKDESIGN

DESIGN
 b. martin pedersen
 and randell pearson
 new york, new york

ART DIRECTION
 b. martin pedersen

STUDIO
 pedersen design

CLIENT
 graphis u.s. inc.

PRINCIPAL TYPE
 helvetica,
 geometric, and
 bodoni

DIMENSIONS
 9 x 12 in.
 (22.9 x 30.5 cm)

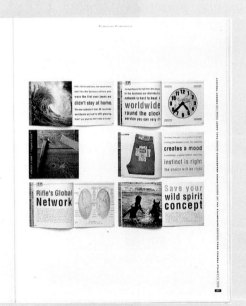

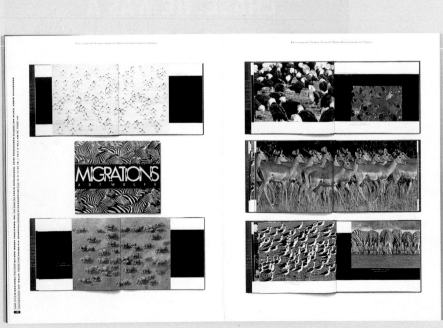

MAGAZINE

DESIGN
david carson
new york, new york

STUDIO
david carson design

CLIENT
ray gun publishing

PRINCIPAL TYPE
din engschrift

DIMENSIONS
12 x 10 in.
(30.5 x 25.4 cm)

Joji Sourdough Co

LOGOTYPE

DESIGN
matt finnigan and
gérard
redwood city, california

STUDIO
solranch

CLIENT
joji sourdough co.

PRINCIPAL TYPE
rougfhouse

DESIGN
neil powell
new york, new york

LETTERING
neil powell

STUDIO
duffy design
new york

CLIENT
matt's hats

PRINCIPAL TYPE
handlettering

DESIGN
geraldine schoeller
vienna, austria

PRINCIPAL TYPE
typeface six

DIMENSIONS
8 ½ x 11 in.
(21.6 x 27.9 cm)

GERALDINE SCHOELLER
STECKHOVENGASSE 22/12
1120 VIENNA, AUSTRIA
222 877.51.60 PHONE

GERALDINE SCHOELLER
STECKHOVENGASSE 22/12
1120 VIENNA, AUSTRIA
222 877.51.60 PHONE

GERALDINE SCHOELLER
25 WEST 13TH STREET 6-HS
NEW YORK CITY, NY 10011
212 243.7694 PHONE/FX

GERALDINE SCHOELLER
25 WEST 13TH STREET 6-HS
NEW YORK CITY, NY 10011
212 243.7694 PHONE FX

GERALDINE SCHOELLER
25 WEST 13TH STREET 6-HS
NEW YORK CITY, NY 10011

281

POSTAGE STAMPS

DESIGN
malcolm waddell
toronto, ontario, canada

ELECTRONIC
PRODUCTION
gary mansbridge

PHOTOGRAPHY
sherman hines
halifax, nova scotia, canada

STUDIO
eskind waddell

CLIENT
canada post
corporation

PRINCIPAL TYPE
grotesque condensed
and emilnuk regular

DIMENSIONS
7 7/8 x 1 in.
(20 x 2.4 cm)

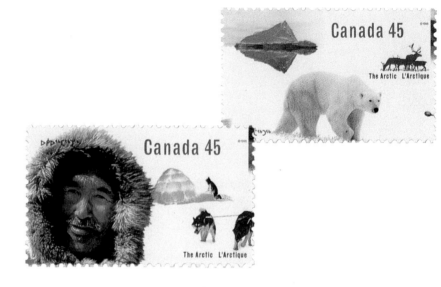

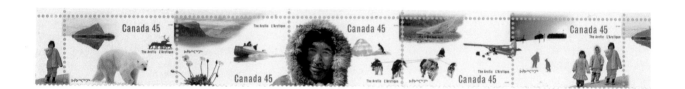

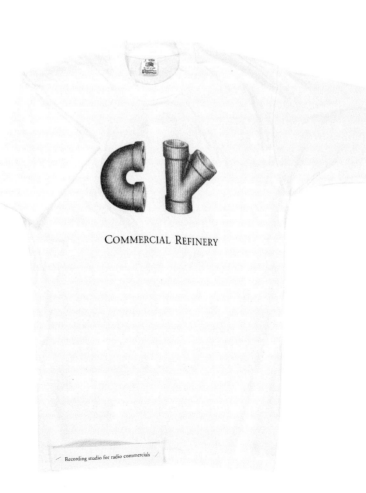

LOGOTYPE

DESIGN
paul sahre
baltimore, maryland

STUDIO
design office of
paul sahre

CLIENT
the commercial
refinery

DESIGN
anita meyer, karin
fickett, matthew
monk, dina
zaccagnini, and jan
baker
boston, massachusetts

LETTERING
jan baker
providence, rhode island

SILKSCREENING
arabesque studio
ltd.

PRODUCTION
anita meyer, karin
fickett, matthew
monk, dina
zaccagnini, jeremy
botts, erin hasley,
and carolyn
mazzucca

PRINTING
benjamin franklin
smith, inc.

CLIENT
plus design inc.

PRINCIPAL TYPE
meta plus and
handlettering

DIMENSIONS
1 1/4 x 4 1/4 x 5 1/2 in.
(3.2 x 10.8 x 14 cm)

279
17 th 42 nd

DESIGN
markus dreßen, lisa
eidt, luitgard
feck, silke
janetzky, angela
metge, eberhard
norden, helge
rieder, anja
schulze, tim
ulrich, heidi
willkom, and petra
schultze
mainz, germany

COVER DESIGN
petra schultze

CLIENT
verlag hermann
schmidt mainz

PRINCIPAL TYPE
rockwell

DIMENSIONS
4 ½ x 2 ½ in.
(11.5 x 6.5 cm)

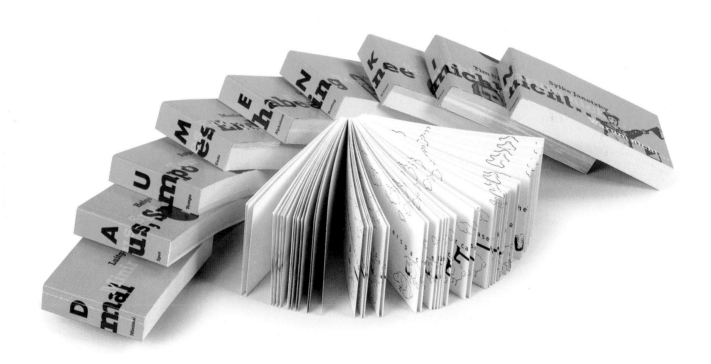

RIB=T

B
E
A
U
T
Y

3

BOOK

DESIGN
john clark, carol
newsom, laurent
tschumy, donna
fischer, jennifer
bressler, and gary
wong
los angeles, california

STUDIO
looking/los angeles

CLIENT
paul vangelisti,
editor, college of
neglected science

PRINCIPAL TYPE
gill sans and
janson

DIMENSIONS
3 3/4 x 8 1/4 in.
(9.5 x 21 cm)

DESIGN
tia doar
portland, oregon

AGENCY
borders, perrin &
norrander

CLIENT
oregon coast
aquarium

PRINCIPAL TYPE
gill sans

DIMENSIONS
11½ x 17 in.
(29.2 x 43.2 cm)

The French eat four million frog legs a year. That's why this announcement is in **English.**

Exhibit Now Open.

Oregon Coast Aquarium **FROGS!**

DESIGN
robynne raye
seattle, washington

LETTERING
robynne raye

STUDIO
modern dog

CLIENT
one reel

PRINCIPAL TYPE
handlettering

DIMENSIONS
23 x 30½ in.
(58.4 x 77.5 cm)

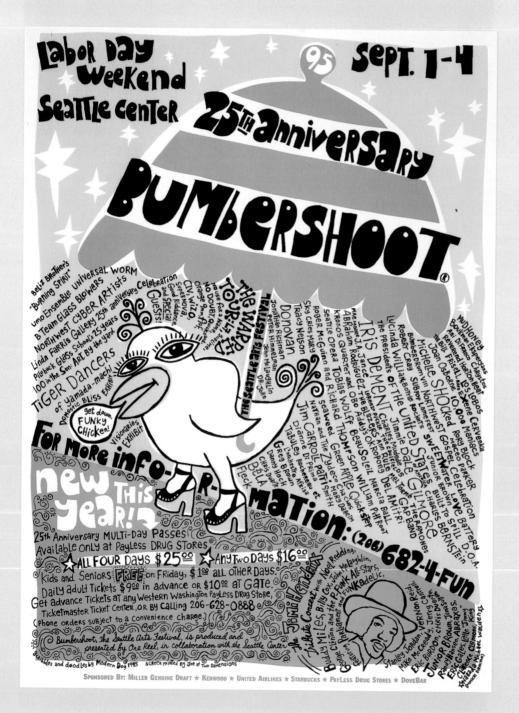

DESIGN
melinda beck
brooklyn, new york

ILLUSTRATION
melinda beck

AGENCY
nick at nite

STUDIO
melinda beck studio

CLIENT
nick at nite

PRINCIPAL TYPE
poncho, franklin
gothic, madrone,
and richard murri

DIMENSIONS
12 x 9½ in.
(30.5 x 24.1 cm)

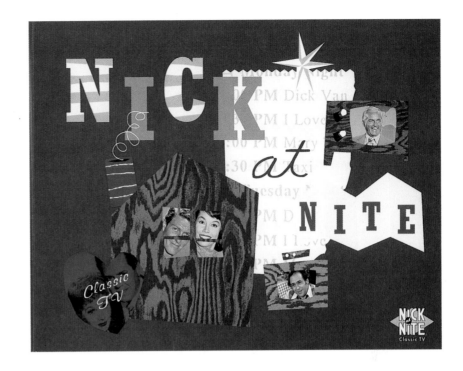

PACKAGING

DESIGN
haley johnson
minneapolis, minnesota

STUDIO
haley johnson
design company

CLIENT
amazing grazing

PRINCIPAL TYPE
matrix, franklin
gothic, and trade
gothic

DIMENSIONS
5¼ in.
(13.5 cm) height

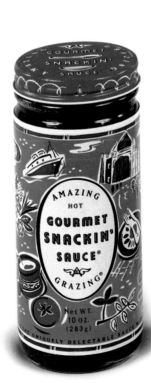
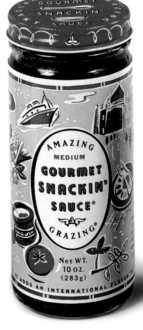
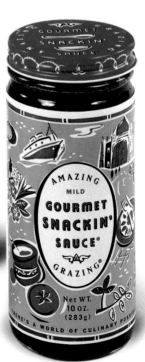

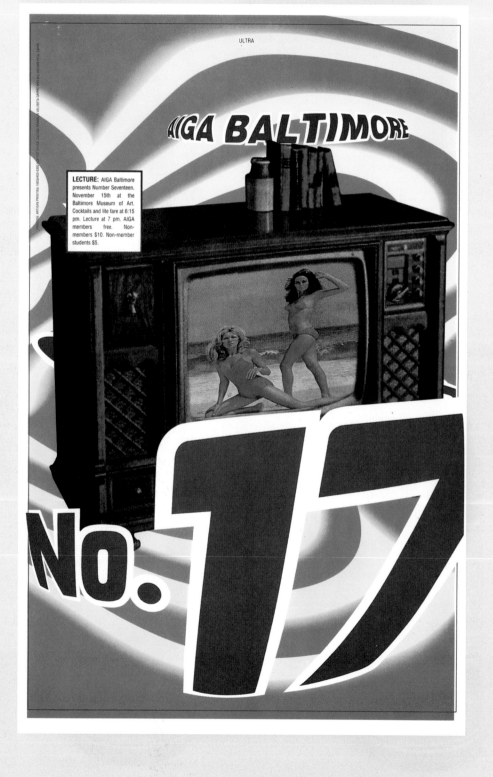

DESIGN
paul sahre and
franklin grippe
baltimore, maryland

STUDIO
design office of
paul sahre

CLIENT
american institute
of graphic arts,
baltimore chapter

PRINCIPAL TYPE
helvetica condensed

DIMENSIONS
11 x 17 in.
(27.9 x 43.2 cm)

273

ADVERTISEMENT AND
POSTER

DESIGN
rüdiger götz
hamburg, germany

LETTERING
rüdiger götz

TYPOGRAPHY
olaf stein

STUDIO
factor design

CLIENT
max sames gmbh

PRINCIPAL TYPE
trade gothic, itc
bodoni, and
handlettering

DIMENSIONS
8 ¼ x 11 ¹¹/₁₆ in.
(21 x 29.7 cm) and
16 ½ x 23 ⁷/₁₆ in.
(42 x 59.4 cm)

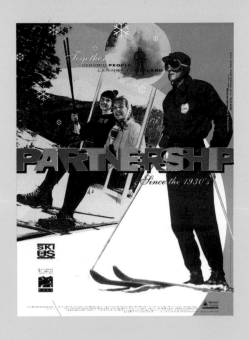

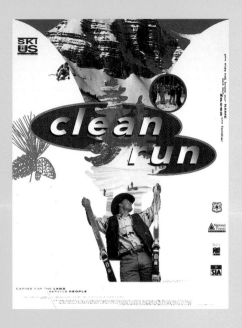

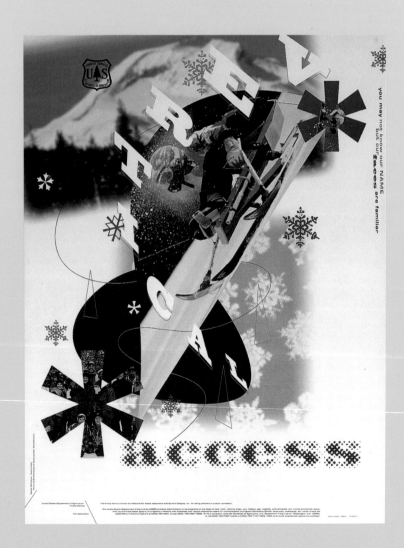

POSTERS

DESIGN
tim thompson and
joe parisi
baltimore, maryland

STUDIO
graffito/active 8,
inc.

CLIENT
u.s. department of
agriculture (usda)

PRINCIPAL TYPE
eurostile, craw
clarendon, and
shelley allegro

DIMENSIONS
17 x 22 in.
(43.2 x 55.9 cm)

DESIGN
david ekizian
wellesley, massachusetts

PHOTOGRAPHY
rick hornick and
sandy rivlin
boston, massachusetts

AGENCY
ekizian design

CLIENT
hornick rivlin
photography

PRINCIPAL TYPE
antus, engravers'
gothic, and letter
gothic

DIMENSIONS
5 ¼ x 7 ⅞ in.
(13.3 x 20 cm)

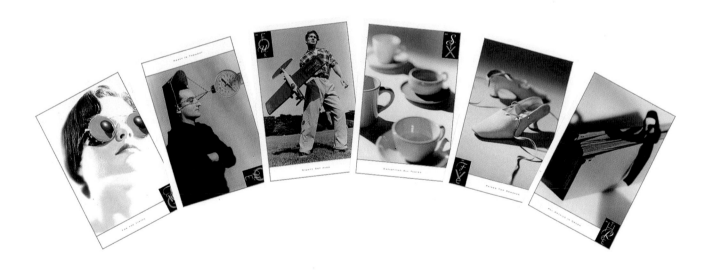

269

17" / 42"

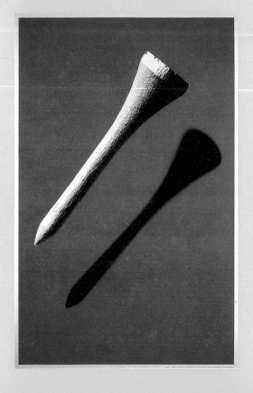

POSTERS

DESIGN
michael bierut,
woody pirtle, and
paula scher
new york, new york

PHOTOGRAPHY
john paul endress

STUDIO
pentagram design

CLIENT
ambassador arts,
inc. and champion
international

PRINCIPAL TYPE
handlettering

DIMENSIONS
23 x 35 in.
(58.4 x 88.9 cm)

DESIGN
stefan sagmeister
and veronica oh
new york, new york

CALLIGRAPHY
veronica oh

PHOTOGRAPHY
tom schierlitz

AGENCY
sagmeister inc.

CLIENT
dave boonshoft/naked
music

PRINCIPAL TYPE
spartan (adapted)
and rotis semi sans

DIMENSIONS
8 ½ x 11 in.
(21.6 x 27.9 cm)

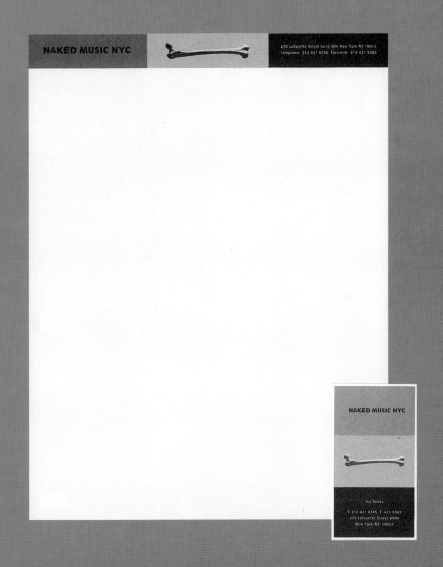

STATIONERY

DESIGN
fritz klaetke
boston, massachusetts

PHOTOGRAPHY
matthew wagenknecht
newton, massachusetts

STUDIO
visual dialogue

CLIENT
firefly films

PRINCIPAL TYPE
charlie's sandwich
shoppe special

DIMENSIONS
8 1/2 x 11 in.
(21.6 x 27.9 cm)

THE STORIES OF
VLADIMIR
VLADIMIR
NABOKOV
NABOKOV

BOOK COVER

DESIGN
stephen doyle
new york, new york

STUDIO
drenttel doyle
partners

CLIENT
alfred a. knopf,
inc.

PRINCIPAL TYPE
hand-cut type based
on orator

DIMENSIONS
6 1/2 x 9 1/2 in.
(16.5 x 24.1 cm)

BIRTH
ANNOUNCEMENT

DESIGN
 peter lord and
 elizabeth carluccio
 lord
 new york, new york

CLIENT
 olivia rae lord

PRINCIPAL TYPE
 itc kabel and hand-
 modified lettering

DIMENSIONS
 3 x 4³/₈ in.
 (7.6 x 11.1 cm)

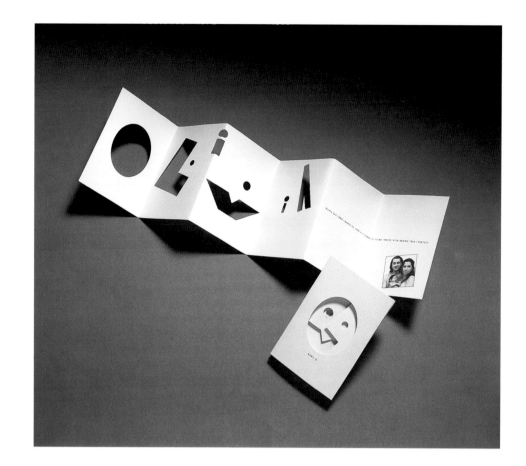

CORPORATE
IDENTITY

DESIGN
 robert valentine
 and jin chung
 new york, new york

ILLUSTRATION
 dave plunkert
 baltimore, maryland

STUDIO
 the valentine group

CLIENT
 gilbert paper

PRINCIPAL TYPE
 american typewriter,
 futura, and bauer
 bodoni (adapted)

DIMENSIONS
 various

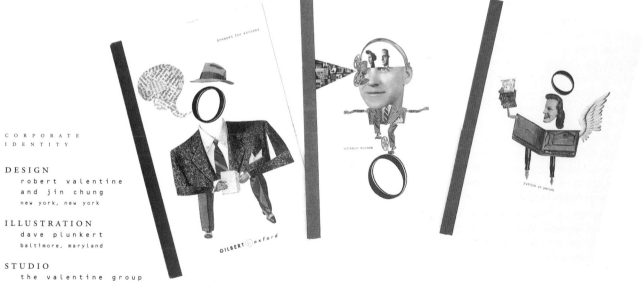

DESIGN
john van dyke and
ann kumasaka
seattle, washington

CALLIGRAPHY
georgia deaver
san francisco, california

PHOTOGRAPHY
holly stewart
san francisco, california

STUDIO
van dyke company
.

CLIENT
fox river paper
company

PRINCIPAL TYPE
galliard and futura
bold

DIMENSIONS
11 x 11 in.
(27.9 x 27.9 cm)

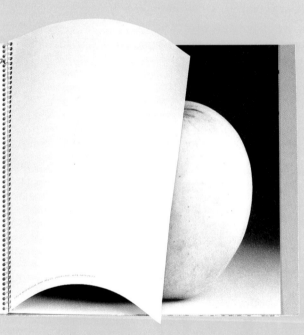

265

DESIGN
greg simpson and
eric baker
new york, new york

STUDIO
eric baker design
associates, inc.

CLIENT
gilbert paper
company

PRINCIPAL TYPE
de vinne, lightline
gothic, cheltenham
old style italic,
franklin gothic,
bookman, and
century old style

DIMENSIONS
5 ½ x 8 ½ in.
(14 x 21.6 cm)

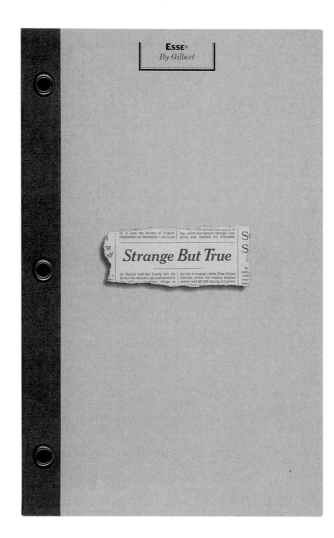

PROMOTION

DESIGN
rüdiger götz and
charlotte bourdeix
hamburg, germany

CALLIGRAPHY
pia lindner
san francisco, california

STUDIO
factor design

CLIENT
römerturm
feinstpapier

PRINCIPAL TYPE
melior, trade
gothic, and adobe
caslon

DIMENSIONS
4 15/16 x 7 5/16 in.
(12.5 x 18.5 cm)

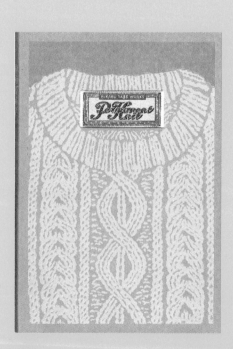

DESIGN
gail swanlund,
zuzana licko, and
rudy vanderlans
sacramento, california

STUDIO
emigre

PRINCIPAL TYPE
various

DIMENSIONS
9 x 11 in.
(22.9 x 27.9 cm)

263

17"⁰ / 42"⁰

BROCHURE

DESIGN
zempaku suzuki,
masahiro naito,
aritomo veno, and
naomi taguchi
shintomi, tokyo, japan

KNIT ARTIST
hikaru tasee
yokohama, kanagawa, japan

ART DIRECTION
zempaku suzuki and
hideyasu tase

PHOTOGRAPHY
tamotsu ikeda
shibuya, tokyo, japan

STUDIO
b·bi studio inc.

CLIENT
hideyasu tase

PRINCIPAL TYPE
bodoni bold italic

DIMENSIONS
10¹¹/₁₆ x 15 in.
(27.1 x 38.2 cm)

MAGAZINE

DESIGN
hans dieter
reichert, dean
pavitt, and simon
dwelly
east malling, england

EDITORIAL ADVISORY
BOARD
martin ashley,
misha anikst, colin
brignall, david
ellis, and alan
fletcher

EDITORS
mike daines and
hans dieter
reichert

STUDIO
hdr design

CLIENT
bradbourne
publishing

PRINCIPAL TYPE
charlotte sans

DIMENSIONS
13 5/8 x 9 5/8 in.
(34.6 x 24.5 cm)

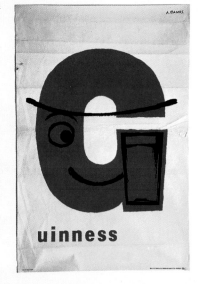

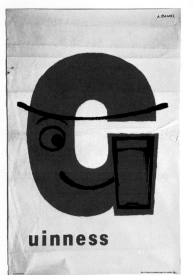

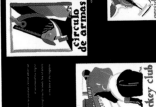

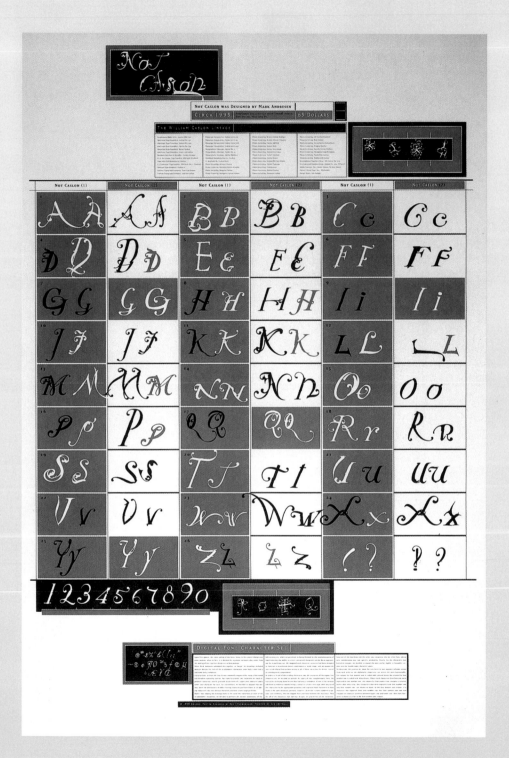

DESIGN
rudy vanderlans
sacramento, california

TYPE DESIGN
mark andresen
metairie, louisiana

STUDIO
emigre

PRINCIPAL TYPE
not caslon

DIMENSIONS
22 1/2 x 32 3/4 in.
(57.2 x 83.2 cm)

DESIGN
john rousseau
birmingham, michigan

STUDIO
john rousseau,
designer

CLIENT
design michigan

PRINCIPAL TYPE
centaur and meta

DIMENSIONS
7 1/2 x 10 1/2 in.
(19.1 x 26.7 cm)

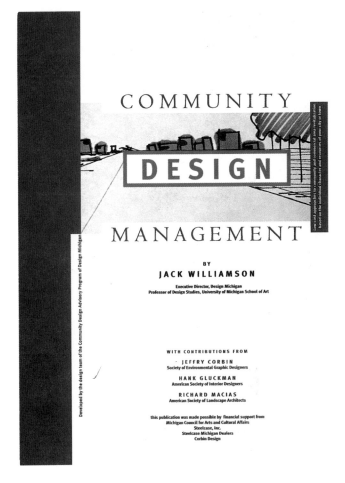

COMMUNITY

DESIGN

MANAGEMENT

BY
JACK WILLIAMSON

Executive Director, Design Michigan
Professor of Design Studies, University of Michigan School of Art

WITH CONTRIBUTIONS FROM

JEFFRY CORBIN
Society of Environmental Graphic Designers

HANK GLUCKMAN
American Society of Interior Designers

RICHARD MACIAS
American Society of Landscape Architects

this publication was made possible by financial support from
Michigan Council for Arts and Cultural Affairs
Steelcase, Inc.
Steelcase Michigan Dealers
Corbin Design

you
are
here

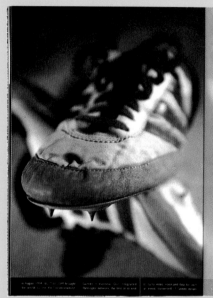

100
metres
45,985 kilometres

ANNUAL REPORT

DESIGN
john van dyke and
dave mason
seattle, washington

WRITERS
tom mccarthy and
dave crowe

PHOTOGRAPHY
victor penner

STUDIO
a design
collaborative

CLIENT
bc telecom

PRINCIPAL TYPE
garamond no. 3 and
gill sans

DIMENSIONS
8 1/2 x 12 in.
(21.6 x 30.5 cm)

259
17" 42"

BROCHURE

DESIGN
stefan hartung and
kevin kuester
minneapolis, minnesota

STUDIO
the kuester group

CLIENT
potlatch paper
corporation,
nw division

PRINCIPAL TYPE
bembo, meta, and
gota

DIMENSIONS
8 ½ x 9 in.
(21.6 x 22.9 cm)

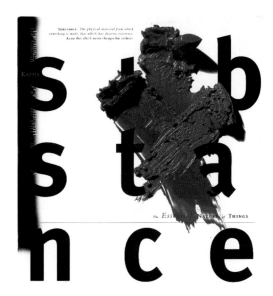

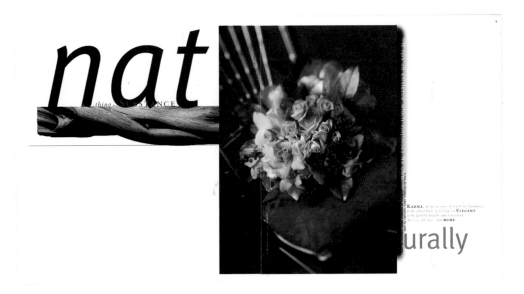

INVITATION

DESIGN
dan richards
beaverton, oregon

STUDIO
nike, inc.

PRINCIPAL TYPE
house broken clean

DIMENSIONS
5 x 6 in.
(12.7 x 15.2 cm)

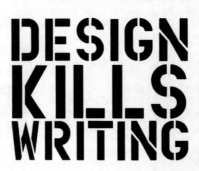

DESIGN KILLS WRITING

Let it be said:

'THE BIRTH OF THE READER MUST BE AT THE
COST OF THE DEATH OF THE AUTHOR'

'AT THE COST OF THE DEATH OF THE AUTHOR'

MAGAZINE

DESIGN
anne burdick,
michael worthington,
elliott earls,
kevin mount, joani
spadaro, andrew
blauvelt, rudy
vanderlans, and
denise gonzales
crisp
sacramento, california

ART DIRECTION
anne burdick

STUDIO
emigre

PRINCIPAL TYPE
various

DIMENSIONS
8 1/4 x 11 1/4 in.
(21 x 28.6 cm)

Duff theory

How hollow

All was well

DESIGN
brian fingeret and
forrest king
new york, new york

ART DIRECTION
michael mcginn

PHOTOGRAPHY
paul aresu

STUDIO
designframe inc.

CLIENT
strathmore papers

PRINCIPAL TYPE
gill sans bold and
sabon

DIMENSIONS
17 3/16 x 11 3/16 in.
(43.6 x 28.4 cm)

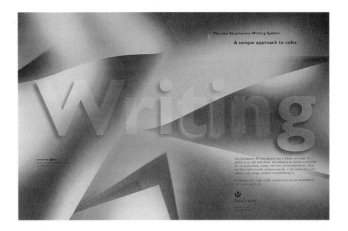

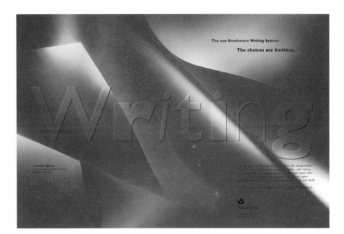

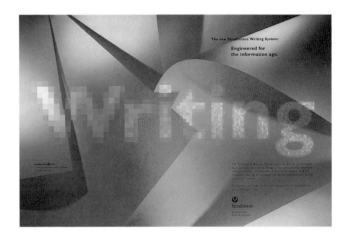

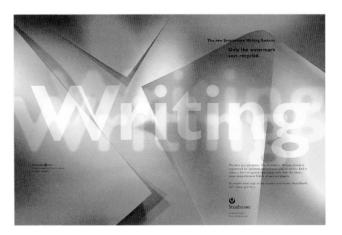

STUDENT PROJECT:
BOOK

DESIGN
 lutz eberle
 stuttgart, germany

TYPE DESIGN
 frank heine

TYPOGRAPHIC SOURCE
 u.o.r.g.

STUDIO
 staatliche akademie
 der bildenden
 künste stuttgart

PRINCIPAL TYPE
 u.o.r.g. coolage
 and jeannette
 (joanna redrawn)

DIMENSIONS
 4 7/8 x 8 1/2 in.
 (12.4 x 21.6 cm)

255

17" 42"

MAGAZINE SPREAD

DESIGN
 don ryun chang and
 heesoo kim
 seoul, korea

CALLIGRAPHY
 joon choi

LETTERING
 woo haeng lee

STUDIO
 dc&a

CLIENT
 cmi

PRINCIPAL TYPE
 helvetica black and
 helvetica bold

DIMENSIONS
 20 1/8 x 14 3/8 in.
 (51.2 x 36 cm)

C A T A L O G

DESIGN
anja fenner and
dorothée
strassburger
düsseldorf, germany

ART DIRECTION
gerhard schmal

PHOTOGRAPHY
achim kukulies

AGENCY
stöhr scheer
werbeagentur gmbh

CLIENT
westdeutsche
spielbanken gmbh &
co. kg

PRINCIPAL TYPE
helvetica neue and
bauer bodoni

DIMENSIONS
6 7/8 x 6 7/8 in.
(17.5 x 17.5 cm)

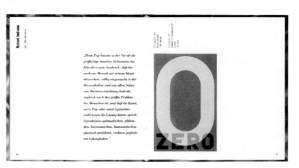

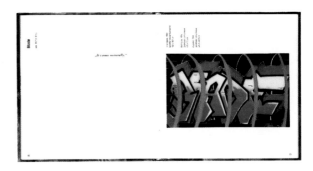

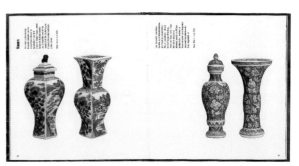

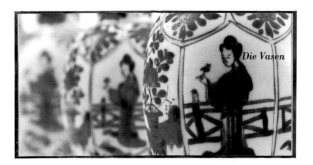

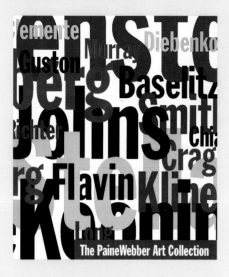

The PaineWebber Art Collection

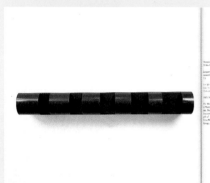

Donald Judd
Untitled, 1967

Cy Twombly
Untitled, 1972

BOOK

DESIGN
woody pirtle, john
klotnia, and brenna
garrett
new york, new york

LETTERING
brenna garrett

STUDIO
pentagram design

CLIENT
rizzoli publishing

PRINCIPAL TYPE
franklin gothic
condensed and
garamond

DIMENSIONS
10½ x 12 in.
(26.7 x 30.5 cm)

DESIGN
uwe loesch
düsseldorf, germany

CLIENT
museum für
kunsthandwerk,
frankfurt am main

PRINCIPAL TYPE
din engschrift

DIMENSIONS
92 ¹⁵/₁₆ x 33 ¹/₁₆ in.
(59.4 x 84 cm)

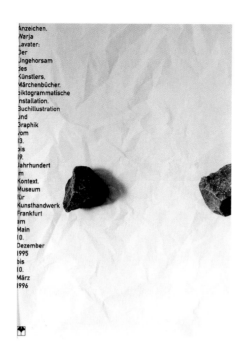

Anzeichen.
Warja
Lavater:
Der
Ungehorsam
des
Künstlers,
Märchenbücher,
piktogrammatische
Installation.
Buchillustration
und
Graphik
vom
13.
bis
19.
Jahrhundert
im
Kontext.
Museum
für
Kunsthandwerk
Frankfurt
am
Main
10.
Dezember
1995
bis
10.
März
1996

Schriftzeichen.
Paul
Franck:
Alphabete.
Schreibmeisterbücher
des
16.
bis
17.
Jahrhunderts.
Peter
Malutzki:
ABC.
Typographie
in
Buch,
Beton
und
Eisen.
Museum
für
Kunsthandwerk
Frankfurt
am
Main
22.
Juni
bis
3.
September
1995

Mahnzeichen.
Memento
Mori
und
andere
Mahnungen
in
Buchillustration
und
Graphik
vom
13.
bis
19.
Jahrhundert.
Felix
Martin
Furtwängler:

Einsam
Dagegen.
Radierungen.
Museum
für
Kunsthandwerk
Frankfurt
am
Main
14.
September
bis
26.
November
1995

Handzeichen.
Buchillustration
und
Graphik
vom
13.
bis
19.
Jahrhundert
zur
Motivgeschichte
der
Hand.
Die
Hand
im
Plakat.
Museum
für
Kunsthandwerk
Frankfurt
am
Main
4.
April
bis
2.
Juni
1996

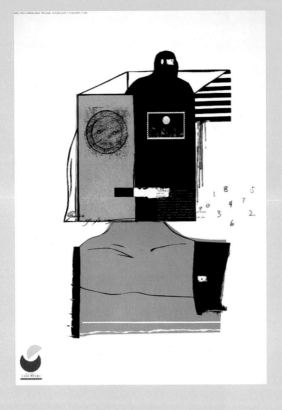

POSTER

DESIGN
 masakazu tanabe
 gifu, japan

STUDIO
 media co., ltd.

CLIENT
 photo library
 sanctuary

DIMENSIONS
 40 9/16 x 28 11/16 in.
 (103 x 72.8 cm)

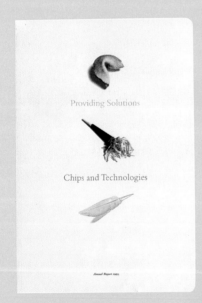

Providing Solutions

Chips and Technologies

Annual Report 1995.

Like combatants in a
religious war, personal
computer users have
been divided into two
camps: PC vs. Macintosh.

ANNUAL REPORT

DESIGN
 michael verdine
 san francisco, california

ART DIRECTION
 bill cahan

STUDIO
 cahan & associates

CLIENT
 chips and
 technologies, inc.

PRINCIPAL TYPE
 bembo

DIMENSIONS
 7 x 10¼ in.
 (17.8 x 26 cm)

CATALOG

DESIGN
olivier trillon
montrouge, france

PHOTOGRAPHY
olivier trillon

STUDIO
trillon & cie

CLIENT
d. i. c.

PRINCIPAL TYPE
mata bold, künstler
script, and caslon
540

DIMENSIONS
10 x 13³/₄ in.
(25.5 x 35 cm)

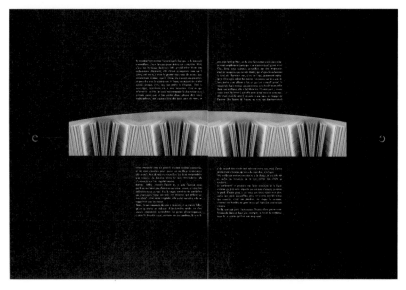

MOLECULAR DYNAMICS COMBINES CORE
COMPETENCIES IN MOLECULAR AND
CELL BIOLOGY, LASER SCANNING, SIGNAL
PROCESSING, DETECTION TECHNOLOGIES
AND COMPUTER SCIENCE TO DEVELOP
INNOVATIVE IMAGING INSTRUMENTS
THAT INCREASE PRODUCTIVITY AND
ENABLE NEW ANALYTICAL TECHNIQUES
IN THE LIFE SCIENCE LABORATORY.

ANNUAL REPORT

DESIGN
 bob dinetz
 san francisco, california

ART DIRECTION
 bill cahan

STUDIO
 cahan & associates

CLIENT
 molecular dynamics

PRINCIPAL TYPE
 bembo

DIMENSIONS
 8 ½ x 11 in.
 (21.6 x 27.9 cm)

249

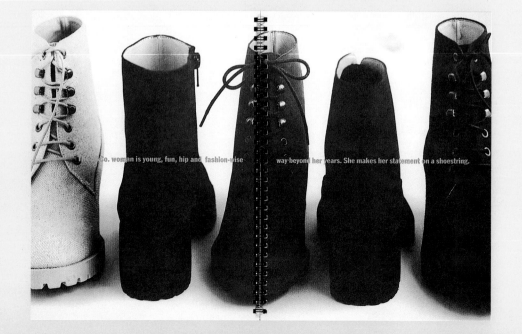

Co. woman is young, fun, hip and fashion-wise way beyond her years. She makes her statement on a shoestring.

ANNUAL REPORT

DESIGN
 woody pirtle, john
 klotnia, and ivette
 montes de oca
 new york, new york

LETTERING
 ivette montes de
 oca

PHOTOGRAPHY
 matthew septimus
 and others

STUDIO
 pentagram design

CLIENT
 nine west

PRINCIPAL TYPE
 bauer bodoni and
 itc officina sans

DIMENSIONS
 8 ¾ x 11 in.
 (22.2 x 27.9 cm)

DESIGN
stefan v. hartung
minneapolis, minnesota

STUDIO
the kuester group,
inc.

CLIENT
pentair, inc.

PRINCIPAL TYPE
goudy

DIMENSIONS
8 ¹/₂ x 11 in.
(21.6 x 27.9 cm)

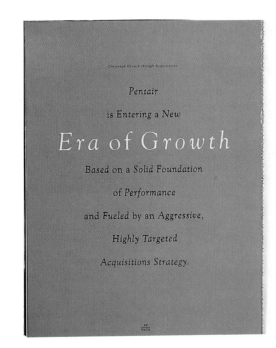

Continued Growth through Acquisitions

Pentair

is Entering a New

Era of Growth

Based on a *Solid Foundation*

of *Performance*

and *Fueled* by an *Aggressive*,

Highly Targeted

Acquisitions Strategy.

Strategic INSIGHTS: **ACQUISITIONS**

Many know Pentair as an acquisitions company. Historically, we have been just that. We have grown by acquiring basically sound but under-utilized companies that we have revitalized through a variety of strategies.

The statistics demonstrate that it is an approach that has worked very well. As of 1994, Pentair industrial acquisitions as a group have experienced internal growth rates of 22%. They generated an 8% return on investment in the year following their acquisition and collectively delivered a 23% return on investment by the end of 1994. In the year after acquisition, these same companies averaged a 5% return on sales and have doubled that to 10%. In the future, acquisitions will become even more important to Pentair. In fact, we have mapped out an acquisitions plan for the next five years that is so aggressive it could rival Pentair's past record.

We will continue our longstanding strategy of acquiring both under-utilized and growth-oriented companies that can become premier businesses, returning growth and building shareholder value through our management approach and capital resources. Pentair will also seek companies with products, manufacturing or distribution that will blend well and can accelerate or reinforce the growth and market strengths of existing companies. Finally, we seek to acquire substantial, established companies that can become significant new Pentair businesses and generate above-average returns to meet our goal of increasing shareholder value.

BUILDING INDUSTRIAL BUSINESS
Average Annual Internal Growth of 22%

DESIGN
akio okumura
osaka-city, osaka, japan

STUDIO
packaging create
inc.

CLIENT
japan graphic
designers
association inc.

PRINCIPAL TYPE
univers black

DIMENSIONS
28 ¹¹/₁₆ x 40 ⁹/₁₆ in.
(72.8 x 103 cm)

原子爆弾投下から50年を経た広島と長崎の土でポスターをつくりました。

This poster was made from the soil of Hiroshima and Nagasaki where the atomic bomb was dropped 50 years ago.

STATIONERY

DESIGN
louise fili
new york, new york

STUDIO
louise fili ltd.

CLIENT
bartlett winery

PRINCIPAL TYPE
engravers' roman
bold, excelsior
script, and
handlettering

DIMENSIONS
8 ½ x 11 in.
(21.6 x 27.9 cm)

247
17"/42"

LOGOTYPE

DESIGN
felix p. sockwell
dallas, texas

AGENCY
latitude

CLIENT
kaelson company
integrated
landscapes

CATALOG

DESIGN
jerry king musser
columbia, pennsylvania

STUDIO
musser design

CLIENT
exit editions

PRINCIPAL TYPE
bell centennial

DIMENSIONS
7 ¹/₄ x 10 in.
(18.4 x 25.4 cm)

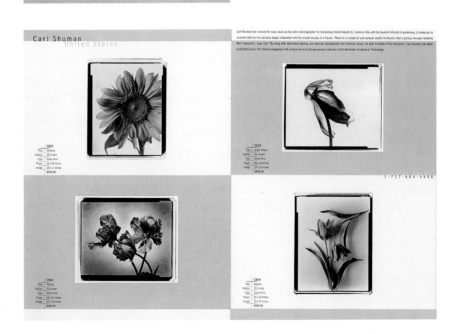

Shou 壽

The chrysanthemum

pine tree and crane

ARE METAPHORS FOR LONGEVITY

IN CHINESE BELIEFS

Shou Lao the god of longevity is a familiar image during Chinese New Year

A *birthday cake* with many candles

celebration

OF THE PASSING OF TIME.

BOOKLET

DESIGN
byron jacobs
hong kong

STUDIO
ppa design limited

PRINCIPAL TYPE
matrix narrow and
trajan

DIMENSIONS
6 15/16 x 8 7/16 in.
(15.5 x 22 cm)

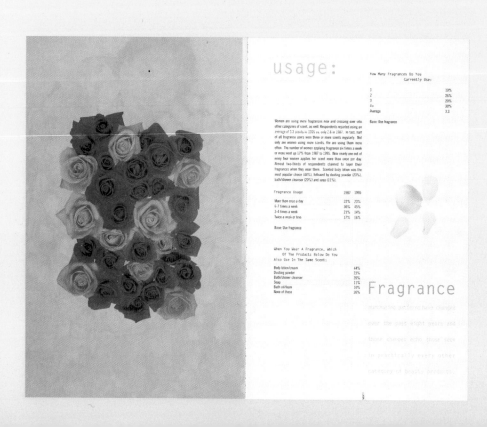

BOOK

ART DIRECTION
christine licata
and elizabeth
baldwin

CREATIVE DIRECTION
sheila sullivan
new york, new york

STUDIO
glamour magazine
promotional art
dept.

CLIENT
glamour

PRINCIPAL TYPE
letter gothic and
trade gothic

DIMENSIONS
7 5/8 x 11 3/4 in.
(19.4 x 29.8 cm)

CALLIGRAPHY
philippe weisbecker
paris, france

ART DIRECTION
libby carton

CREATIVE DIRECTION
klaus fehsenfeld
berlin, germany

AGENCY
w.a.f.
werbegesellschaft
mbh

CLIENT
deutsche handelsbank
ag

PRINCIPAL TYPE
slimbach and
frutiger

DIMENSIONS
8 1/4 x 11 3/8 in.
(21 x 29 cm)

CATALOG

DESIGN
allison muench and
j. phillips
williams
new york, new york

COPYWRITING
laura silverman

PHOTOGRAPHY
william abranowicz

STUDIO
design:m/w

CLIENT
takashimaya new
york

PRINCIPAL TYPE
gill sans,
perpetua, and scala
sans

DIMENSIONS
7 1/8 x 5 3/4 in.
(18.1 x 14.6 cm)

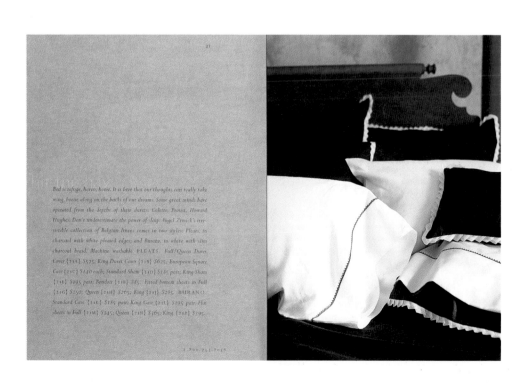

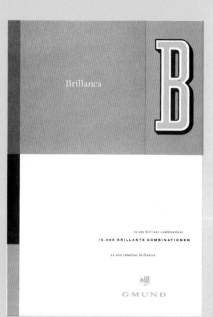

SWATCHBOOK

DESIGN
olaf stein and
rüdiger götz
hamburg, germany

STUDIO
factor design

CLIENT
büttenpapierfabrik
gmund

PRINCIPAL TYPE
bembo and monotype
grotesque

DIMENSIONS
8 ¼ x 11 ¹¹/₁₆ in.
(21 x 29.7 cm)

Specifier

Die Gmunder Papierkollektionen im Überblick

Overview of Gmund's paper collections

Répertoire des collections de papier de Gmund

GMUND

243

SWATCHBOOK

DESIGN
olaf stein and
rüdiger götz
hamburg, germany

STUDIO
factor design

CLIENT
büttenpapierfabrik
gmund

PRINCIPAL TYPE
bembo and monotype
grotesque

DIMENSIONS
5 ¹³/₁₆ x 8 ¼ in.
(14.8 x 21 cm)

CATALOG

DESIGN
gerhard blättler,
martin gaberthüel,
and andréas
netthoevel
bern, biel, switzerland

COPYWRITING
olivier
bauermeister, peck
erismann, rätus
luck, marius
michaud, and
pierre-louis surchat

PHOTOGRAPHY
marco schibig

CLIENT
swiss national
library

PRINCIPAL TYPE
foundry, bauer
bodoni, and ocr-a

DIMENSIONS
8 ¼ x 11 ¹¹/₁₆ in.
(21 x 29.7 cm)

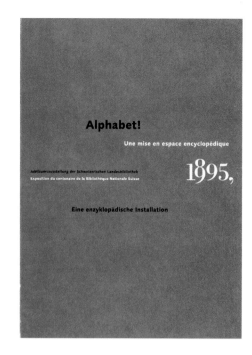

Alphabet!

Une mise en espace encyclopédique

1895,

Jubiläumsausstellung der Schweizerischen Landesbibliothek
Exposition du centenaire de la Bibliothèque Nationale Suisse

Eine enzyklopädische Installation

Tabac (Indien-espagnol)

Unterwalden

GTE Telepho ne Operations

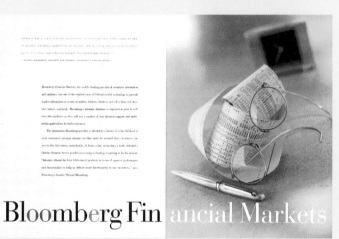

Bloomberg Fin ancial Markets

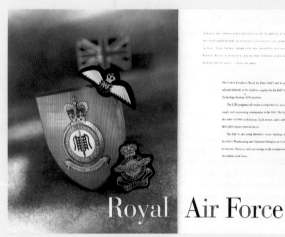

Royal Air Force

ANNUAL REPORT

DESIGN
kevin roberson
san francisco, california

ART DIRECTION
bill cahan

STUDIO
cahan & associates

CLIENT
informix software,
inc.

PRINCIPAL TYPE
bauer bodoni and
futura

DIMENSIONS
8 1/2 x 11 in.
(21.6 x 27.9 cm)

241

BROCHURE

DESIGN
sibylle haase,
katja hirschfelder,
and regina
spiekermann
bremen, germany

PHOTOGRAPHY
fritz haase,
stefanie nawrot,
jürgen nogai,
alfred rostek,
klaus rohmeyer, and
jochen mönch

STUDIO
atelier haase &
knels

CLIENT
böttcherstraße gmbh

PRINCIPAL TYPE
futura and bodoni

DIMENSIONS
9 x 4 15/16 in.
(23 x 12.5 cm)

BOOK

DESIGN
cheng kar wai
hong kong

CREATIVE DIRECTION
tommy li and
wing chuen

STUDIO
tommy li design &
associates

CLIENT
hong kong institute
of professional
photographers

PRINCIPAL TYPE
letter gothic,
ocr-b, new
baskerville, snell
roundhand bold, and
monotype m hei-
light

DIMENSIONS
11 1/4 x 8 9/16 in.
(28.6 x 21.7 cm)

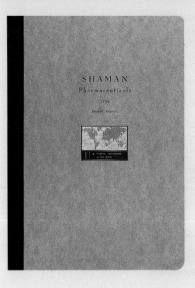

DESIGN
sharrie brooks
san francisco, california

ART DIRECTION
bill cahan

STUDIO
cahan & associates

CLIENT
shaman
pharmaceuticals,
inc.

PRINCIPAL TYPE
belcian book,
courier, centaur,
and univers 55

DIMENSIONS
8 x 11 in.
(20.3 x 27.9 cm)

239

17" 42""

DESIGN
robert petrick and
laura ress
chicago, illinois

STUDIO
petrick design

CLIENT
jacor
communications, inc.

PRINCIPAL TYPE
univers and times
roman

DIMENSIONS
8 1/2 x 8 1/2 in.
(21.6 x 21.6 cm)

1994 WAS A SOUND YEAR FOR JACOR

YMCA
of Greater Toronto

Annual Report 1993/94
(and picture book)

DESIGN
diti katona, john
pylypczak, and
renata chubb
toronto, ontario, canada

PHOTOGRAPHY
roman pylypczak,
john pylypczak, and
diti katona

STUDIO
concrete design
communications inc.

CLIENT
ymca of greater
toronto

PRINCIPAL TYPE
franklin gothic and
deepdene

DIMENSIONS
8 1/2 x 7 in.
(21.6 x 17.8 cm)

A true story. Once upon a time, there was
an old building called the Toronto Central YMCA.
And then there was a new building, the Metro-Central
YMCA, that took its place exactly 10 years ago.
Metro-Central YMCA is a bit of a surprise.
When people look inside, they are invariably convinced
they have walked into a brand-new building. The
design is, of course, as outstanding as ever. But the way
it's been maintained is another great story. All true.
The pools are drained each year for a general cleaning
and safety inspection. All areas of wall, floors and
ceiling are looked at carefully and maintained to ensure
they are in safe and "as new" condition.
Metro-Central is not unique. This is the policy
of the YMCA — to keep our assets in "as new" condition.
To achieve this, we spent $260,000 this past year to
repaint walls, regrout tiles in pools and change areas and
generally renew building surfaces. This is in addition
to more than $600,000 spent to replace equipment that
had reached the end of its useful life. An additional
$1.3 million was invested in new program equipment
and program sites.

POTLATCH CORPORATION

DESIGN
 steve tolleson and
 jean orlebeke
 san francisco, california

PHOTOGRAPHY
 tom tracy and david
 magnussen

STUDIO
 tolleson design

CLIENT
 potlatch corporation

PRINCIPAL TYPE
 garamond no. 3

DIMENSIONS
 8 ½ x 11 in.
 (21.6 x 27.9 cm)

237

FOLLOW

3 *DESIGN WINS*

ANNUAL REPORT

DESIGN
 bob dinetz
 san francisco, california

ART DIRECTION
 bill cahan

STUDIO
 cahan & associates

CLIENT
 trident
 microsystems, inc.

PRINCIPAL TYPE
 din schriften and
 univers

DIMENSIONS
 8 ½ x 11 in.
 (21.6 x 27.9 cm)

1-800-I-FEEL-OK

-FUNNY/INFORMATIVE!
-U DIAL, U TALK, U PRESS BUTTONS!
-SPONSORED BY "OK" SODA!
-LIMITED TIME ONLY! (MAY 1-MAY 21)
-SPECIAL "RANDOM" CATEGORY!

5 QUICK STEPS TO FEELING OK
1. BUY "OK" SODA.
2. THINK OK/DRINK OK
3. DIAL 1-800-I-FEEL-OK FROM
 MAY 1 THROUGH MAY 21.
4. KEY IN # FROM UNDERNEATH
 BOTTLE CAP OR INSIDE BOTTOM OF CAN.
5. THAT'S 1-800-I-FEEL-OK.

•E-Z TO USE!
•ROTARY DIAL OR TOUCH-TONE!
•LEAVE MESSAGES!
•LISTEN TO MESSAGES LEFT BY OTHERS!
•FEEL MORE OK!
•BROUGHT TO YOU BY "OK" SODA!

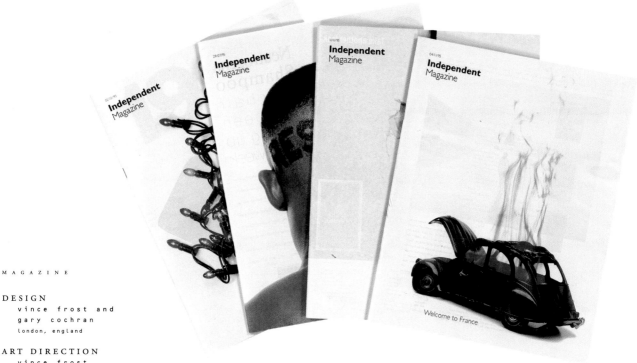

MAGAZINE

DESIGN
vince frost and
gary cochran
london, england

ART DIRECTION
vince frost

STUDIO
vince frost design

CLIENT
newspaper publishing
plc

PRINCIPAL TYPE
gill sans

DIMENSIONS
13 ¾ x 11 in.
(35 x 28 cm)

PROMOTION

DESIGN
diti katona and
john pylypczak
toronto, ontario, canada

PHOTOGRAPHY
ron baxter smith

STUDIO
concrete design
communciations inc.

CLIENT
c.j. graphics inc.

PRINCIPAL TYPE
underwood el 2772

DIMENSIONS
5 ½ x 8 ½ in.
(14 x 21.6 cm)

235

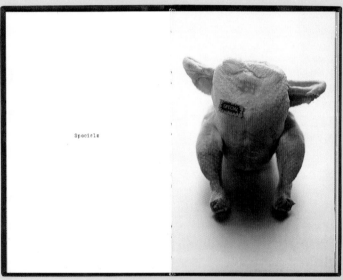

Specials

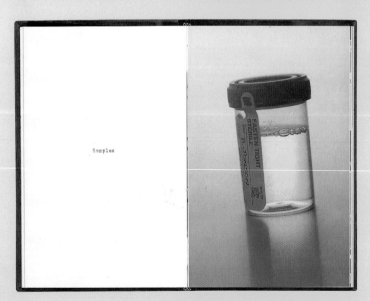

Samples

DESIGN
 reiner hebe, anda
 manea, britta
 moarefi, joachim
 reyle, and mike
 loos
 leonberg, baden-württemberg,
 germany

STUDIO
 hebe . werbung &
 design

PRINCIPAL TYPE
 fairbanks, template,
 winsor sword,
 tripoli, and
 reykjavik

DIMENSIONS
 10 x 13³/₈ in.
 (25.5 x 34 cm)

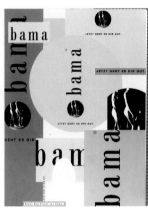

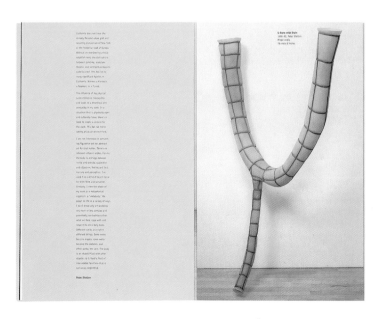

BROCHURE

DESIGN
 john ball and
 deborah fukushima
 san diego, california

STUDIO
 mires design, inc.

CLIENT
 california center
 for the arts museum

PRINCIPAL TYPE
 itc officina sans

DIMENSIONS
 8 x 12 in.
 (20.3 x 30.5 cm)

Lilienthal 2600

Lilienthal 2000

Lilienthal
Design: Heribert Wesgen

Die absolut neue Idee im
Möbelbau: Stabilität
durch Spannung statt
durch Masse. Ein voll
belastbarer Holztisch in
Leichtbaukonstruktion,
für dessen Herstellung
ein Minimum an Material
verbraucht wird, der sich
mit wenigen Handgriffen
aufbauen und zerlegen,
mühelos verstauen oder
transportieren läßt. Das
Gesamtgewicht beträgt
je nach Größe 13 kg oder
18 kg.

Unter einer dünnen
Sperrholzplatte aus Birke
wird mit flachen Bögen
eine zweite dünne
Sperrholzplatte einge-
spannt. Das Ergebnis ist
ein fester, verwindungs-
steifer Körper, vergleich-
bar einer Flugzeug-
tragfläche. Die gedrech-
selten, ellipsoiden
Vollholzbeine werden
mit Keilen ebenfalls
verspannt. Das bedeutet:
keine Verleimung, keine
Schrauben.

Der Leichtbautisch ist
vielfältig einsetzbar:
in der Wohnung als Eß-
tisch, im Büro als
Schreib- oder Konferenz-
tisch, in der Manufaktur
als Präsentationstisch.
Er ist schnell mitten in
den Raum gestellt zur
Besprechung oder
wenn Freunde zum Essen
kommen.

Lilienthal

L 2600
B 740
H 740

L 2000
B 740
H 740

Lampert & Sudrow

A5

A4 50

Compagnons

Tradition und techni-
scher Fortschritt, sorg-
fältige Entwicklung und
Wirtschaftlichkeit, Ein-
fachheit der Konstruk-
tion und Formenvielfalt,
Zeitlosigkeit und
Aktualität – widerspricht
sich das?

Warum gibt es so weniger
Erzeugnisse, die noch
nach Jahren angeboten
werden?

Lampert & Sudrow hat
das Ziel, industrielle
Fertigung, handwerk-
liche Qualität, gestal-
terischen Anspruch und
Umweltverträglichkeit
miteinander zu verbin-
den.

Richard Lampert

Nichts zweifach erfinden.
Albert Einstein

Compagnons
Design: Otto Sudrow

Diese Taschen sind keine
Gestaltungsleistung mit
dem Anspruch des Außer-
gewöhnlichen, sondern
des Typischen. In der
Regel beabsichtigt Design
das Besondere. Wenn aber
jedes Produkt durch seine
Form Aufsehen erregen
muß, gerät das Vertraute
ins Abseits.

Die Taschen werden
handwerklich in hoch-
wertigem schwarzen
Vollrindleder in einer
kleinen schwäbischen
Manufaktur gefertigt. Es
gibt drei Taschen in A4
und je eine Tasche in A3
und A5.

BROCHURE

DESIGN
baumann & baumann
schwäbisch gmünd, germany

CLIENT
lampert & sudrow
gmbh & co. kg

PRINCIPAL TYPE
rotis sans serif 20
and light 9

DIMENSIONS
11¹¹/₁₆ x 8³/₁₆ in.
(29.7 x 20.9 cm)

233

17" x 42"

BROCHURE

DESIGN
peter harrison and
john klotnia
new york, new york

STUDIO
pentagram design

CLIENT
hansberger global
investors

PRINCIPAL TYPE
goudy

DIMENSIONS
7 x 10½ in.
(17.8 x 26 cm)

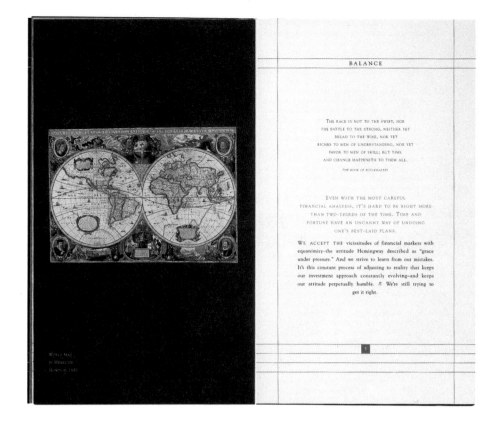

BOOK

DESIGN
terrance zacharko
vancouver, british columbia,
canada

CALLIGRAPHY
kim endo

PHOTOGRAPHY
hidemi kanezuka,
paul chesley,
leland bobbe,
mel curtis,
labounty/johl, and
claudia meyer-newman

STUDIO
zacharko design
partnership

CLIENT
island paper mills

PRINCIPAL TYPE
frutiger, ff scala,
and gill sans

DIMENSIONS
6 x 9 in.
(15.2 x 22.9 cm)

A Brief
on the
Agency Brief

(in brief)

BOOK

DESIGN
todd waterbury
portland, oregon

AGENCY
wieden & kennedy

CLIENT
the coca-cola
company

PRINCIPAL TYPE
news gothic

DIMENSIONS
5 ¼ x 6 ¾ in.
(13.3 x 17.1 cm)

How you can make more
money:

Sell more product.

2 3

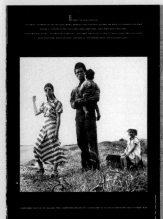

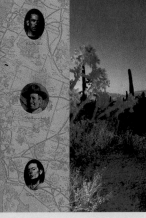

BROCHURE

DESIGN
don sibley and
donna aldridge
dallas, texas

STUDIO
sibley/peteet design

CLIENT
weyerhaeuser paper
company

PRINCIPAL TYPE
futura, kabel,
copperplate, and
headline

DIMENSIONS
9 x 12 ½ in.
(22.9 x 31.8 cm)

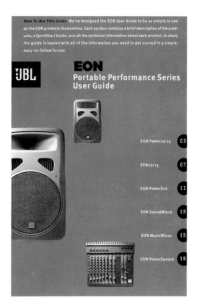

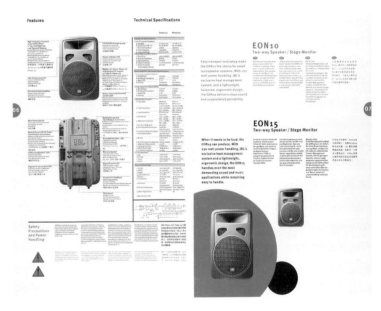

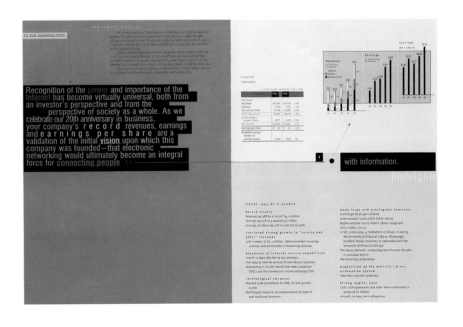

DESIGN
steve tolleson and
jennifer sterling
san francisco, california

PHOTOGRAPHY
stan musilek

STUDIO
tolleson design

CLIENT
adia services, inc.

PRINCIPAL TYPE
cochin and bembo

DIMENSIONS
8 ¼ x 11 ¾ in.
(21 x 29.8 cm)

229

POSTER AND
INVITATION

DESIGN
robert valentine
and jin chung
new york, new york

ILLUSTRATION
dave plunkert
baltimore, maryland

STUDIO
the valentine group

CLIENT
the school of
visual arts

PRINCIPAL TYPE
american typewriter

DIMENSIONS
18 x 25 in.
(45.7 x 63.5 cm)
and 6 x 12 in.
(15.2 x 30.5 cm)

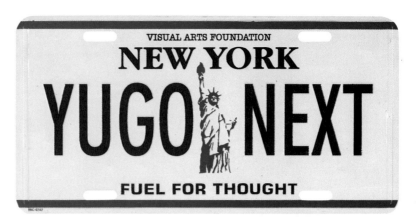

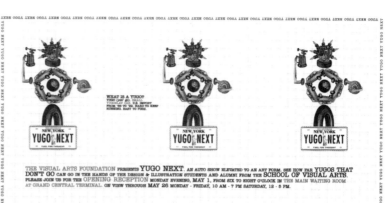

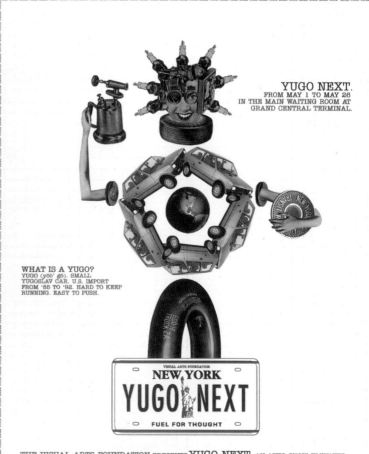

DESIGN
woody pirtle, john
klotnia, and robert
spica
new york, new york

LETTERING
john klotnia

PHOTOGRAPHY
john paul endress

STUDIO
pentagram design

CLIENT
simpson paper
company

PRINCIPAL TYPE
trade gothic
condensed

DIMENSIONS
9 x 12 in.
(22.9 x 30.5 cm)
and 24 x 36 in.
(61 x 91.4 cm)

BROCHURE

DESIGN
james koval and
steve ryan
chicago, illinois

STUDIO
vsa partners, inc.

CLIENT
beckett paper/
northlich stolley
lawarre

PRINCIPAL TYPE
franklin gothic
condensed and adobe
caslon

DIMENSIONS
8 1/2 x 10 in.
(21.6 x 25.4 cm)

SELF-PROMOTION

DESIGN
tom duvall, matt
clark, and eduard
serapio
sunnyvale, california

PRINTING
diversified graphics
inc.

ARBITER
hartmut esslinger

CREATIVE DIRECTION
steven skov holt
and gregory hom

PHOTOGRAPHY
dietmar henneka,
steven moeder, and
hashi

CLIENT
frogdesign, inc.

PRINCIPAL TYPE
univers condensed,
univers bold, and
caslon 540

DIMENSIONS
9 1/16 x 13 in.
(23 x 33 cm)

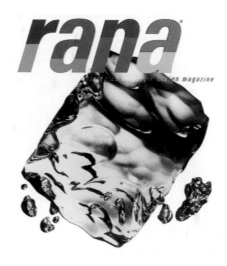

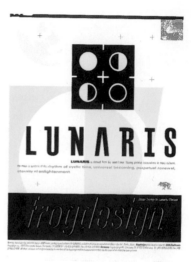

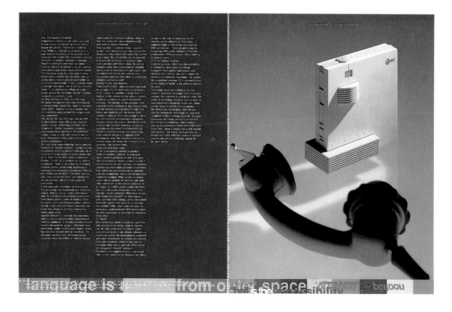

MAGAZINE

DESIGN
klaas kielmann, jan
kock, pepe lange,
heinrich paravicini,
johannes plass,
christoph petersen,
julica vieth, and
holger wild
kiel, germany

STUDIO
mutabor, forum für
kunst und
gestaltung an der
muthesiushochschule
kiel

PRINCIPAL TYPE
din mittelschrift,
din engschrift, and
handlettering

DIMENSIONS
8 11/16 x 15 5/16 in.
(22.5 x 39.5 cm)

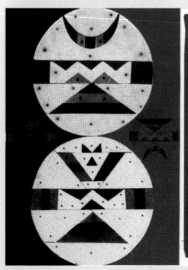

MAGAZINE

DESIGN
garth walker
durban, south africa

LETTERING
garth walker

COPYWRITING
siobhan gunning

STUDIO
orange juice design

PRINCIPAL TYPE
bodoni, avenir,
helvetica, and
handlettering

DIMENSIONS
16 1/2 x 11 11/16 in.
(42 x 29.7 cm)

BOOK

DESIGN
michael bierut and
esther bridavsky
new york, new york

PHOTOGRAPHY
various

STUDIO
pentagram design

CLIENT
council of fashion
designers of
america

PRINCIPAL TYPE
bembo and nuptial
ribbon

DIMENSIONS
10 ½ x 13 ½ in.
(26.7 x 34.3 cm)

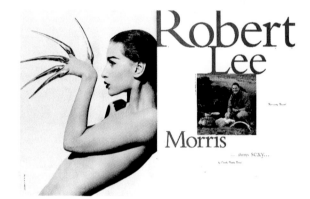

CALENDAR

DESIGN
helen fiorentino,
lou fiorentino, and
andy eng
new york, new york

STUDIO
fiorentino
associates

CLIENT
macdonald & evans

PRINCIPAL TYPE
futura bold and
futura condensed
family

DIMENSIONS
11 ½ x 9 ½ in.
(29.2 x 24.1 cm)

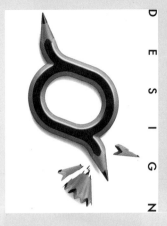

D
E
S
I
G
N

BOOK

DESIGN
 b. martin pedersen
 and randell pearson
 new york, new york

ART DIRECTION
 b. martin pedersen

STUDIO
 pedersen design

CLIENT
 graphis u.s. inc.

PRINCIPAL TYPE
 helvetica,
 geometric, and
 bodoni

DIMENSIONS
 9 x 12 in.
 (22.9 x 30.5 cm)

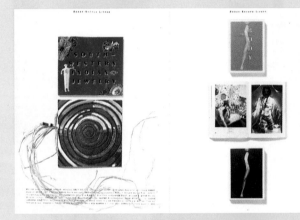

223

17ᵀᴴ 42ᴺᴰ

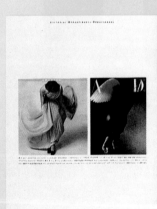

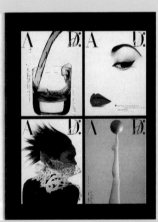

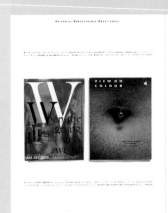

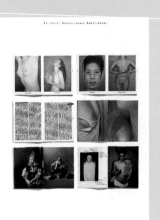

MAGAZINE

DESIGN
j. abbott miller
new york, new york

STUDIO
design/writing/
research

CLIENT
dance ink, inc.

PRINCIPAL TYPE
whirligigs, scala,
and garage gothic

DIMENSIONS
10 ½ x 14 ¼ in.
(26.7 x 36.2 cm)

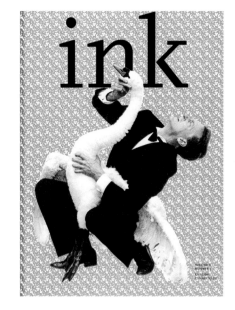

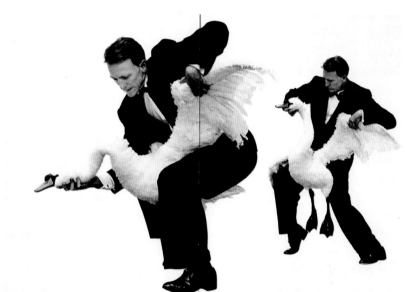

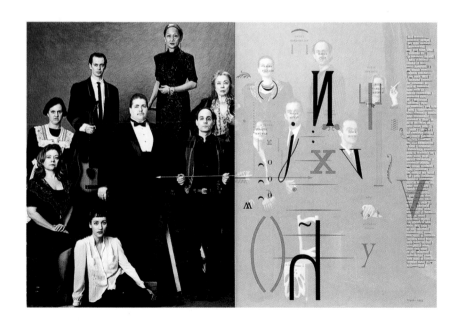

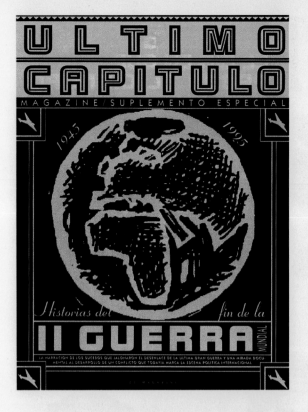

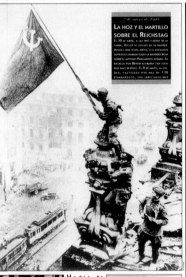

DESIGN
rodrigo sanchez and
miguel buckenmeyer
madrid, spain

DESIGN DIRECTION
carmelo caderot

ART DIRECTION
rodrigo sanchez

STUDIO
el mundo magazine

PRINCIPAL TYPE
bolt bold, ribbon,
and kabel

DIMENSIONS
11 3/8 x 15 1/8 in.
(29 x 38.4 cm)

221

42°
n.17

POSTER

DESIGN
robynne raye
seattle, washington

LETTERING
robynne raye

STUDIO
modern dog

CLIENT
adac sacramento

PRINCIPAL TYPE
orator and hand
stencilling

DIMENSIONS
21 x 28 in.
(53.3 x 71.1 cm)

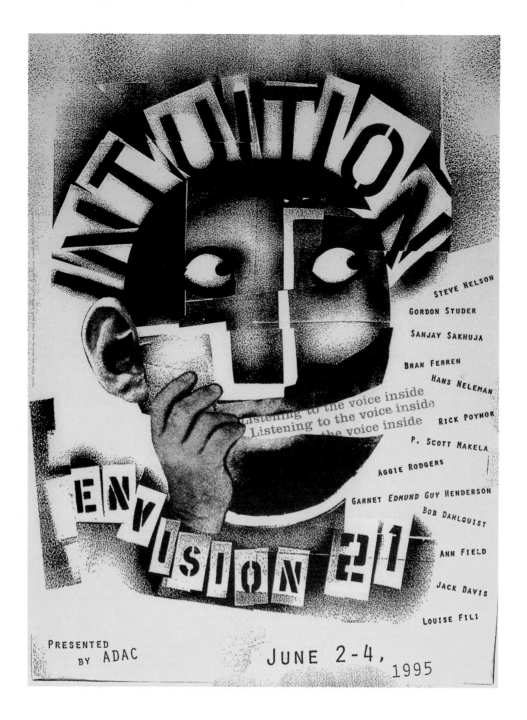

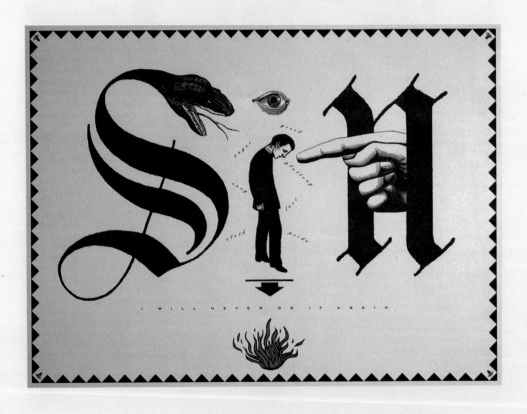

DESIGN
joe scorsone and
alice drueding
jenkintown, pennsylvania

STUDIO
scorsone/drueding

PRINCIPAL TYPE
bank gothic,
künstler script,
and various 19th-
century decorative
initials

DIMENSIONS
22 x 30 in.
(55.9 x 76.2 cm)

DESIGN
miguel buckenmeyer
and rodrigo sanchez
madrid, spain

DESIGN DIRECTION
carmelo caderot

ART DIRECTION
rodrigo sanchez

STUDIO
el mundo magazine

PRINCIPAL TYPE
silhouette, bell
gothic, and cochin

DIMENSIONS
11 3/8 x 15 1/8 in.
(29 x 38.4 cm)

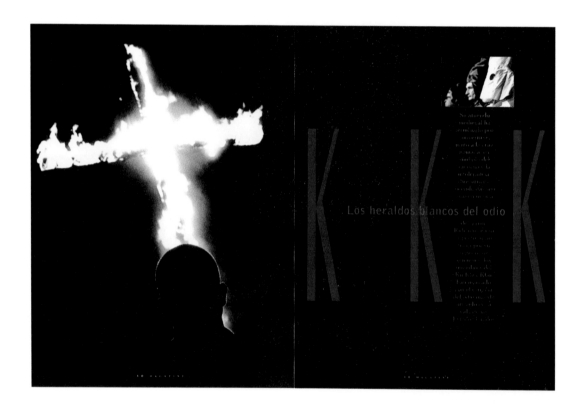

BROCHURE

DESIGN
gavin bradley and
len cheeseman
wellington, new zealand

AGENCY
saatchi & saatchi
wellington, new zealand

STUDIO
carl kennard and
saatchi studio

PRINCIPAL TYPE
various

DIMENSIONS
13 x 9⅝ in.
(33 x 24.5 cm)

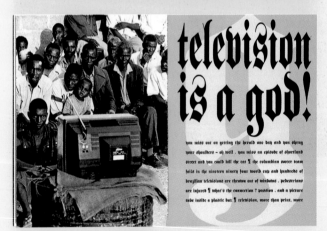

217

DESIGN
j. abbott miller
new york, new york

STUDIO
design/writing/
research

CLIENT
geoffrey beene,
inc. and harry n.
abrams, inc.

PRINCIPAL TYPE
renner futura by
architype

DIMENSIONS
10½ x 14¼ in.
(26.7 x 36.2 cm)

Geoffrey Beene

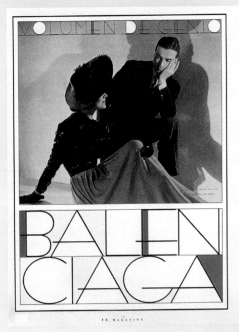

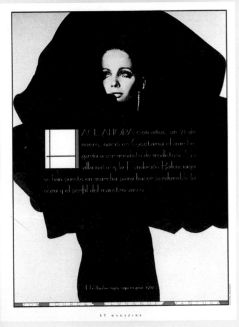

MAGAZINE SPREAD

DESIGN
rodrigo sanchez and
miguel buckenmeyer
madrid, spain

DESIGN DIRECTION
carmelo caderot

ART DIRECTION
rodrigo sanchez

STUDIO
el mundo magazine

PRINCIPAL TYPE
bernhard fashion

DIMENSIONS
11 3/8 x 15 3/8 in.
(29 x 38.4 cm)

215

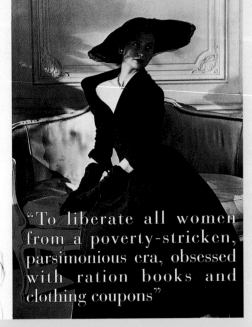

MAGAZINE SPREAD

DESIGN
byron jacobs
hong kong

STUDIO
ppa design limited

CLIENT
swire properties

PRINCIPAL TYPE
bodoni

DIMENSIONS
9 x 11 13/16 in.
(22.8 x 30 cm)

DESIGN
j. abbott miller
new york, new york

STUDIO
design/writing/
research

CLIENT
geoffrey beene,
inc. and harry n.
abrams, inc.

PRINCIPAL TYPE
renner futura by
architype

DIMENSIONS
10½ x 14¼ in.
(26.7 x 36.2 cm)

Geoffrey Beene

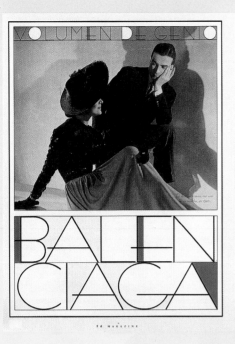

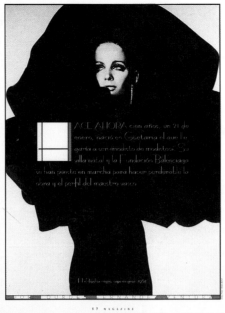

MAGAZINE SPREAD

DESIGN
rodrigo sanchez and
miguel buckenmeyer
madrid, spain

DESIGN DIRECTION
carmelo caderot

ART DIRECTION
rodrigo sanchez

STUDIO
el mundo magazine

PRINCIPAL TYPE
bernhard fashion

DIMENSIONS
11 3/8 x 15 3/8 in.
(29 x 38.4 cm)

215

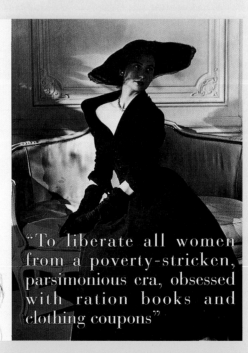

MAGAZINE SPREAD

DESIGN
byron jacobs
hong kong

STUDIO
ppa design limited

CLIENT
swire properties

PRINCIPAL TYPE
bodoni

DIMENSIONS
9 x 11 13/16 in.
(22.8 x 30 cm)

DESIGN
 rodrigo sanchez,
 miguel buckenmeyer,
 and amparo redondo
 madrid, spain

DESIGN DIRECTION
 carmelo caderot

ART DIRECTION
 rodrigo sanchez

STUDIO
 el mundo magazine

PRINCIPAL TYPE
 bubba love, cochin,
 latin bold, and
 industria solid

DIMENSIONS
 11³/₈ x 15¹/₈ in.
 (29 x 38.4 cm)

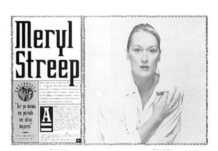

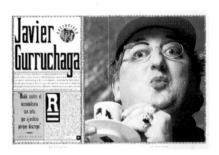

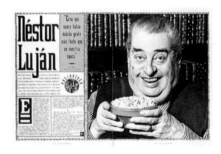

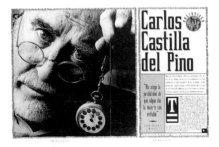

MAGAZINE

DESIGN
wayne ford
teddington, middlesex,
england

STUDIO
haymarket trade &
leisure publications
limited

CLIENT
british tourist
association

PRINCIPAL TYPE
ftape type (fuse)

DIMENSIONS
8 1/4 x 11 11/16 in.
(21 x 29.7 cm)

STREET
FASHION

PHOTOGRAPHS BY NOEL DRAGGLE

GO OUT INTO THE STREETS OF ANY TOWN OR CITY IN THE UK AND LOOK AT THE
EXTRAORDINARY CLOTHES THAT PEOPLE WEAR. IN THIS SELECTION WE FEATURE A RANGE
OF THE GOOD, THE BAD AND THE DOWNRIGHT UGLY AVAILABLE FROM THE WORLD BEATING
FASHION EMPORIA OF BRITISH HIGH STREETS.

LEFT. STEVE McQUEEN.
25. ARTIST / FILM MAKER.
JACKET, FLIP, JUMPER, MARKS AND SPENCER (DAD'S), JEANS, CARHARTT, BOOTS, JONES,
T SHIRT. (MUM'S)

33

213
17"

42"

MAGAZINE

DESIGN
vince frost
london, england

STUDIO
frost design

CLIENT
big location

PRINCIPAL TYPE
various wood fonts

DIMENSIONS
14 5/8 x 11 in.
(37 x 28 cm)

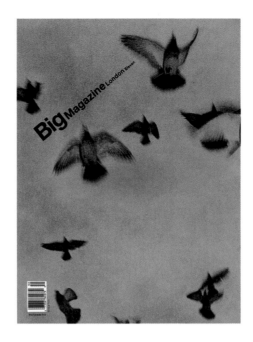

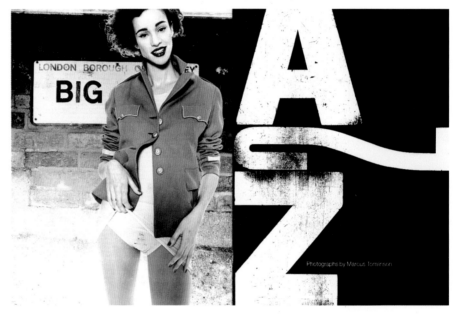

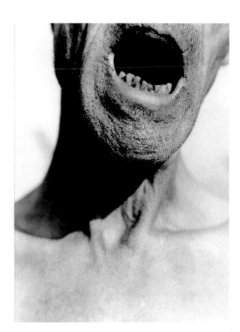

TELEVISION
COMMERCIAL

DESIGN
ivy arce and
alejandro arce
new york, new york

PRODUCER
todd mueller

ANIMATION
alejandro arce

CLIENT
mtv networks/viacom

PRINCIPAL TYPE
ocr-b, data seventy,
helvetica neue, and
ff screen matrix

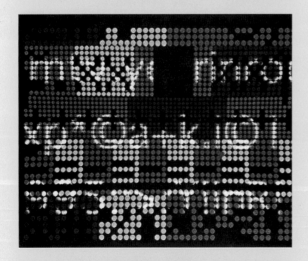

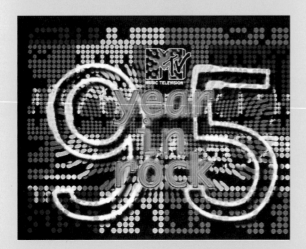

DESIGN
fred woodward, gail
anderson, lee
bearson, geraldine
hessler, and eric
siry
new york, new york

PHOTO EDITOR
jodi peckman

CREATIVE DIRECTION
fred woodward

STUDIO
rolling stone

CLIENT
rolling stone press
and little, brown

PRINCIPAL TYPE
ironmonger,
ponderosa, poplar,
ironwood, mesquite,
juniper, blackoak,
cottonwood, giza,
and acropolis

DIMENSIONS
9 x 11 in.
(22.9 x 27.9 cm)

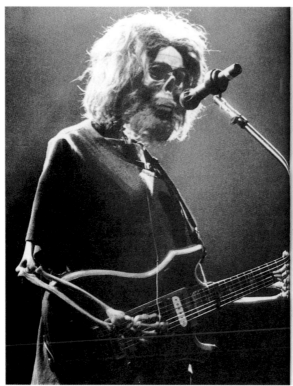

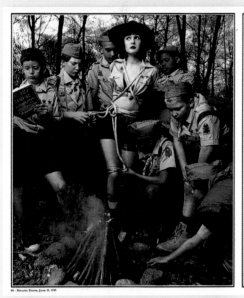

DREW BARRYMORE is knocking back a beer. Not a near beer, mind you, but a good old-fashioned Pilsener. Hops and barley. The kind of libation that would impair her ability to operate heavy machinery if, for some odd reason, there happened to be any heavy machinery in sight. It is a celebratory beverage, and Barrymore is in the mood for a little revelry. For one thing, she is flush with the afterglow of having flashed David Letterman. Two nights ago, while demonstrating a striptease-style bump and grind on his desk, Barrymore lifted her T-shirt to present Dave with compelling evidence that she is not a little girl anymore. This afternoon, as she's walked the streets of New York, lascivious men of all ages have raised their thumbs in appreciation. Couple that with the fact that today is her 10-month

DREW WILD THING
BY CHRIS MUNDY PHOTOGRAPHS BY MARK SELIGER
DREW BARRYMORE

MAGAZINE SPREAD

DESIGN
fred woodward and
geraldine hessler
new york, new york

PHOTO EDITOR
jodi peckman

CREATIVE DIRECTION
fred woodward

PHOTOGRAPHY
mark seliger

STUDIO
rolling stone

PRINCIPAL TYPE
standard

DIMENSIONS
12 x 20 in.
(30.5 x 50.8 cm)

209

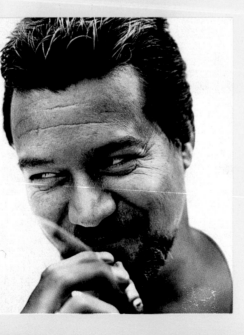

BALANCING ACT
EDDIE VANH ALE N
THE
ROLLING STONE
INTERVIEW BY DAVID WILD
PHOTOGRAPHS BY MARK SELIGER

MAGAZINE SPREAD

DESIGN
geraldine hessler
new york, new york

PHOTO EDITOR
jodi peckman

CREATIVE DIRECTION
fred woodward

PHOTOGRAPHY
mark seliger

STUDIO
rolling stone

PRINCIPAL TYPE
gill sans

DIMENSIONS
12 x 20 in.
(30.5 x 50.8 cm)

MAGAZINE SPREAD

DESIGN
fred woodward and
geraldine hessler
new york, new york

PHOTO EDITOR
jodi peckman

CREATIVE DIRECTION
fred woodward

PHOTOGRAPHY
frank ockenfels 3

STUDIO
rolling stone

PRINCIPAL TYPE
epitaph

DIMENSIONS
12 x 20 in.
(30.5 x 50.8 cm)

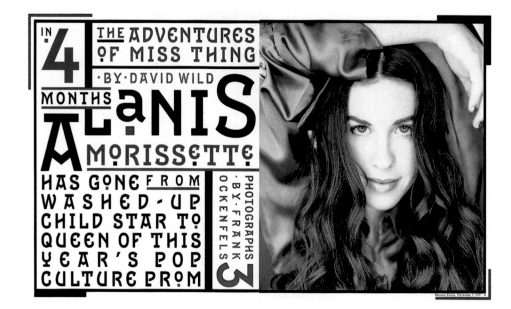

MAGAZINE SPREAD

DESIGN
gail anderson
new york, new york

PHOTO EDITOR
jodi peckman

CREATIVE DIRECTION
fred woodward

PHOTOGRAPHY
dan winters

STUDIO
rolling stone

PRINCIPAL TYPE
showcard gothic

DIMENSIONS
12 x 20 in.
(30.5 x 50.8 cm)

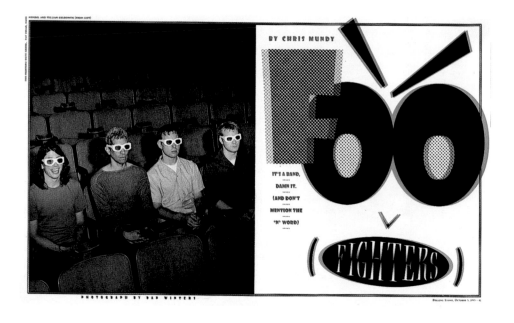

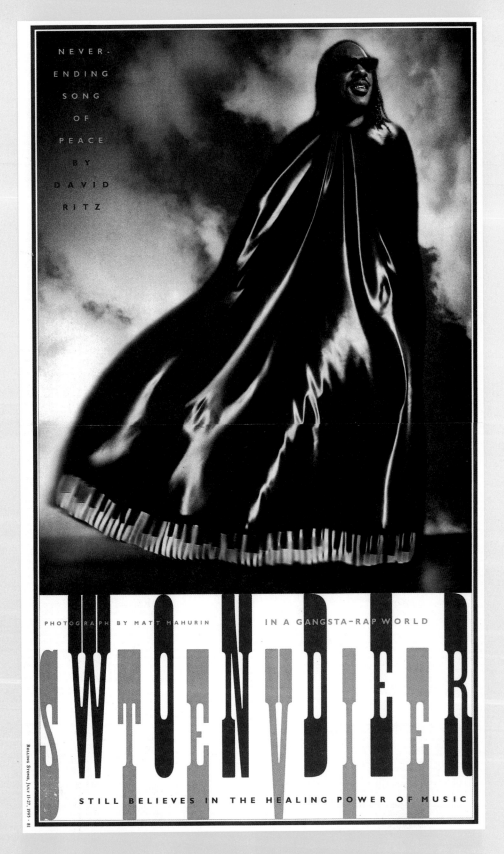

NEVER-ENDING SONG OF PEACE BY DAVID RITZ

PHOTOGRAPH BY MATT MAHURIN

IN A GANGSTA-RAP WORLD

STEVIE WONDER

STILL BELIEVES IN THE HEALING POWER OF MUSIC

ROLLING STONE, JULY 13-27, 1995 · 81

MAGAZINE SPREAD

DESIGN
fred woodward and
geraldine hessler
new york, new york

PHOTO EDITOR
jodi peckman

CREATIVE DIRECTION
fred woodward

PHOTOGRAPHY
matt mahurin

STUDIO
rolling stone

PRINCIPAL TYPE
ponderosa

DIMENSIONS
12 x 20 in.
(30.5 x 50.8 cm)

DESIGN
fred woodward and
geraldine hessler
new york, new york

LETTERING
eric siry

PHOTO EDITOR
jodi peckman

CREATIVE DIRECTION
fred woodward

PHOTOGRAPHY
matthew rolston

STUDIO
rolling stone

PRINCIPAL TYPE
barcode

DIMENSIONS
12 x 20 in.
(30.5 x 50.8 cm)

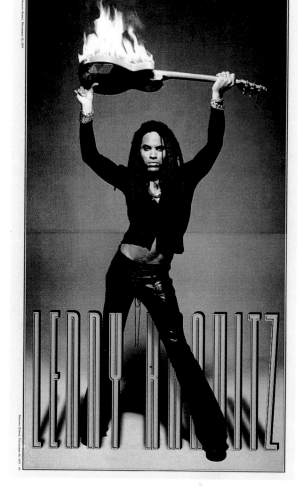

MAGAZINE SPREAD

DESIGN
fred woodward and
gail anderson
new york, new york

PHOTO EDITOR
jodi peckman

CREATIVE DIRECTION
fred woodward

PHOTOGRAPHY
kate garner

STUDIO
rolling stone

PRINCIPAL TYPE
bell centennial

DIMENSIONS
12 x 20 in.
(30.5 x 50.8 cm)

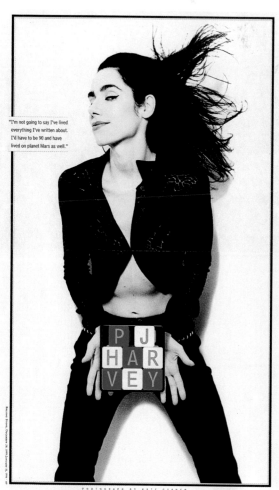

DESIGN
howard brown
philadelphia, pennsylvania

STUDIO
urban outfitters

PRINCIPAL TYPE
pelican latin,
futura extra bold,
times roman, and
century bold

DIMENSIONS
17 1/2 x 22 3/4 in.
(44.5 x 57.8 cm)

DESIGN
 mark geer
 houston, texas

STUDIO
 geer design, inc.

CLIENT
 art directors club
 of houston

PRINCIPAL TYPE
 gill sans light and
 bold, and snell
 roundhand black

DIMENSIONS
 24 ¼ x 35 in.
 (61.6 x 88.9 cm)

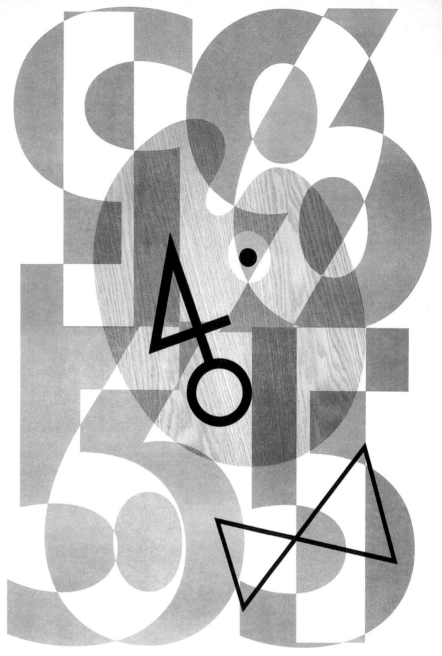

ART DIRECTORS CLUB OF HOUSTON

Fortieth Anniversary Exhibition

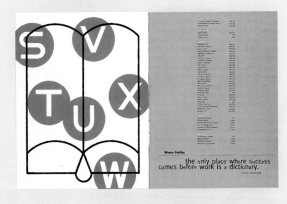

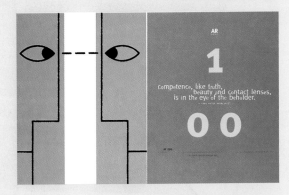

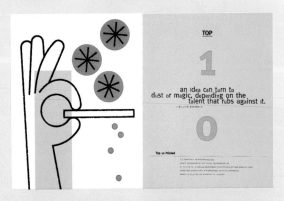

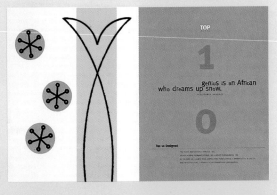

BOOK

DESIGN
 kin yuen
 new york, new york

CREATIVE DIRECTION
 kent hunter

STUDIO
 frankfurt balkind
 partners

CLIENT
 black book
 marketing group,
 inc.

PRINCIPAL TYPE
 meta

DIMENSIONS
 8 7/8 x 11 1/2 in.
 (22.5 x 29.2 cm)

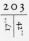

BOOK

DESIGN
rob wilson
dallas, texas

PRODUCTION
brian bevolo

WRITER
michael langley

PHOTOGRAPHY
fredrik brodén

STUDIO
sullivan perkins

CLIENT
williamson printing

PRINCIPAL TYPE
clarendon and trade
gothic

DIMENSIONS
9 x 12 in.
(22.9 x 30.5 cm)

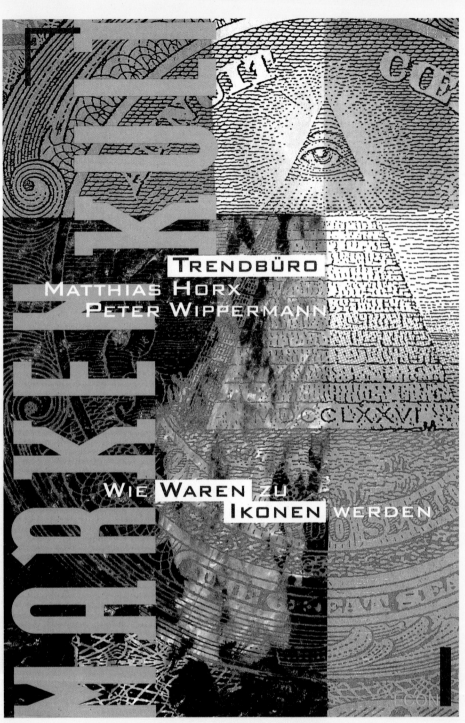

DESIGN
régine thienhaus
and birgit eggers
hamburg, germany

STUDIO
k.k.w. büro hamburg
gesellschaft für
kommunikationsdesign
mbh

CLIENT
trendbüro hamburg
and econ verlag

PRINCIPAL TYPE
meta, modular, and
bank gothic

DIMENSIONS
6 7/16 x 9 11/16 in.
(16.3 x 24.5 cm)

DESIGN
jenny shainin
los angeles, california

DIRECTOR
david fincher

SPECIAL IMAGE
ENGINEER
findlay bunting

CREATIVE DIRECTION
kyle cooper

STUDIO
r/greenberg
associates, inc.

CLIENT
arnold kopelson
productions/new line
cinema

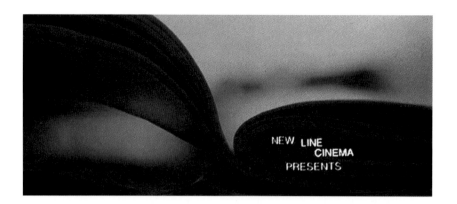

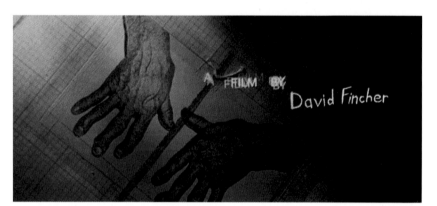

FILM TITLE

DESIGN
jenny shainin
los angeles, california

DIRECTOR
david fincher

SPECIAL IMAGE
ENGINEER
findlay bunting

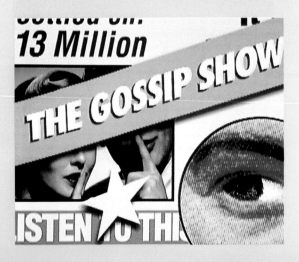

TELEVISION
TITLING

DESIGN
 rick morris
 los angeles, california

CREATIVE DIRECTION
 andy hann

STUDIO
 e! entertainment
 television, inc.

PRINCIPAL TYPE
 futura condensed
 extra bold oblique

199
17" / 42"

DESIGN
reuben lee
los angeles, california

CREATIVE DIRECTION
andy hann

STUDIO
e! entertainment
television, inc.

PRINCIPAL TYPE
helvetica neue 95
black

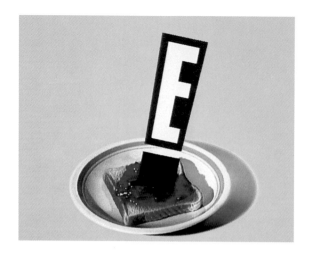

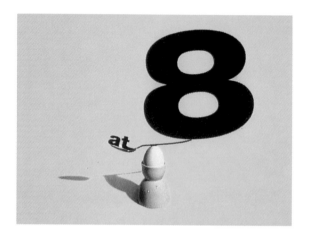

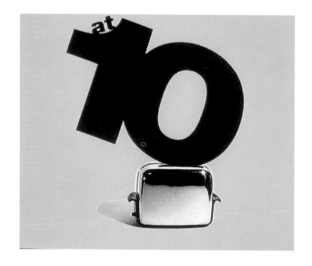

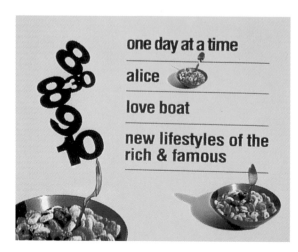

TELEVISION
TITLING

DESIGN
 alexander krause
 unterfoehring, germany

STUDIO
 pro sieben design

CLIENT
 pro sieben
 television ag

PRINCIPAL TYPE
 neue helvetica
 black extended

TELEVISION
TITLING

DESIGN
 roswitha berger and
 armin reinhardt
 unterfoehring, germany

STUDIO
 pro sieben design

CLIENT
 pro sieben
 television ag

PRINCIPAL TYPE
 ff blur medium

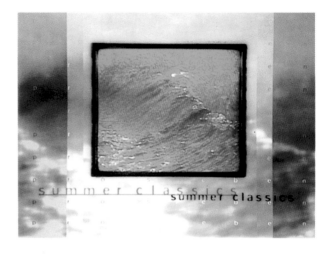

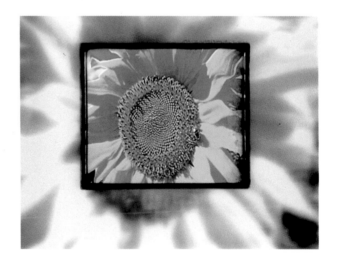

TELEVISION
TITLING

DESIGN
 inka kardys
 unterfoehring, germany

STUDIO
 pro sieben design

CLIENT
 pro sieben
 television ag

PRINCIPAL TYPE
 helvetica

195

DESIGN
david mcelwaine and
dan appel
new york, new york

DIRECTORS
jason harrington
and roberto
espinosa

EDITOR
chris hengeveld
and national video

ART DIRECTION
dan appel
new york, new york

AGENCY
vh1 on-air
promotions

PRINCIPAL TYPE
antique olive nord
italic and
helvetica neue thin

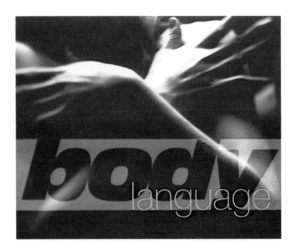

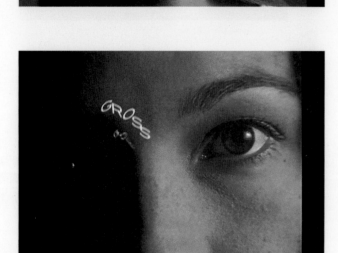

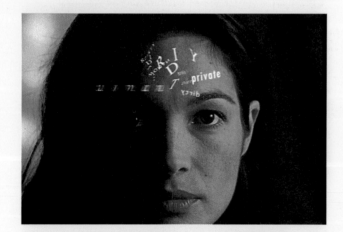

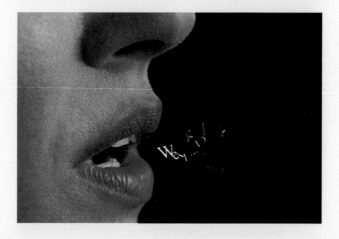

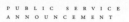

DESIGN
 lisa berghout
 san francisco, california

AGENCY
 good pictures

CLIENT
 planned parenthood

PRINCIPAL TYPE
 times roman, times
 roman italic,
 futura condensed,
 and snell roundhand
 script

TELEVISION
ADVERTISEMENT

DIRECTOR
 henry sandbank,
 sandbank kamen &
 partners

ART DIRECTION
 jakob trollbeck

CREATIVE DIRECTION
 larry hampel and
 dean stefanides
 new york, new york

AGENCY
 houston effler
 hampel & stefanides

STUDIO
 r/greenberg
 associates, inc.

CLIENT
 nec technologies

PRINCIPAL TYPE
 futura, sabon,
 akzidenz grotesk,
 and avenir

TITLE GRAPHICS

DESIGN
jakob trollbeck
new york, new york

STUDIO
r/greenberg
associates, inc.

CLIENT
ted conferences
inc.

PRINCIPAL TYPE
futura

191
17" / 42""

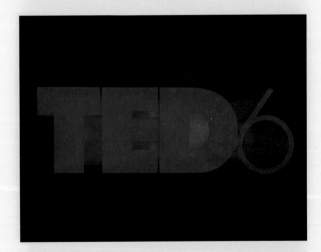

DESIGN
thomas cobb
new york, new york

LETTERING
r/greenberg
associates and cosa
after efx

OPTICAL COMPOSITING
pacific title
los angeles, california

ANIMATION
stokes kohne
los angeles, california

ART DIRECTION
rob crabtree

CREATIVE DIRECTION
kyle cooper

STUDIO
r/greenberg
associates, inc.

CLIENT
aspect ratio

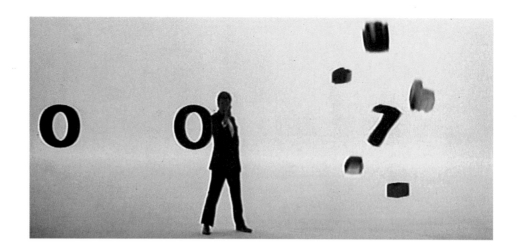

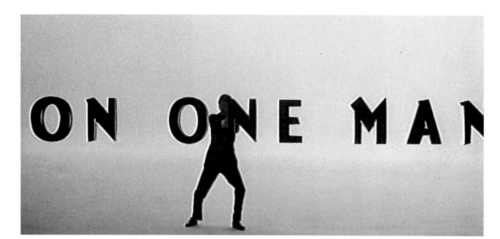

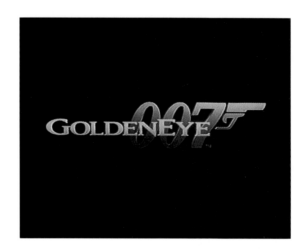

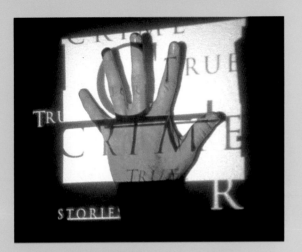

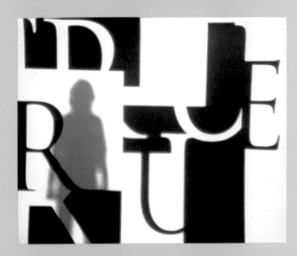

TELEVISION
TITLING

DESIGN
steve rogers
sydney, australia

EDITOR
alissa dedman

LIGHTING CAMERAMAN
jonathan clabburn

STUDIO
conja

CLIENT
network seven

PRINCIPAL TYPE
trajan

189
17" | 42"

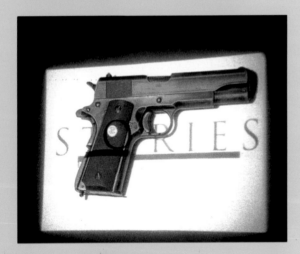

TELEVISION
COMMERCIAL

DESIGN
david j. hwang
los angeles, california

COPYWRITING
howard roughen
new york, new york

ART DIRECTION
victor mazzeo
new york, new york

AGENCY
bates usa

STUDIO
two headed monster

CLIENT
team lucky strike
suzuki

PRINCIPAL TYPE
stamp gothic

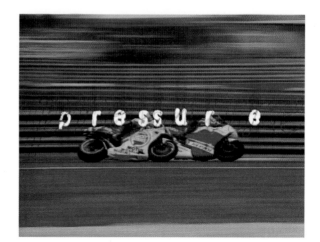

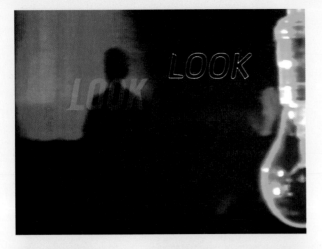

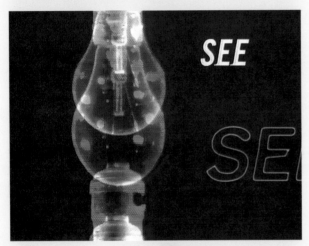

VIDEO

DESIGN
elizabeth daggar
and dan appel
new york, new york

DIRECTOR
rob grobengieser

EDITING
scott harrison and
national video

ART DIRECTION
dan appel
new york, new york

AGENCY
vh1 on-air
promotions

PRINCIPAL TYPE
deconstruct, beach
savage, and beach
bronze

TELEVISION
COMMERCIAL

DESIGN
gideon kendall and
bernard maisner
white plains, new york

LETTERING
gideon kendall and
bernard maisner

DIRECTOR
j.j. sedelmaier

ANIMATION
david wachtenheim

AGENCY
houston herstek
favat
boston, massachusetts

STUDIO
j.j. sedelmaier
productions, inc.

CLIENT
converse

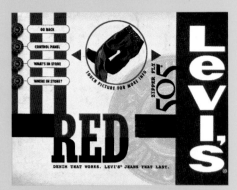

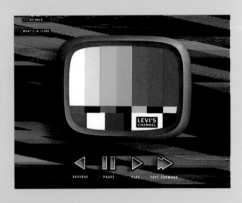

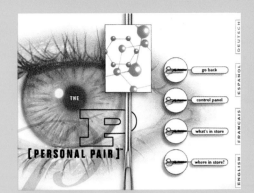

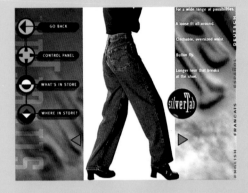

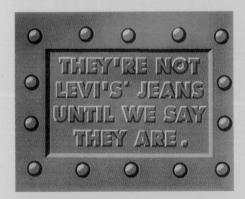

INTERACTIVE KIOSK

DESIGN
antoine tinguely,
jeremy lasky, and
jakob trollbeck
new york, new york

EXECUTIVE PRODUCER
brian loube

PRODUCER
lesli horowitz

PROGRAMMER
john jones

ART DIRECTION
john dire

AGENCY
foote, cone &
belding
san francisco, california

STUDIO
r/greenberg
associates, inc.

CLIENT
levi strauss & co.

185

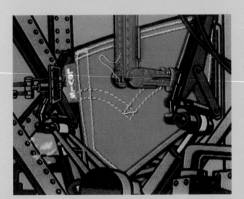

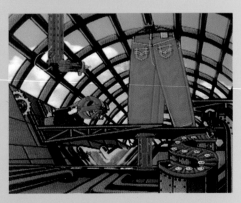

TELEVISION
COMMERCIAL

DESIGN
douglas fraser
calgary, alberta, canada

LETTERING
douglas fraser

DIRECTOR
j.j. sedelmaier

ANIMATION
tony eastman
white plains, new york

AGENCY
foote, cone &
belding
san francisco, california

STUDIO
j.j. sedelmaier
productions, inc.

CLIENT
levi strauss & co.

TELEVISION
COMMERCIAL

DESIGN
lisa berghout
san francisco, california

STUDIO
good pictures

CLIENT
aeron chair

PRINCIPAL TYPE
shelley script,
cochin italic, din
mittelschrift, gill
sans, din neuzeit,
and grotesk light

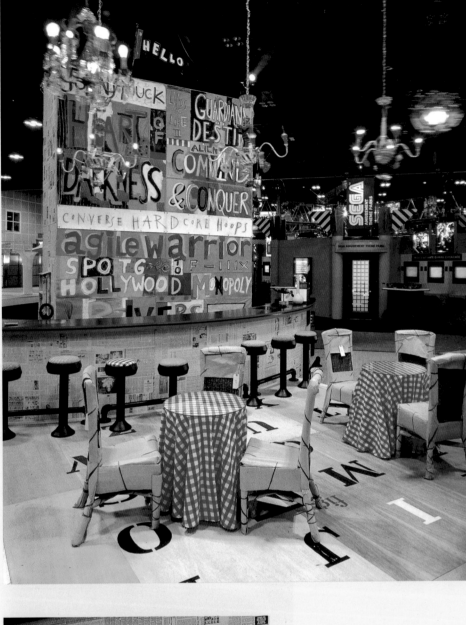

EXHIBIT BOOTH

DESIGN
clive piercy
santa monica, california

LETTERING
ann field

STUDIO
ph.d

CLIENT
virgin interactive
entertainment

PRINCIPAL TYPE
handlettering

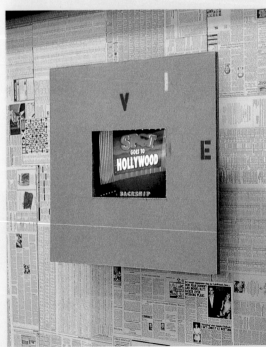

ARCHITECTURAL
DESIGN
james hicks

PROJECT MANAGER
cameron manning

CREATIVE DIRECTION
miguel oks, stephen
doyle, and william
drenttel
new york, new york

STUDIO
drenttel doyle
partners

CLIENT
the new york state
division for women

PRINCIPAL TYPE
bureau grotesque

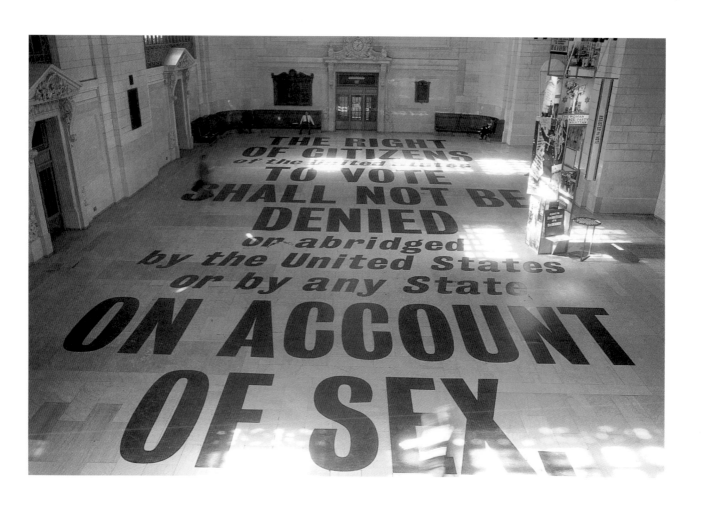

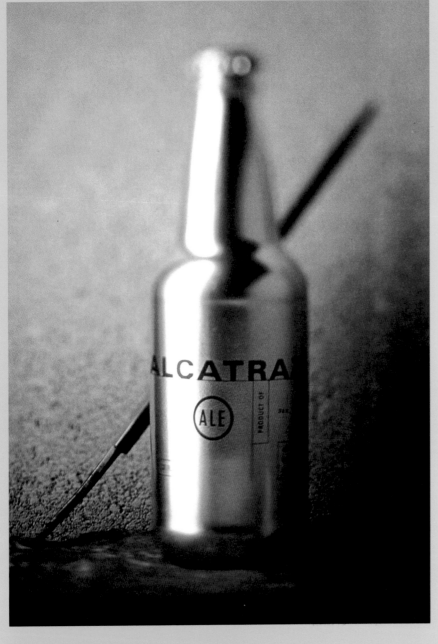

DESIGN
sharrie brooks
san francisco, california

ART DIRECTION
bill cahan

STUDIO
cahan & associates

CLIENT
boisset usa

PRINCIPAL TYPE
univers, itc
officina, din
neuzeit grotesk

181

17″ 42″

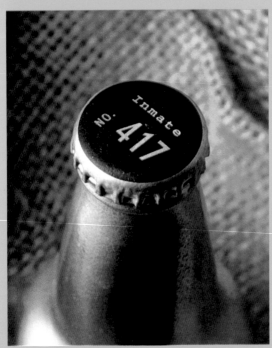

PACKAGING

DESIGN
chad hagen
minneapolis, minnesota

DESIGN DIRECTION
bill thorburn

COPYWRITING
matt elhardt

STUDIO
thorburn design

CLIENT
millennium import
company

PRINCIPAL TYPE
trade gothic

PACKAGING

DESIGN
haley johnson
minneapolis, minnesota

STUDIO
haley johnson
design company

CLIENT
make up group

PRINCIPAL TYPE
trixie and
helvetica

DIMENSIONS
4 1/4 in.
(10.8 cm) height

PACKAGING

DESIGN
dan olson and todd
bartz
minneapolis, minnesota

PHOTOGRAPHY
leo tushaus

STUDIO
duffy design

CLIENT
flagstone brewery

PRINCIPAL TYPE
bank gothic,
utopia, stone
serif, and new
baskerville

DIMENSIONS
4 ¹/₂ x 3 ³/₄ in.
(11.4 x 9.5 cm)

179

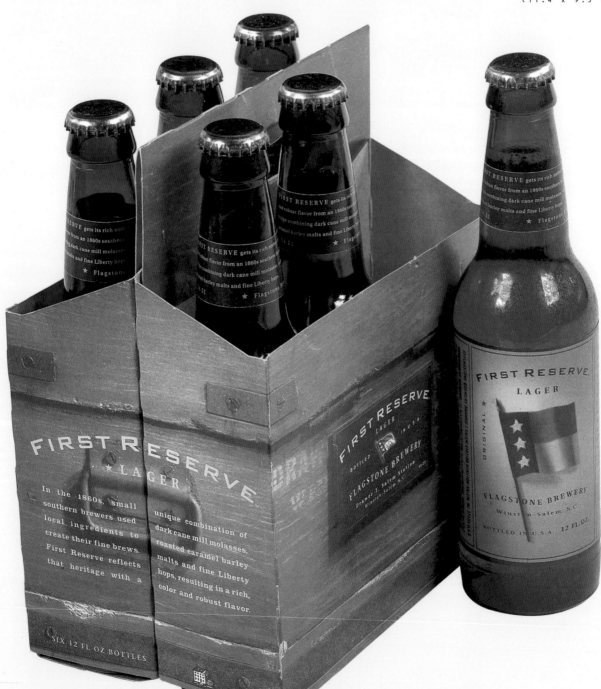

DESIGN
dan olson
minneapolis, minnesota

STUDIO
duffy design

CLIENT
flagstone brewery

PRINCIPAL TYPE
bank gothic,
utopia, stone
serif, and new
baskerville

DIMENSIONS
8 ¹/₂ x 11 in.
(21.6 x 27.9 cm)

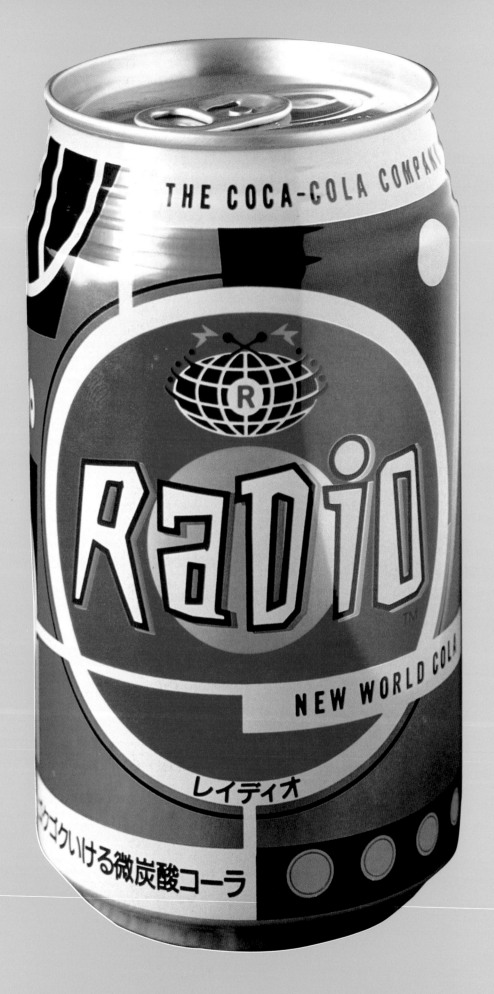

PACKAGING

DESIGN
kobe, alan leusink,
and neil powell
minneapolis, minnesota

LETTERING
kobe

STUDIO
duffy design

CLIENT
the coca-cola
company

PRINCIPAL TYPE
trade gothic and
handlettering

177
17" / 42"

**"MARVELOUS STUFF FROM THE FUNNIEST AMERICAN
WRITER STILL OPEN FOR BUSINESS"**
—*TIME*

"Guys are in trouble these days," says Garrison Keillor. "Years
ago, manhood was an opportunity for achievement and now it's just
a problem to be overcome. Guys who once might have painted the
Sistine Chapel ceiling are now just trying to be Mr. O.K. All-Rite, the
man who can bake a cherry pie, cry, be passionate in a skillful way,
and yet also lift them bales and tote that barge."

In this book of twenty-two stories about ordinary guys, gods,
heroes, and dim bulbs we meet:

• *LONESOME SHORTY*, a cowpoke torn between life in the saddle and
the comforts of domesticity

• *AL DENNY*, author of *Rebirthing the Me You Used to Be*, a big sham-
bling galoot who has forgotten his address and the names of his children

• *DIONYSUS*, the god of wine, who turns fifty and has to give up orgies

• *CASEY*, who comes up to bat for Mudville in a road game in
Dustburg, where the fans despise him

*This brilliant collection confirms Keillor's reputation
as an ingenious storyteller and a very funny guy.*

"Brilliant and imaginative.... Recommended for anyone who's a guy,
who knows a guy, or enjoys good writing and a laugh."
—*Houston Post*

Cover design and illustrations by Paul Buckley

A PENGUIN BOOK
Fiction

ISBN 0-14-023372-5

9 780140 233728

90000>

Garrison Keillor

The Book of GuYS

Garrison
Keillor

The Book of
GuYS

NATIONAL
BESTSELLER

STORIES BY
GARRISON
KEILLOR

PULL

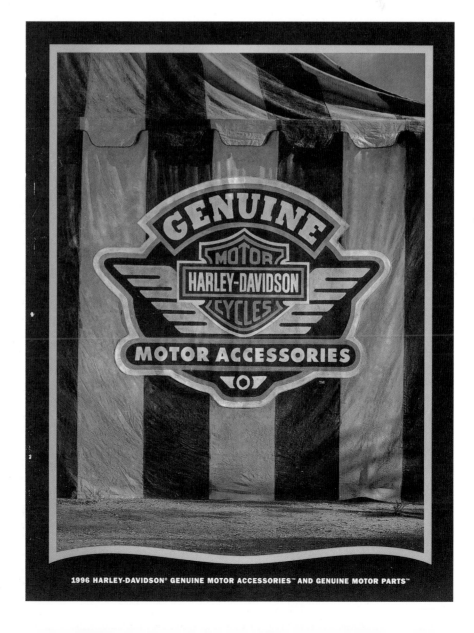

1996 HARLEY-DAVIDSON® GENUINE MOTOR ACCESSORIES™ AND GENUINE MOTOR PARTS™

DESIGN
 stefan sagmeister
 and veronica oh
 new york, new york

PHOTOGRAPHY
 tom schierlitz

AGENCY
 sagmeister inc.

CLIENT
 hans platzgummer/
 energy records

PRINCIPAL TYPE
 spartan, peignot,
 caslon, garamond,
 courier, franklin
 gothic, and futura

DIMENSIONS
 5 ½ x 5 in.
 (14 x 12.7 cm)

175

BOOK

DESIGN
 sandra hoffman and
 christoph staehli
 basel, switzerland

WRITER
 peter gisi

STUDIO
 hoffmannstaehli,
 visuelle gestaltung

PRINCIPAL TYPE
 akzidenz grotesk

DIMENSIONS
 6 ¹¹/₁₆ x 8 ¹¹/₁₆ in.
 (17 x 22 cm)

STATIONERY

DESIGN
 howard brown and
 mike calkins
 philadelphia, pennsylvania

ART DIRECTION
 howard brown

STUDIO
 urban outfitters

PRINCIPAL TYPE
 franklin gothic and
 akzidenz grotesk

DIMENSIONS
 8 ½ x 11 in.
 (21.6 x 27.9 cm)

FROM

READABLE Skaxit NEWSPAPER

WE ARE NOT AN ALTERNATIVE PUBLICATION
1809 WALNUT ST • PHILADELPHIA, PA • 19103
PLEASE READ ALL INFORMATION CAREFULLY

THREE TIMES A YEAR

FROM

READABLE Skaxit NEWSPAPER

WE ARE NOT AN ALTERNATIVE PUBLICATION
1809 WALNUT ST • PHILADELPHIA, PA • 19103
FORWARDING AND RETURN POSTAGE GUARANTEED

THREE TIMES A YEAR

PROMOTIONAL KIT

DESIGN
 carlos segura
 chicago, illinois

LETTERING
 carlos segura and
 hatch
 chicago, illinois, and
 nashville, tennessee

ILLUSTRATION
 jordan isip
 new york, new york

STUDIO
 segura, inc.

CLIENT
 the alternative
 pick

PRINCIPAL TYPE
 mattress

DIMENSIONS
 23 x 11 in.
 (58.4 x 27.9 cm)

DESIGN
dana arnett, curtis
schreiber, geoffrey
mark, and fletcher
martin
chicago, illinois

STUDIO
vsa partners, inc.

CLIENT
potlatch corporation

PRINCIPAL TYPE
franklin gothic
extra condensed

DIMENSIONS
25 ½ x 36 in.
(64.8 x 91.4 cm)

173

17" 42"

STATIONERY

DESIGN
steven guarnaccia
montclair, new jersey

ILLUSTRATION
steven guarnaccia

PRINCIPAL TYPE
handlettering

DIMENSIONS
8 ½ x 11 in.
(21.6 x 27.9 cm)

Steven Guarnaccia

Strathmore
SCRIPT RECYCLED

31 Fairfield Street
Montclair, N J 07042
(201)746·9785 (201)746·9786·fax

BOOKS

DESIGN
hans dieter
reichert, dean
pavitt, simon
dwelly, and brian
cunningham
east malling, england

EDITOR
peter owens

COMMISSIONING
EDITOR
roger sears

STUDIO
hdr design

CLIENT
phaidon press
limited

PRINCIPAL TYPE
garamond and futura

DIMENSIONS
8 ⅝ x 6 ⅛ in.
(22 x 15.5 cm)

INVITATION

DESIGN
jefferson rall
jacksonville, florida

PHOTOGRAPHY
jeff maher and judi
williamson

STUDIO
robin shepherd
studios

CLIENT
commercial
photographers of
jacksonville

PRINCIPAL TYPE
erasure

DIMENSIONS
24 x 26 in.
(61 x 66 cm)

DESIGN
dan kriemer
west dundee, illinois

ART DIRECTION
greg samata and b.
martin pedersen
dundee, illinois, and
new york, new york

STUDIO
samatamason

CLIENT
graphis u.s. inc.

PRINCIPAL TYPE
trade gothic, and
trade gothic bold,
condensed, and bold
condensed

DIMENSIONS
10³/₄ x 11¹/₄ in.
(27.3 x 28.6 cm)

THE SPIRIT OF **BLACK AND** **WHITE BLUES** STEMS FROM

A RESPECT FOR A GENRE OF MUSIC THAT HAS BEEN A SIGNIFICANT INFLUENCE ON THE DEVELOPMENT OF AMERICAN POPULAR CULTURE.

THE BOOK HONORS **THOSE ARTISTS WHO**

HAVE PERFORMED WITHIN A MUSICAL FORM THAT IS RICH IN HISTORICAL TRADITIONS.

IT IS A CELEBRATION IN **PORTRAITURE** TEXT, AND **MUSIC** THAT PLAYS

TRIBUTE TO THIS UNIQUE AMERICAN INSTITUTION,

THE **BLUES.**

THIS MONOGRAPH IS FROM AN ARCHIVE THAT SPANS OVER TWELVE YEARS OF DEVELOPMENT BY PHOTOGRAPHER MARC NORBERG.
IT IS A WORK IN PROGRESS THAT HAS A GOAL OF CREATING A GREATER APPRECIATION OF THE BLUES.
IN ITS PUBLICATION, THE BOOK WILL BUILD A STRONGER UNDERSTANDING OF THE BLUES AND THE MUSICIANS THEMSELVES.
THE PHOTOGRAPHER AND THE PUBLISHER WILL BE GIVING A PORTION OF THE PROCEEDS FROM THE BOOK TO EACH OF THE ARTISTS DEPICTED AND TO NONPROFIT ORGANIZATIONS.

We wouldn't get you all hopped-up on **caffeine** and leave you **hanging there.**

STARBUCKS BY STARLIGHT

JAZZ JAMS. HOT COFFEE. PIONEER COURTHOUSE SQUARE. MONDAYS 5:30 TO 7. FREE 'N SOLID.

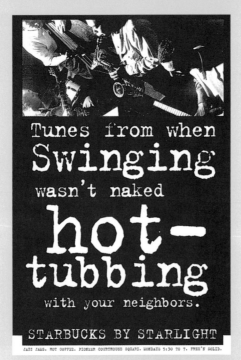

Tunes from when **Swinging** wasn't naked **hot-tubbing** with your neighbors.

STARBUCKS BY STARLIGHT

JAZZ JAMS. HOT COFFEE. PIONEER COURTHOUSE SQUARE. MONDAYS 5:30 TO 7. FREE 'N SOLID.

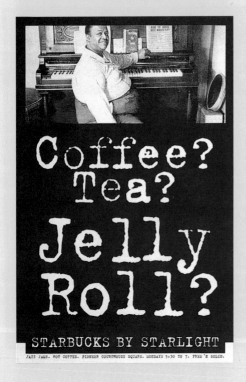

Coffee? Tea? Jelly Roll?

STARBUCKS BY STARLIGHT

JAZZ JAMS. HOT COFFEE. PIONEER COURTHOUSE SQUARE. MONDAYS 5:30 TO 7. FREE 'N SOLID.

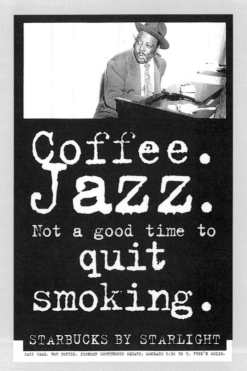

Coffee. Jazz. Not a good time to **quit smoking.**

STARBUCKS BY STARLIGHT

JAZZ JAMS. HOT COFFEE. PIONEER COURTHOUSE SQUARE. MONDAYS 5:30 TO 7. FREE 'N SOLID.

POSTERS

DESIGN
jerry ketel
portland, oregon

WRITER
meg rogers
new york, new york

AGENCY
rogers/ketel

STUDIO
bang bang bang

CLIENT
starbucks coffee

PRINCIPAL TYPE
trixie

DIMENSIONS
15½ x 22½ in.
(39.4 x 57.2 cm)

DESIGN
ada whitney and
roberto gonzalez
new york, new york

EDITOR
jon vesey

PRODUCER
marion rosenfeld

STUDIO
beehive

CLIENT
american movie
classics

PRINCIPAL TYPE
typewriter

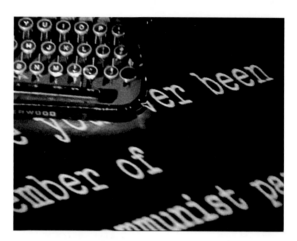

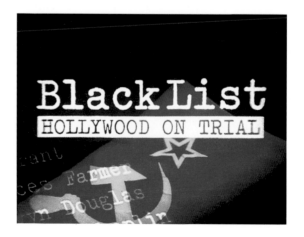

POSTER AND
CATALOG

DESIGN
kerri dupont
milwaukee, wisconsin

PRINTING
zimmermann printing
company
sheboygan, wisconsin

CLIENT
milwaukee art
museum

PRINCIPAL TYPE
monospace

DIMENSIONS
22 x 34 in.
(55.9 x 86.4 cm)
and 11 x 17 in.
(27.9 x 43.2 cm)

167

CD PACKAGING

DESIGN
 greg ross and lyn
 bradley
 burbank, california

ILLUSTRATION
 nate giorgio

PHOTOGRAPHY
 annie leibovitz

CLIENT
 qwest records

PRINCIPAL TYPE
 news gothic,
 bodoni, and bodega
 sans

DIMENSIONS
 5 1/2 x 5 in.
 (14 x 12.7 cm)

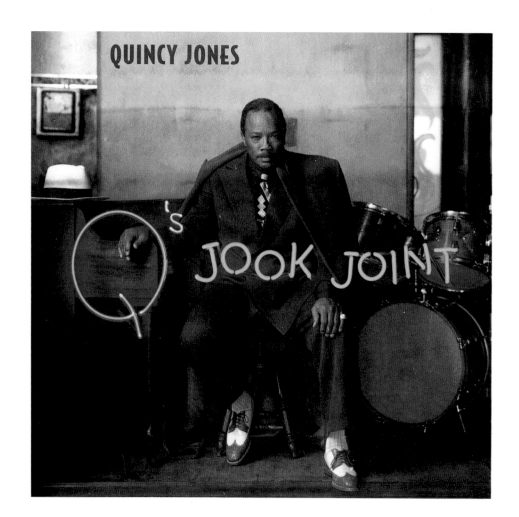

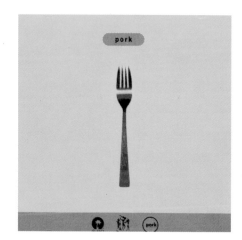

CD PACKAGING

DESIGN
 clive piercy and
 carol kono
 santa monica, california

STUDIO
 ph.d

CLIENT
 quango music group

PRINCIPAL TYPE
 meta, trixie, and
 news gothic

DIMENSIONS
 5 1/2 x 5 in.
 (14 x 12.7 cm)

STATIONERY

DESIGN
jeri heiden and
reverb
los angeles, california

ENGRAVING
the ligature

STUDIO
a & m records

PRINCIPAL TYPE
escorial, meta, and
various wood types

DIMENSIONS
8 ½ x 11 in.
(21.6 x 27.9 cm)

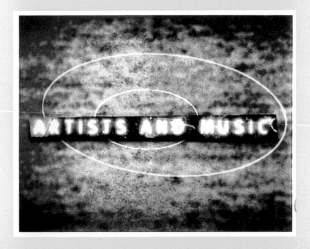

VIDEO

DESIGN
amie nguyen
los angeles, california

CREATIVE DIRECTION
jeri heiden, john
campbell, and
christopher wargin

STUDIO
christopher wargin

CLIENT
a & m records, inc.

PRINCIPAL TYPE
escorial, meta, and
various wood types

BOOK

DESIGN
régine thienhaus
hamburg, germany

ILLUSTRATION
birgit eggers

AGENCY
k.k.w. büro hamburg
gesellschaft für
kommunicationdesign

CLIENT
trendbüro hamburg
and econ verlag

PRINCIPAL TYPE
meta, modular, bank
gothic, and trixie
plain

DIMENSIONS
5 5/16 x 8 7/16 in.
(13.5 x 21.5 cm)

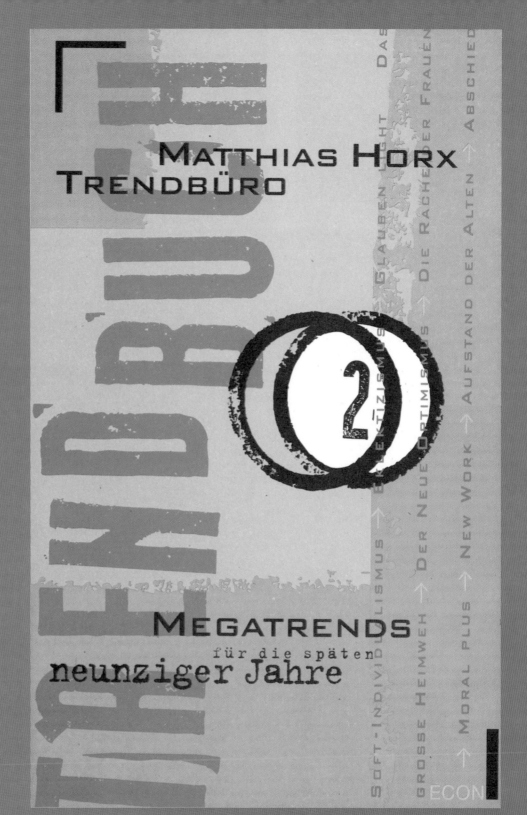

MATTHIAS HORX
TRENDBÜRO

TRENDBUCH

2

MEGATRENDS
für die späten
neunziger Jahre

DAS · GLAUBEN · LIGHT · DIE RÄCHER DER FRAUEN · ABSCHIED

EKLEKTIZISMUS · DER NEUE OPTIMISMUS · AUFSTAND DER ALTEN

SOFT-INDIVIDUALISMUS · GROSSE HEIMWEH · MORAL PLUS · NEW WORK

ECON

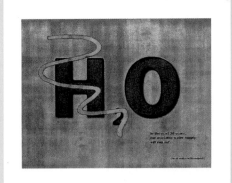 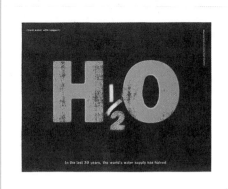

ADVERTISEMENTS

DESIGN
antony redman and
martin lim
singapore

COPYWRITING
jim aitchison,
antony redman, and
ian batey

ART DIRECTION
antony redman

CREATIVE DIRECTION
jim aitchison and
graham fink

AGENCY
batey ads

CLIENT
asian pals of the
planet

PRINCIPAL TYPE
franklin gothic

DIMENSIONS
8 1/4 x 10 3/4 in.
(21 x 27.3 cm)

163

POSTER

DESIGN
david butler
atlanta, georgia

ILLUSTRATION
david butler

STUDIO
copeland hirthler
design +
communications

CLIENT
arts festival of
atlanta

PRINCIPAL TYPE
monospace

DIMENSIONS
25 x 38 in.
(63.5 x 96.5 cm)

POSTER

DESIGN
ken fox
chicago, illinois

ART DIRECTION
dana arnett

STUDIO
vsa partners inc.

CLIENT
diffa/chicago

PRINCIPAL TYPE
old english,
künstler script
medium, bulmer, and
bulmer expert

DIMENSIONS
22 x 34 1/2 in.
(55.9 x 87.6 cm)

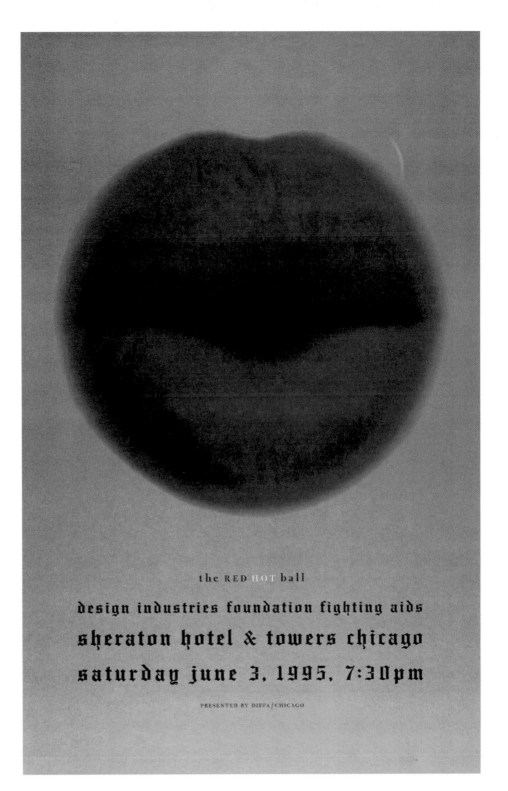

the RED HOT ball

design industries foundation fighting aids
sheraton hotel & towers chicago
saturday june 3, 1995, 7:30pm

PRESENTED BY DIFFA/CHICAGO

OUTDOOR
ADVERTISEMENT

DESIGN
imin pao
portland, oregon

ART DIRECTION
john c. jay

CREATIVE DIRECTION
dan wieden

PHOTOGRAPHY
brad harris

AGENCY
wieden & kennedy

CLIENT
nike, inc.

PRINCIPAL TYPE
itc kabel bold,
mason alternate,
and mason regular

161

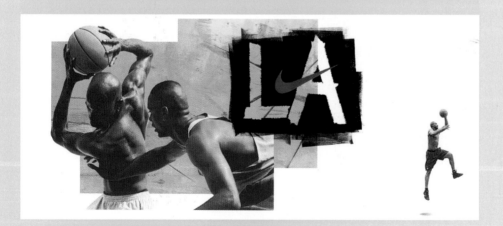

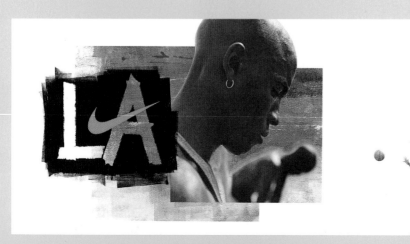

OUTDOOR
ADVERTISEMENT

DESIGN
imin pao and nicole
misiti
portland, oregon

ART DIRECTION
john c. jay

CREATIVE DIRECTION
dan wieden

PHOTOGRAPHY
brad harris

AGENCY
wieden & kennedy

CLIENT
nike, inc.

PRINCIPAL TYPE
itc kabel, mason
alternate, and
mason regular

DESIGN
ron dumas
beaverton, oregon

COPYWRITING
bob lambie

STUDIO
nike, inc.

PRINCIPAL TYPE
futura

DIMENSIONS
8 x 8 in.
(20.3 x 20.3 cm)

But wait, there's more.
The solo Swoosh rolls out in Spring
1996 for all uses in the United States.
Its application in Europe, Asia
and Latin America will follow in the
near future. Comprehensive audits
of consumer brand awareness
will determine the appropriate
schedule for these regions.

A logo identifies product values and
quality standards, a distinct corporate
voice, and offers a point of entry into
the battle-tough world of consumer
preference. Across 24 years of history,
Nike has parlayed authentic,
athletic product and truly innovative
communications into an unaided
brand awareness of 90%,
second only to Coca-Cola in the
United States and similar to
Coke and IBM worldwide.

nike
1971

NIKE
1978

NIKE
1985

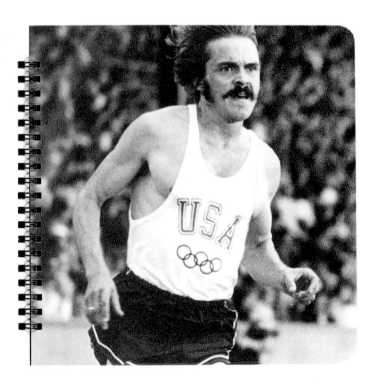

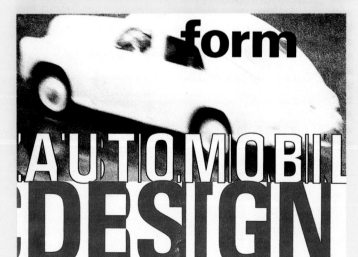

BOOK COVER

DESIGN
michael ian kaye
new york, new york

PHOTOGRAPHY
michael p.
mcglaughlin

STUDIO
farrar, straus and
giroux

PRINCIPAL TYPE
monotype grotesque
black

DIMENSIONS
5 ³/₄ x 8 ¹/₂ in.
(14.6 x 21.6 cm)

MAGAZINE COVER

DESIGN
david carson
new york, new york

STUDIO
david carson design

CLIENT
form magazine
germany

PRINCIPAL TYPE
lugard

DIMENSIONS
9 ¹/₂ x 11 ³/₄ in.
(24.1 x 29.9 cm))

DESIGN
 barbara dewilde
 brooklyn, new york

TYPESETTING
 photo-lettering,
 inc.

STUDIO
 barbara dewilde
 design

CLIENT
 alfred a. knopf,
 inc.

PRINCIPAL TYPE
 brodovitch albro
 and helvetica

DIMENSIONS
 5 3/4 x 8 1/2 in.
 (14.6 x 21.6 cm)

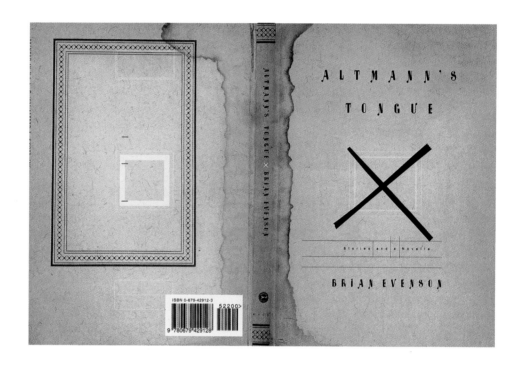

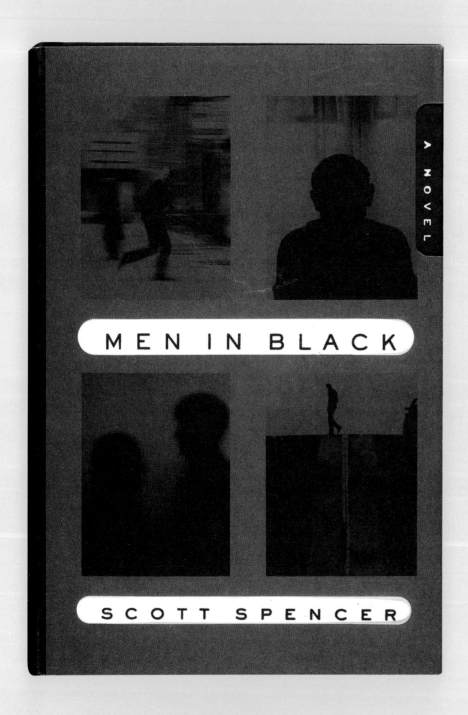

A NOVEL

MEN IN BLACK

SCOTT SPENCER

BOOK COVER

DESIGN
 alexander knowlton
 new york, new york

STUDIO
 best design inc.

CLIENT
 alfred a. knopf,
 inc.

PRINCIPAL TYPE
 sackes gothic

DIMENSIONS
 5 ³/₄ x 8 ⁹/₁₆ (14.6 x
 21.7 cm)

BOOK COVER

DESIGN
john gall
new york, new york

ILLUSTRATION
alfred gescheidt

STUDIO
john gall graphic
design

CLIENT
grove/atlantic inc.

PRINCIPAL TYPE
univers ultra
condensed

DIMENSIONS
5 3/8 x 8 1/4 in.
(13.6 x 21 cm)

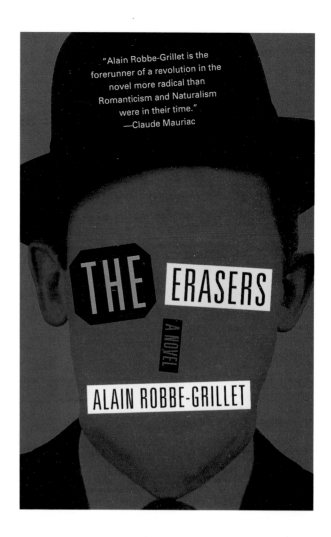

BOOK COVER

DESIGN
john gall
new york, new york

PHOTOGRAPHY
barnaby hall

STUDIO
john gall graphic
design

CLIENT
grove/atlantic inc.

PRINCIPAL TYPE
alternate gothic

DIMENSIONS
5 3/8 x 8 1/4 in.
(13.6 x 21 cm)

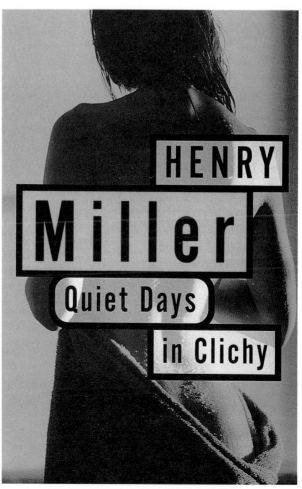

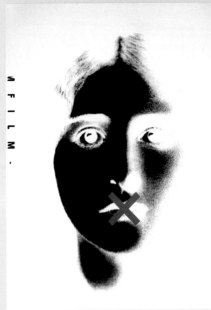

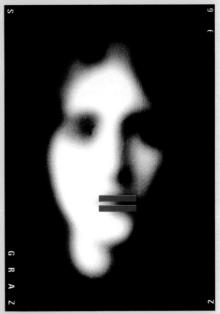

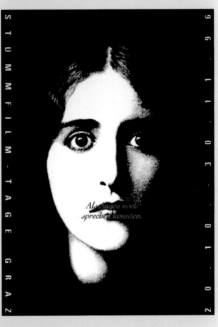

POSTERS

DESIGN
 fons m. hickman
 düsseldorf, germany

STUDIO
 fons

CLIENT
 georg corman and
 mikor musik

PRINCIPAL TYPE
 univers and zapf
 dingbats

DIMENSIONS
 33 1/16 x 23 5/8 in.
 (84 x 60 cm)

CD COVER AND
BOOKLET

DESIGN
 fons m. hickman
 düsseldorf, germany

CALLIGRAPHY
 gesine grotrian

PHOTOGRAPHY
 oliver eltinger

STUDIO
 fons

CLIENT
 georg corman and
 mikor musik

PRINCIPAL TYPE
 trixie and gesines
 left hand

DIMENSIONS
 5 ½ x 5 in.
 (14 x 12.7 cm)

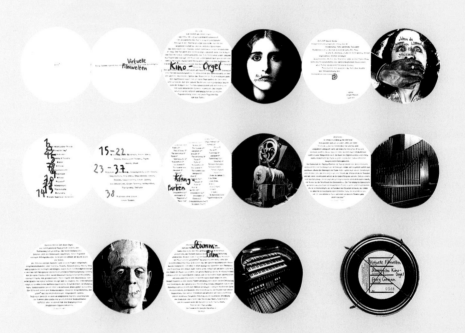

DESIGN
 carlos segura
 chicago, illinois

ILLUSTRATION
 tony klassen and
 carlos segura

STUDIO
 segura, inc.

CLIENT
 xxx snowboards

PRINCIPAL TYPE
 amplifier

DIMENSIONS
 4 in. diameter
 (10.2 cm)

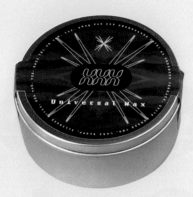

153

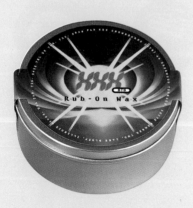

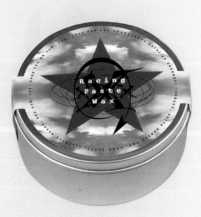

DESIGN
jerry king musser
columbia, pennsylvania

STUDIO
musser design

CLIENT
boyer printing
company

PRINCIPAL TYPE
bell centennial

DIMENSIONS
5 x 10 in.
(12.7 x 25.4 cm)

DESIGN
 michael gericke
 new york, new york

STUDIO
 pentagram design

CLIENT
 american institute
 of architectects,
 new york chapter

PRINCIPAL TYPE
 futura extra bold
 and bodoni bold

DIMENSIONS
 24 x 36 in.
 (61 x 91.4 cm)

151

42"

17"

POSTER

DESIGN
akio okumura and
katsuji minami
osaka, japan

CALLIGRAPHY
akio okumura

STUDIO
packaging create
inc.

CLIENT
new oji paper co.,
ltd.

PRINCIPAL TYPE
univers 75

DIMENSIONS
28 11/16 x 40 9/16 in.
(72.8 x 103 cm)

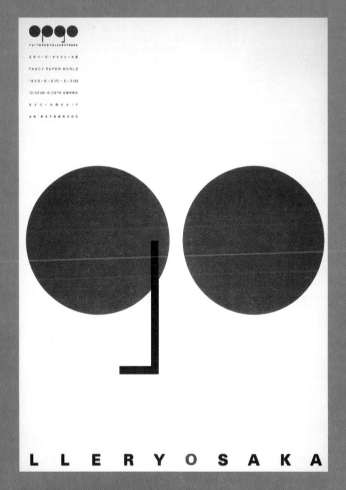

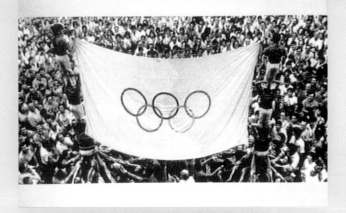

TELEVISION
COMMERCIAL

DESIGN
todd waterbury
portland, oregon

DIRECTORS
donna pittman and
mark hensley
los angeles, california

AGENCY
wieden & kennedy

CLIENT
the coca-cola
company

PRINCIPAL TYPE
news gothic

MEXICO CITY 1968

TOKYO 1964

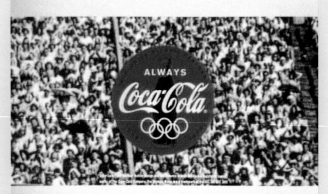

FOR THE FANS

DESIGN
todd waterbury
portland, oregon

AGENCY
wieden & kennedy

CLIENT
the coca-cola
company

PRINCIPAL TYPE
news gothic

DIMENSIONS
8 ¹/₂ x 10 ¹/₄ in.
(21.6 x 26 cm)

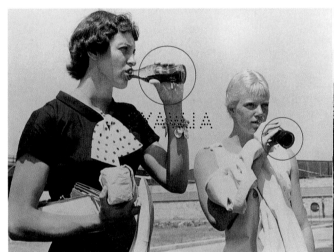

Rome 1960

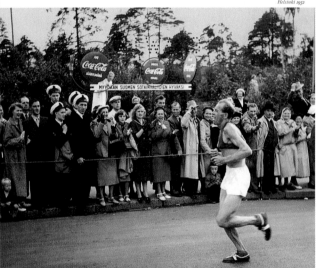

Helsinki 1952

N I K E ⬤ T O W N

N E W Y O R K C I T Y

6 West 57th Street

LOGOTYPE

DESIGN
jeff weithman and
clint gorthy
portland, oregon

LETTERING
clint gorthy

DESIGN DIRECTION
jeff weithman

STUDIO
nike, inc.

PRINCIPAL TYPE
niketown nyc
regular

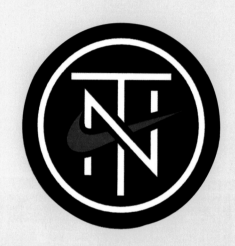

147

A B C D E F G H I
J K L M N O P Q R
S T U V W X Y Z
1 2 3 4 5 6 7 8 9 0

TYPEFACE

DESIGN
jeff weithman
portland, oregon

LETTERING
clint gorthy and
c.j. dewaal

STUDIO
nike, inc.

PRINCIPAL TYPE
niketown nyc

DESIGN
steve tolleson and
jean orlebeke
san francisco, california

STUDIO
tolleson design

CLIENT
woodtech

PRINCIPAL TYPE
univers condensed
and helvetica
rounded condensed

DIMENSIONS
8 ½ x 11 in.
(21.6 x 27.9 cm)

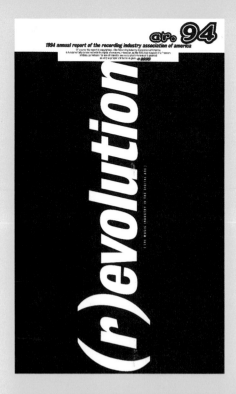

ANNUAL REPORT

DESIGN
 neal ashby
 annapolis, maryland

CLIENT
 recording industry
 association of
 america

PRINCIPAL TYPE
 bureau grotesque
 and dogma outline

DIMENSIONS
 8 x 13 in.
 (20.3 x 33 cm)

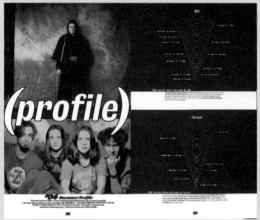

145

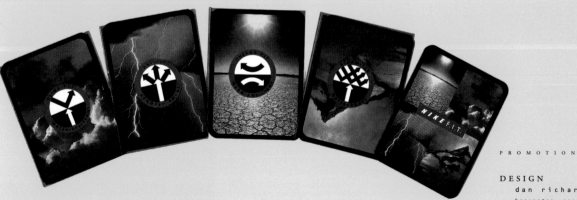

PROMOTION

DESIGN
 dan richards
 beaverton, oregon

COPYWRITING
 stanley hainsworth

STUDIO
 nike, inc.

PRINCIPAL TYPE
 futura condensed
 extra bold

DIMENSIONS
 3¼ x 4¼ in.
 (8.3 x 10.8 cm)

TELEVISION
COMMERCIAL

DESIGN
david j. hwang
los angeles, california

AGENCY
bozell/sms

STUDIO
two headed monster

CLIENT
airtouch cellular

PRINCIPAL TYPE
meta

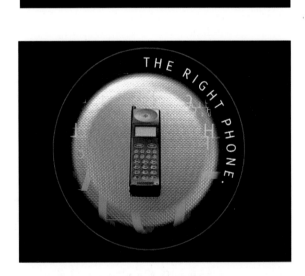

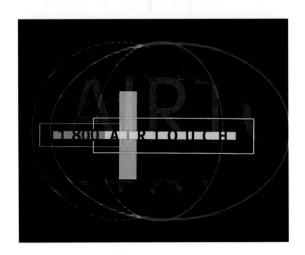

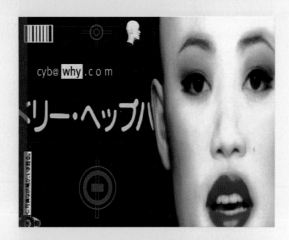

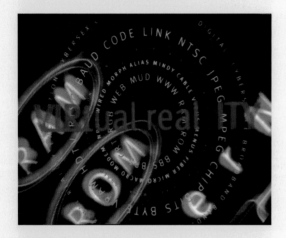

TELEVISION
COMMERCIAL

DESIGN
david j. hwang
los angeles, california

ASSOCIATE DESIGNER
joan raspo

AGENCY
red ball tiger

STUDIO
two headed monster

CLIENT
tci

PRINCIPAL TYPE
meta

143
17" 42"

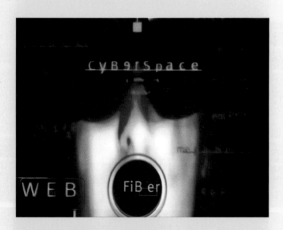

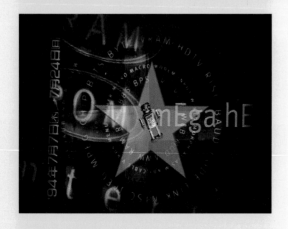

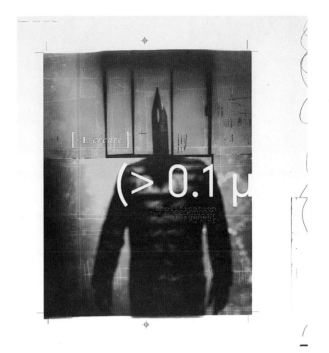

POSTER

DESIGN
 michael verdine
 san francisco, california

ART DIRECTION
 bill cahan

STUDIO
 cahan & associates

CLIENT
 creative alliance

PRINCIPAL TYPE
 din schriften

DIMENSIONS
 23 x 36 in.
 (58.4 x 91.4 cm)

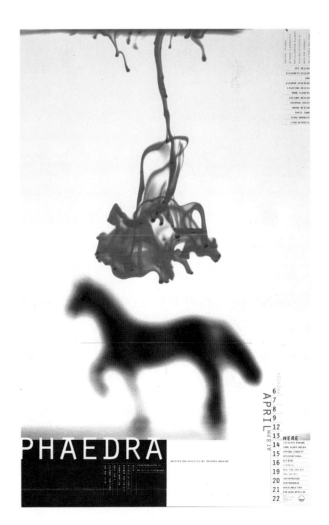

POSTER

DESIGN
 katrin schmit-tegge
 new york, new york

CREATIVE DIRECTION
 stephen doyle

STUDIO
 drenttel doyle
 partners

CLIENT
 creative productions

PRINCIPAL TYPE
 modified orator

DIMENSIONS
 19 x 30 in.
 (48.3 x 76.2 cm)

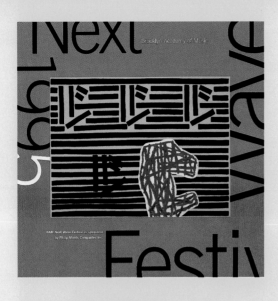

CORPORATE
IDENTITY

DESIGN
michael bierut and
emily hayes
new york, new york

PHOTOGRAPHY
various

STUDIO
pentagram design

CLIENT
brooklyn academy of
music

PRINCIPAL TYPE
news gothic

DIMENSIONS
various

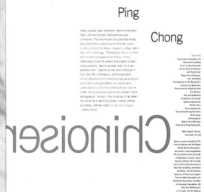

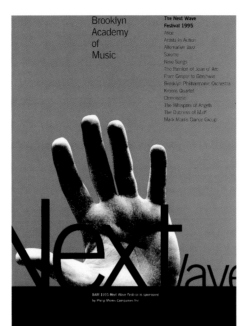

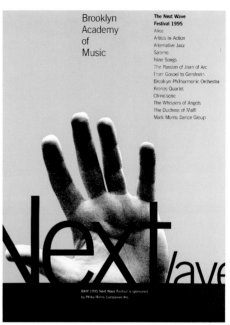

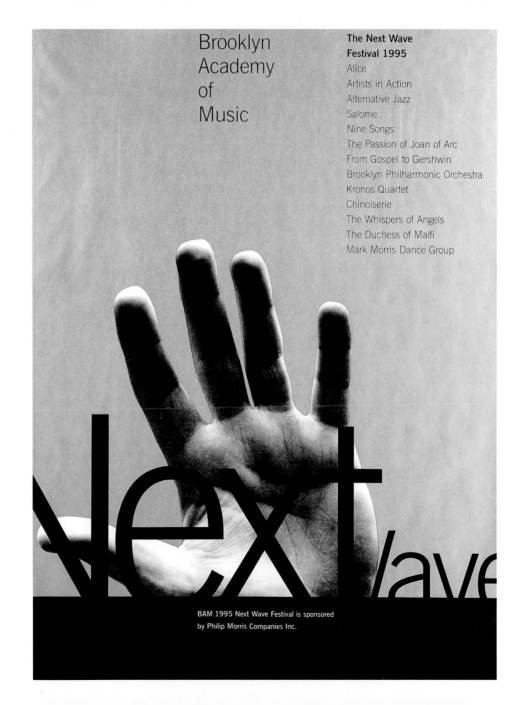

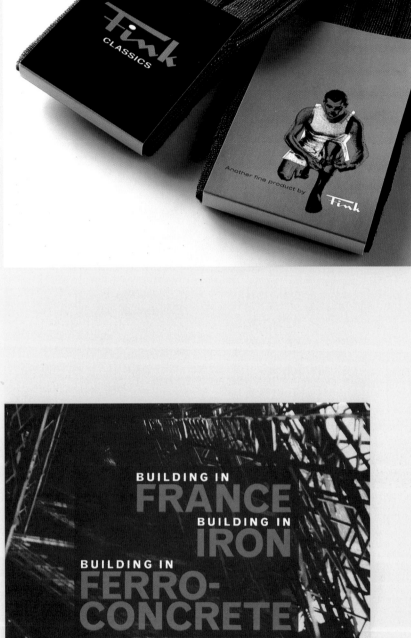

PACKAGING

DESIGN
mike calkins
philadelphia, pennsylvania

LETTERING
mike calkins

ART DIRECTION
howard brown

STUDIO
urban outfitters

PRINCIPAL TYPE
akzidenz grotesk
and handlettering

DIMENSIONS
2 x 5 3/4 in.
(5.1 x 14.6 cm)

BOOK

DESIGN
bruce mau with
chris rowat
toronto, ontario, canada

STUDIO
bruce mau design,
inc.

CLIENT
getty center for
the history of art
and humanities

PRINCIPAL TYPE
scala, bodoni, and
grotesque

DIMENSIONS
7 1/2 x 10 1/4 in.
(19.1 x 26 cm)

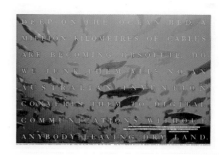

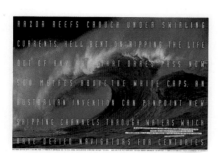

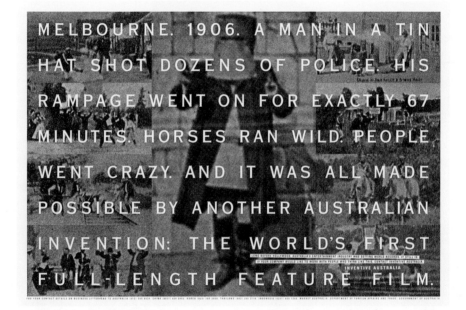

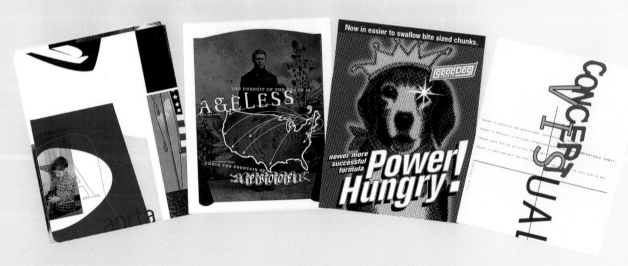

DESIGN
keith brown, david covell, richard curren, steve farrar, kirk james, karin johnson, george mench, steve redmond, dan sharp, michael shea, mark sylvester, andrew szurley, and christopher vice
burlington, vermont

ILLUSTRATION
keith brown, david covell, and cam deleon

ART DIRECTION
michael jager, janet johnson, and christopher vice

PHOTOGRAPHY
geoff fosbrook, michael jager, and kirk james

STUDIO
jager di paola kemp design

PRINCIPAL TYPE
kopykatkut and texorna

DIMENSIONS
5 x 6 in.
(12.7 x 15.5 cm)

137

STATIONERY

DESIGN
jacques koeweiden
and paul postma
amsterdam, the netherlands

STUDIO
koeweiden postma
associates

PRINCIPAL TYPE
kp din

DIMENSIONS
8 ¼ x 11 ¼ in.
(21 x 28.6 cm)

BOOK COVER

DESIGN
chip kidd
new york, new york

STUDIO
chip kidddesign

CLIENT
alfred a. knopf,
inc.

PRINCIPAL TYPE
hc tempo heavy
condensed

DIMENSIONS
11 ½ x 8 in.
(29.2 x 20.3 cm)

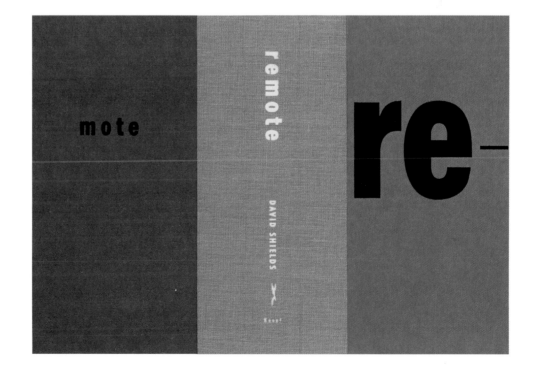

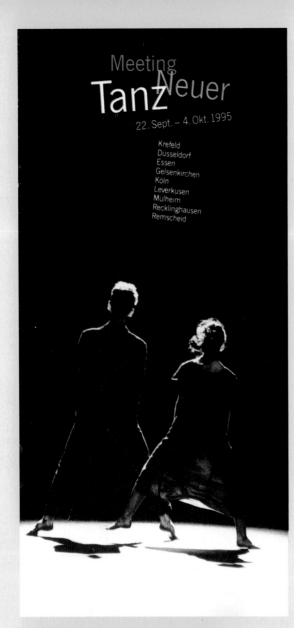

CAMPAIGN

DESIGN
holger giffhorn and
thomas serres
wuppertal, germany

STUDIO
giffhorn und serres
designbüro

CLIENT
sekretariat für
gemeinsame
kulturarbeit

PRINCIPAL TYPE
news gothic

DIMENSIONS
various

DESIGN
akio okumura and
emi kajihara
osaka, japan

STUDIO
packaging create
inc.

CLIENT
new oji paper co.,
ltd.

DIMENSIONS
28 11/16 x 40 9/16 in.
(72.8 x 103 cm)

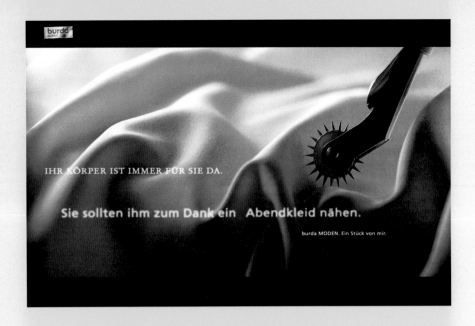

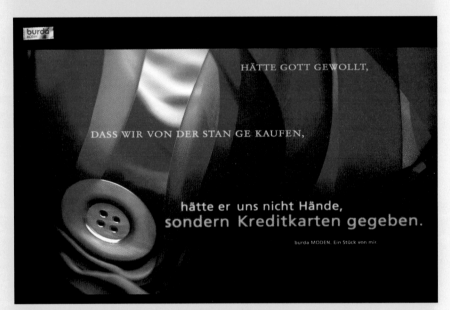

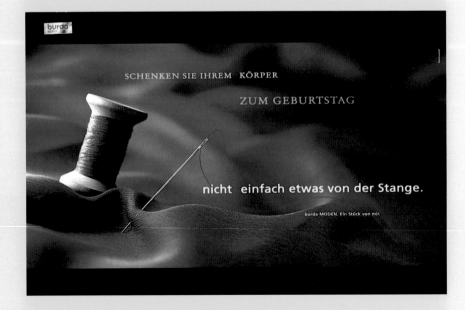

ADVERTISEMENT

DESIGN
tonguç baykurt
hamburg, germany

LETTERING
katja häcker

COPYWRITING
erik heitmann

AGENCY
springer & jacoby

CLIENT
burda moden

PRINCIPAL TYPE
adobe stempel
garamond and adobe
frutiger

DIMENSIONS
11 x 17 in.
(28 x 43 cm)

DESIGN
scott clum
silverton, oregon

STUDIO
ride

CLIENT
ray gun publishing

PRINCIPAL TYPE
handlettering

DIMENSIONS
10 x 10 in.
(25.4 x 25.4 cm)

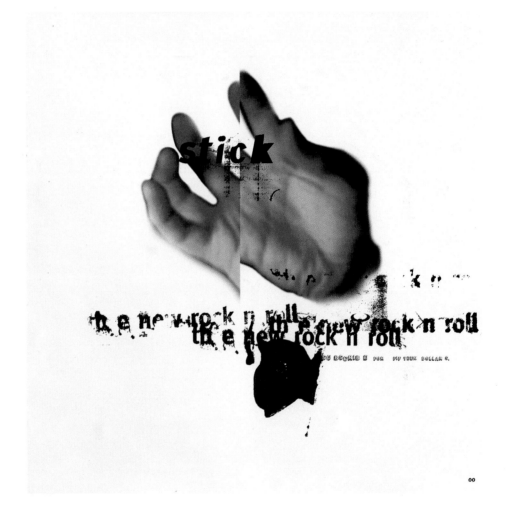

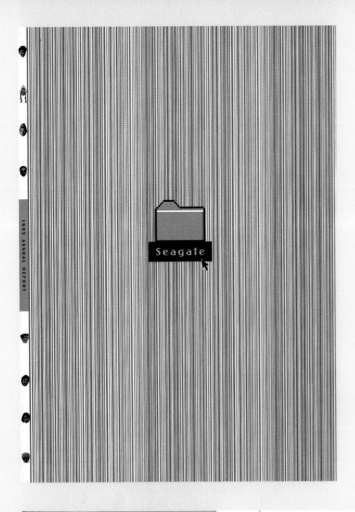

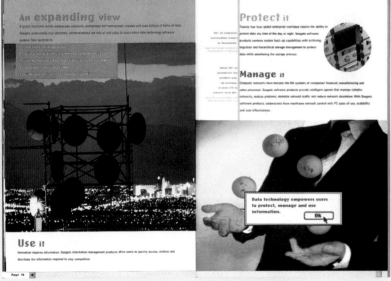

DESIGN
yu-mei tam and
robert wong
new york, new york

CREATIVE DIRECTION
kent hunter and
aubrey balkind

STUDIO
frankfurt balkind
partners

CLIENT
seagate technology,
inc.

PRINCIPAL TYPE
oakland and univers
condensed

DIMENSIONS
8 ¼ x 11 ⅝ in.
(21 x 28.9 cm)

DESIGN
jo davison
minneapolis, minnesota

STUDIO
the edison group

PRINCIPAL TYPE
sabon and frutiger

DIMENSIONS
8 1/2 x 11 in.
(21.6 x 27.9 cm)

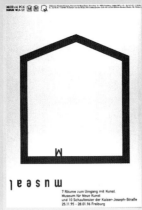

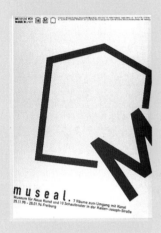

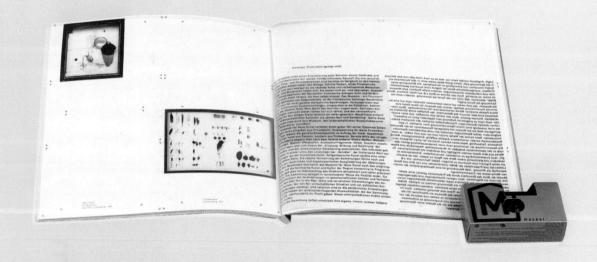

CAMPAIGN

DESIGN
petra knyrim and
stefan nowak
düsseldorf, germany

AGENCY
grafikbüro

CLIENT
museum für neue
kunst, freiburg

PRINCIPAL TYPE
din

DIMENSIONS
various

DESIGN
yoshimaru takahashi
osaka-city, osaka, japan

STUDIO
kokokumaru co.,
ltd.

CLIENT
japan graphic
designers
association inc.

DIMENSIONS
39 ¼ x 28 in.
(99.7 x 71.1 cm)

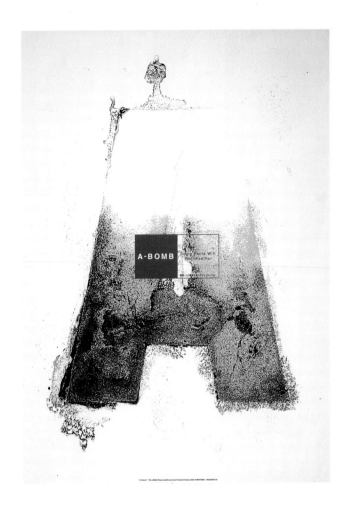

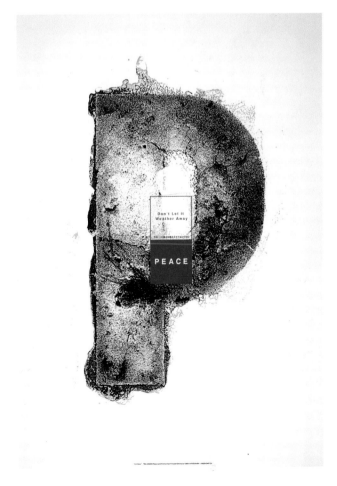

ONDCK&ITE MARABLE

ONDCK&ITE MARABLE

BOOK COVER

DESIGN
alan hill
new york, new york

LETTERING
alan hill

STUDIO
alan hill design

CLIENT
verso

PRINCIPAL TYPE
handlettering

DIMENSIONS
6 x 9 in.
(15.2 x 22.9 cm)

BOOK COVER

DESIGN
michael ian kaye
new york, new york

PHOTOGRAPHY
melissa hayden

STUDIO
farrar, straus and
giroux

PRINCIPAL TYPE
trade gothic and
letter gothic

DIMENSIONS
5 3/4 x 7 1/4 in.
(14.6 x 18.4 cm)

CALENDAR

DESIGN
diti katona, john
pylypczak, susan
mcintee
toronto, canada

ILLUSTRATION
mike constable

STUDIO
concrete design
communications inc.

CLIENT
keilhauer contract
seating

PRINCIPAL TYPE
interstate

DIMENSIONS
7 x 11 in.
(17.8 x 27.9 cm)

toshinobu
kubota

CALENDAR

DESIGN
zempaku suzuki and
aritomo ueno
shintomi, tokyo, japan

ART DIRECTION
zempaku suzuki

PHOTOGRAPHY
kim stringfellow
new york, new york

AGENCY
heiwa paper co.,
ltd.

STUDIO
b·bi studio inc.

CLIENT
funky jam
corporation

PRINCIPAL TYPE
helvetica bold

DIMENSIONS
14 $\frac{3}{8}$ x 21 $\frac{1}{8}$ in.
(36.4 x 53.6 cm)

CALENDAR

DESIGN
kenzo nakagawa
tokyo, japan

STUDIO
ndc graphics inc.

PRINCIPAL TYPE
itc anna

DIMENSIONS
8 ¹/₄ x 11 ¹¹/₁₆ in.
(21 x 29.7 cm)

02 February

1996

2 3

4 5 6 7 8 9 10

12 13 14 15 16 17

18 19 20 21 22 23

25 26 27 28 29

DESIGN
david hukari
san mateo, california

GRAPHIC ARTIST
kim vogel
san jose, california

STUDIO
priscaro & hukari,
inc.

CLIENT
hal computer
systems

PRINCIPAL TYPE
template gothic

DIMENSIONS
15 x 22 in.
(38 x 55.9 cm)

123
17"
42"

SELF-PROMOTION

DESIGN
 azita panahpour
 new york, new york

LETTERING
 azita panahpour

AGENCY
 panahpour &
 partners

PRINCIPAL TYPE
 lightline gothic
 and handlettering

MAILER

DESIGN
 bob dahlquist
 sacramento, california

LETTERING
 bob dahlquist

STUDIO
 bob's haus

PRINCIPAL TYPE
 charlemagne
 (adapted) and
 custom letterforms

DIMENSIONS
 10 x 6⅛ in.
 (25.4 x 15.5 cm)

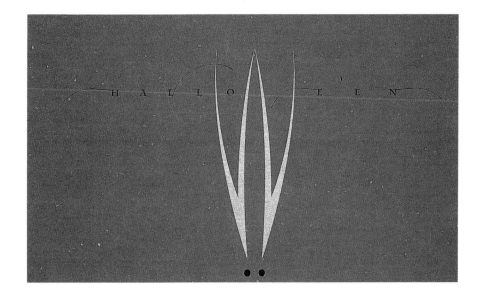

STATIONERY

DESIGN
jerry king musser
columbia, pennsylvania

STUDIO
musser design

CLIENT
global beat music,
inc.

PRINCIPAL TYPE
bell centennial

DIMENSIONS
8 1/2 x 11 in.
(21.6 x 27.9 cm)

ANNUAL REPORT

DESIGN
john van dyke and
ann kumasaka
seattle, washington

COPYWRITING
tom mccarthy

PHOTOGRAPHY
jeff corwin

STUDIO
van dyke company

CLIENT
icos corporation

PRINCIPAL TYPE
itc officina sans
book and sans bold

DIMENSIONS
8 1/2 x 11 in.
(21.6 x 27.9 cm)

ICOS

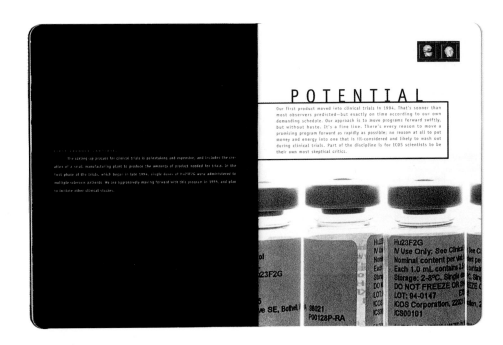

POTENTIAL

Our first product moved into clinical trials in 1994. That's sooner than most observers predicted—but exactly on time according to our own demanding schedule. Our approach is to move programs forward swiftly, but without haste. It's a fine line. There's every reason to move a promising program forward as rapidly as possible; no reason at all to put money and energy into one that is ill-considered and likely to wash out during clinical trials. Part of the discipline is for ICOS scientists to be their own most skeptical critics.

The scaling-up process for clinical trials is painstaking and expensive, and includes the creation of a small manufacturing plant to produce the amounts of product needed for trials. In the first phase of the trials, which began in late 1994, single doses of Hu23F2G were administered to multiple sclerosis patients. We are aggressively moving forward with this program in 1995, and plan to initiate other clinical studies.

PAF
(PLATELET ACTIVATING FACTOR)

A computer schematic representation of the structure of the inflammatory mediator PAF. PAF is rendered biologically inactive by PAF-AH.

DISCOVERY

PAF-AH has caused excitement at ICOS because it has a profile similar to those of some of the most successful therapeutics developed in the biotechnology industry's short history. That is, it is a natural enzyme, one the body produces. It plays a role in some very important diseases. In addition, it is present in the body in small amounts, so it should be relatively easy to administer effective doses. And its action is understood—it helps moderate harmful activity of a molecule that also is natural and found in the body.

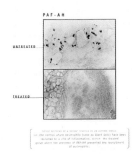

PAF-AH

UNTREATED

TREATED

DESIGN
andrea bernhard,
andreas reihse,
christoph niermann,
ingo blaeser,
isabel erier, peter
buennagel, regina
klebinger, sebastian
kutscher, and
thomas bock
düsseldorf, germany

AGENCY
heft 2000, verein
i.g.

PRINCIPAL TYPE
arbitrary sans

DIMENSIONS
16 3/16 x 11 11/16 in.
(41 x 29.7 cm)

DESIGN
lana rigsby,
michael b. thede,
and alvin ho young
houston, texas

LETTERING
lana rigsby

WRITER
joann stone

PHOTOGRAPHY
chris shinn and
sebastião salgado
houston, texas, and new york,
new york

STUDIO
rigsby design, inc.

CLIENT
earth tech

PRINCIPAL TYPE
helvetica neue 75
bold and 45 light

DIMENSIONS
7 9/16 x 10 5/8 in.
(19.2 x 27 cm)

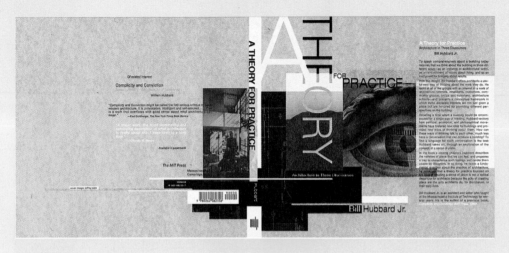

BOOK COVER

DESIGN
jeffrey kälin
cambridge, massachusetts

CLIENT
the mit press

PRINCIPAL TYPE
adobe helvetica
neue

DIMENSIONS
20 5/8 x 9 1/4 in.
(52.4 x 23.5 cm)

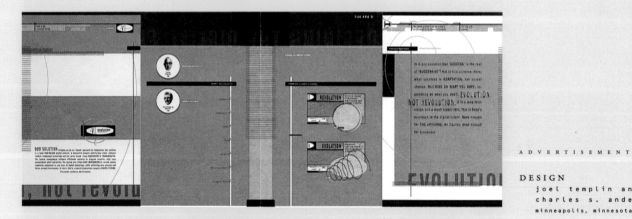

ADVERTISEMENT

DESIGN
joel templin and
charles s. anderson
minneapolis, minnesota

ART DIRECTION
charles s. anderson
and christie kelley

AGENCY
hill holliday
advertising

STUDIO
charles s. anderson
design company

CLIENT
sony

PRINCIPAL TYPE
franklin gothic and
trade gothic

DIMENSIONS
27 1/2 x 10 3/4 in.
(69.9 x 27.3 cm)

DESIGN
hajdeja subotic-
ehline
san francisco, california

STUDIO
hajdeja s. ehline
design

PRINCIPAL TYPE
din 16/17, avant
garde, and
helvetica inserat
roman

DIMENSIONS
15 x 5 5/8 in.
(38.1 x 14.3 cm)

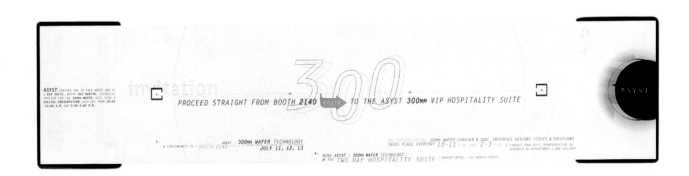

INVITATION

DESIGN
steve tolleson and
jean orlebeke
san francisco, california

PHOTOGRAPHY
robert schlatter

STUDIO
tolleson design

CLIENT
asyst technologies,
inc.

PRINCIPAL TYPE
letter gothic,
rotis, orator,
trajan, and syntax

DIMENSIONS
2 7/8 x 4 7/8 in.
(7.3 x 12.4 cm)

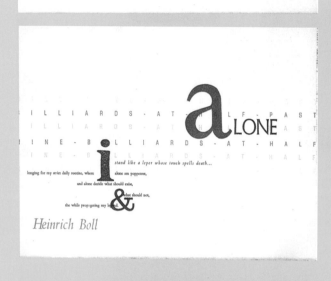

STUDENT PROJECT

DESIGN
rafael esquer
pasadena, california

INSTRUCTOR
vance studley

AGENCY
archetype press

CLIENT
art center college
of design

PRINCIPAL TYPE
various

DIMENSIONS
10 x 7½ in.
(25.4 x 19.1 cm)

115

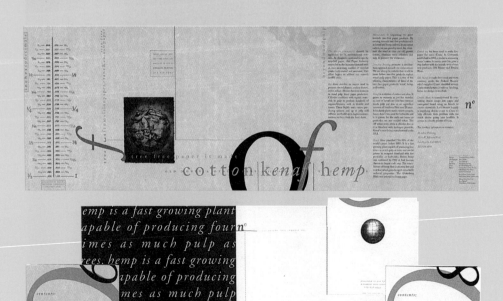

PROMOTION

DESIGN
petrula vrontikis,
kim sage, and
christine hsiao
los angeles, california

PHOTOGRAPHY
don miller

STUDIO
vrontikis design
office

CLIENT
nan faessler and
donahue printing
company

PRINCIPAL TYPE
caslon, futura, and
garamond

DIMENSIONS
various

B O O K

DESIGN
 vance studley and
 21 student
 designers
 pasadena, california

AGENCY
 art center college
 of design

STUDIO
 archetype press

PRINCIPAL TYPE
 various

DIMENSIONS
 9 x 12 in.
 (22.9 x 30.5 cm)

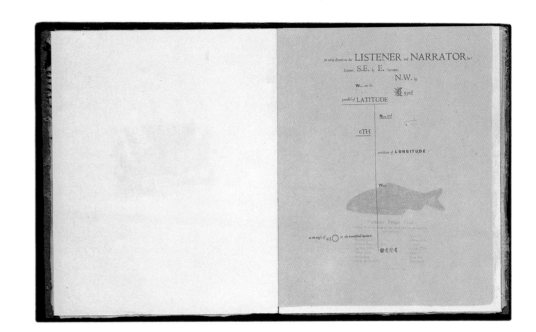

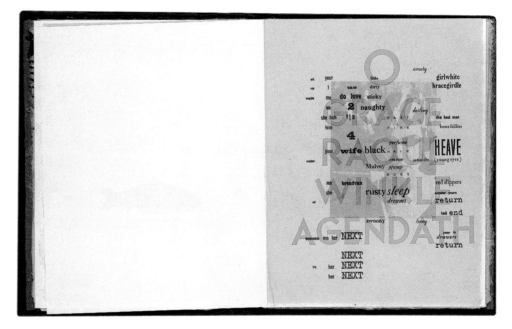

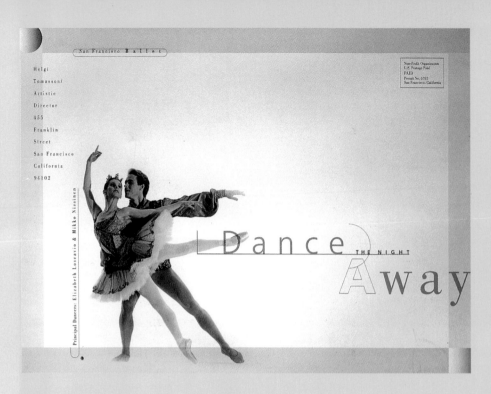

CAMPAIGN

DESIGN
paul schulte
san francisco, california

PHOTOGRAPHY
r. j. muna

STUDIO
jacobs fulton
design group

CLIENT
san francisco
ballet

PRINCIPAL TYPE
humanist and bodoni

DIMENSIONS
various

PROMOTION

DESIGN
steve tolleson and
jennifer sterling
san francisco, california

PHOTOGRAPHY
various

STUDIO
tolleson design

CLIENT
fox river paper
company

PRINCIPAL TYPE
keedy sans and meta

DIMENSIONS
11 x 17 in.
(27.9 x 43.2 cm)

DESIGN
steve tolleson and
jennifer sterling
san francisco, california

STUDIO
tolleson design

CLIENT
nvidia corporation

PRINCIPAL TYPE
garamond no. 3,
keedy sans, and
democratica

DIMENSIONS
10 3/8 x 13 3/8 in.
(26.3 x 34 cm)

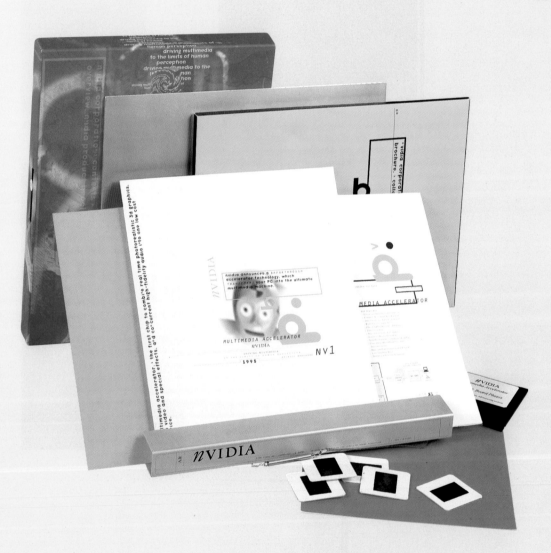

III
42"

DESIGN
 doc visser, huber
 jaspers, and will
 holder
 amsterdam, the netherlands

STUDIO
 visser/poortman
 design

PRINCIPAL TYPE
 meta, matrix, and
 cochin

DIMENSIONS
 10 ⁵/₈ x 7 ¹/₂ in.
 (27 x 19 cm)

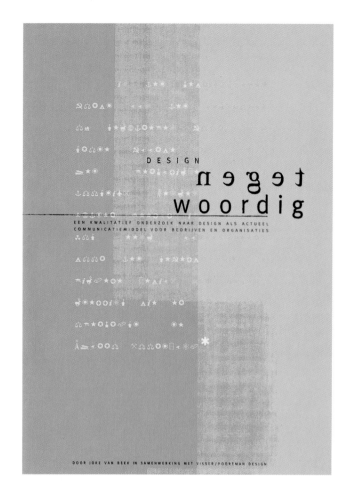

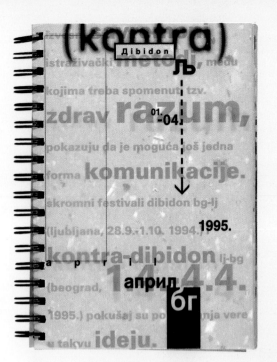

CATALOG

DESIGN
eduard cehovin
ljubljana, belgrade, slovenia

STUDIO
a ± b

CLIENT
open society
institute—slovenia
and soros fund,
yugoslavia

PRINCIPAL TYPE
various

DIMENSIONS
6 5/16 x 9 1/16 in.
(16 x 23 cm)

DESIGN
 uwe loesch
 düsseldorf, germany

CLIENT
 linea grafica
 moscow, russia

PRINCIPAL TYPE
 univers 67
 condensed bold

DIMENSIONS
 3 3 ¹/₁₆ x 4 6 ⁷/₈ i n .
 (8 4 x 1 1 9 c m)

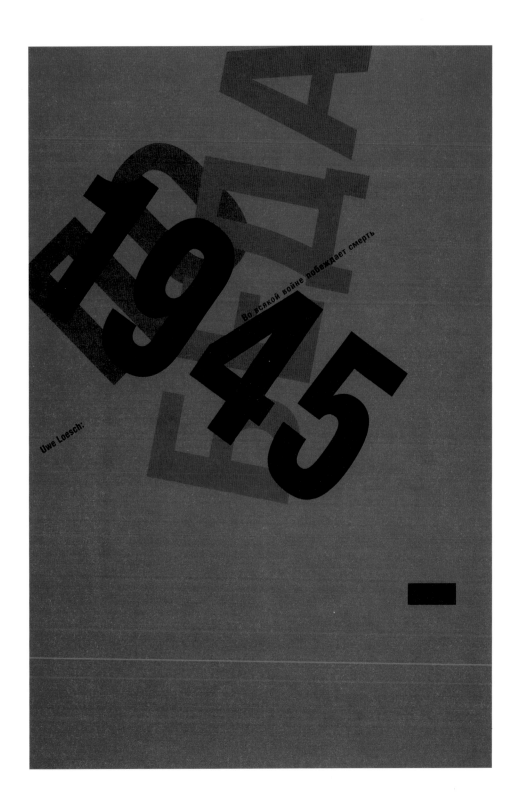

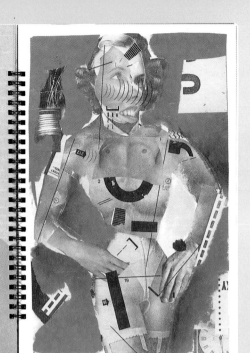

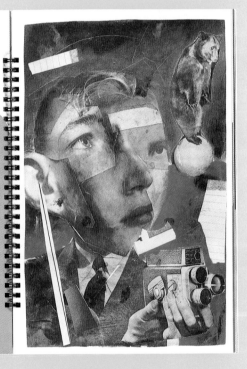

DESIGN
orazio fantini and
lyne lefebvre
montréal, québec, canada

ILLUSTRATION
alain pilon

STUDIO
discreet logic

PRINCIPAL TYPE
block berthold,
courier bold, and
letter gothic

DIMENSIONS
11 3/4 x 7 3/4 in.
(29.8 x 19.7 cm)

107
42"/17"

PROMOTION

DESIGN
andrew hoyne
st. kilda, victoria,
australia

CALLIGRAPHY
amanda mcpherson
and andrew hoyne

PHOTOGRAPHY
dean phipps

STUDIO
andrew hoyne design

CLIENT
australian teachers
of media and john
nicoll events

PRINCIPAL TYPE
triplex and
handlettering

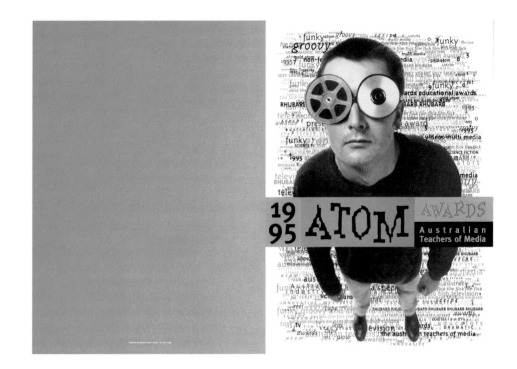

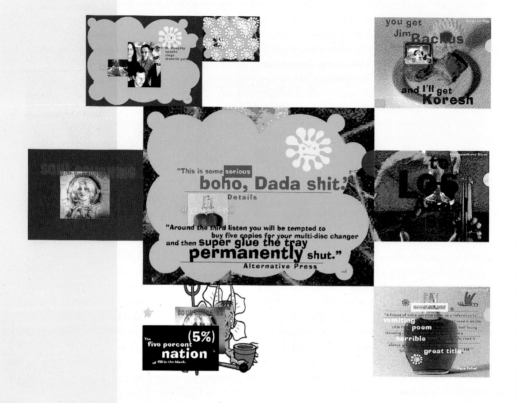

105

42"
17"

MULTIMEDIA

DESIGN
bob aufuldish
san anselmo, california

MUSIC
soul coughing

ILLUSTRATION
steve wacksman

VIDEO DIRECTOR
mark kohr

ART DIRECTION
kim briggs, warner
bros. records

CREATIVE DIRECTION
jeri heiden, warner
bros. records

PHOTOGRAPHY
anthony artiaga,
annalisa, and bob
aufuldish

STUDIO
aufuldish &
warinner

CLIENT
warner bros.
records

PRINCIPAL TYPE
ad lib

DESIGN
bob aufuldish
san anselmo, california

WRITER
mark bartlett

INTERACTIVE
PROGRAMMING
dave granvold

SOUND
scott pickering and
bob aufuldish

FONT DESIGN
bob aufuldish, eric
donelan, and kathy
warinner

STUDIO
aufuldish &
warinner

CLIENT
fontboy

PRINCIPAL TYPE
whiplash and baufy

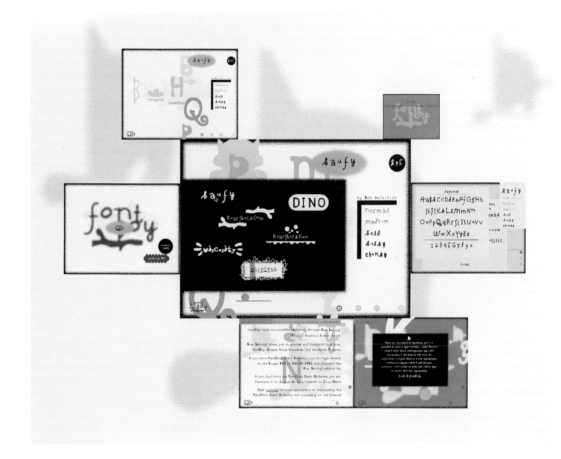

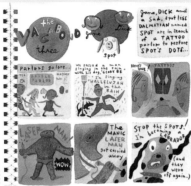

BROCHURES

DESIGN
robert valentine
and jin chung
new york, new york

LETTERING
jessie hartland

ILLUSTRATION
jessie hartland

STUDIO
the valentine group

CLIENT
gilbert paper
company

PRINCIPAL TYPE
new century
schoolbook and
handlettering

DIMENSIONS
7 ¼ x 7 in.
(18.4 x 17.8 cm)

LOGOTYPE

DESIGN
neil powell
new york, new york

LETTERING
neil powell

STUDIO
duffy design
new york

CLIENT
i village

PRINCIPAL TYPE
bodoni bold, cut-
out type, and
handlettering

PROMOTION

DESIGN
steve tolleson and
jennifer sterling
san francisco, california

ILLUSTRATION
david golden

STUDIO
tolleson design

CLIENT
fox river paper
company

PRINCIPAL TYPE
democratica, orator,
minion, and
garamond no. 3

DIMENSIONS
11 x 17 in.
(27.9 x 43.2 cm)

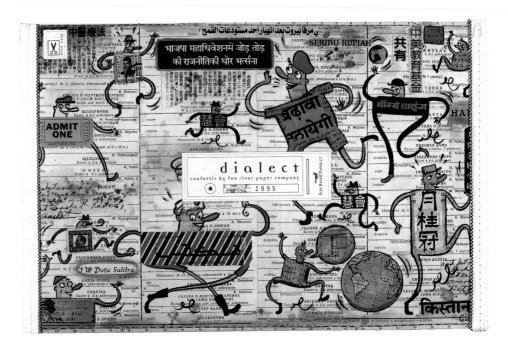

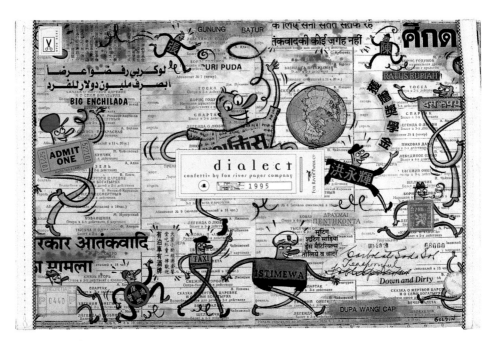

DESIGN
bob dinetz
san francisco, california

ART DIRECTION
bill cahan

STUDIO
cahan & associates

CLIENT
rational software
corporation

PRINCIPAL TYPE
caslon

DIMENSIONS
8 1/4 x 11 3/4 in.
(21 x 29.8 cm)

101

42 nd
47 th

MAGAZINE

DESIGN
 arthur eisenberg,
 tiffany taylor,
 bruce wynne-jones,
 jason barnes, susan
 birkenmayer, larry
 white, lauren
 dirusso, liz
 bulloch, cortland
 langworthy iv, and
 sonya yencer
 dallas, texas

STUDIO
 eisenberg and
 associates

CLIENT
 dallas society
 of visual
 communications

PRINCIPAL TYPE
 various

DIMENSIONS
 17 x 17 in.
 (43.2 x 43.2 cm)

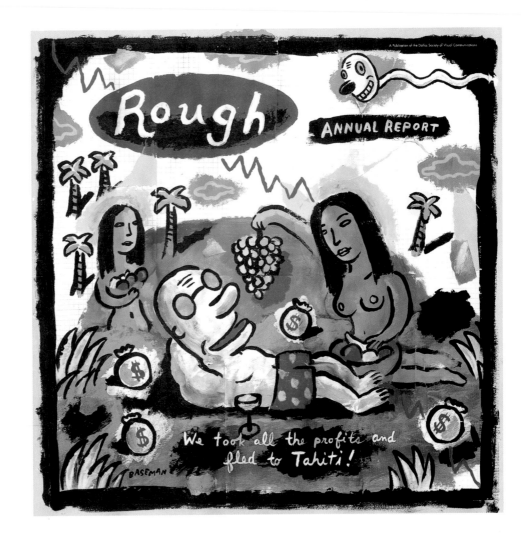

DESIGN
craig clark
san francisco, california

ART DIRECTION
bill cahan

STUDIO
cahan & associates

CLIENT
adaptec, inc.

PRINCIPAL TYPE
bembo, futura, and
zapf dingbats

DIMENSIONS
8 x 11¾ in.
(20.3 x 29.8 cm)

Company Profile. **Adaptec, Inc. designs, manufactures and markets a comprehensive family of hardware and software solutions, collectively called IOware products, which eliminate performance bottlenecks between computers, peripherals and networks.** Solutions range from simple connectivity products for single-user and small-office desktops, to intelligent subsystem, high-performance SCSI, RAID and ATM products for enterprise-wide computing and networked environments.

99

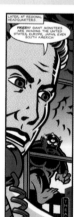
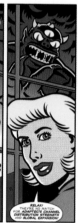

DESIGN
 jill giles and
 barbara schelling
 san antonio, texas

ILLUSTRATION
 michelle wilby
 friesenhahn

STUDIO
 giles design inc.

CLIENT
 h-e-b grocery
 company

PRINCIPAL TYPE
 ocr-b and candida

DIMENSIONS
 8 ¼ x 12 in.
 (21 x 30.5 cm)

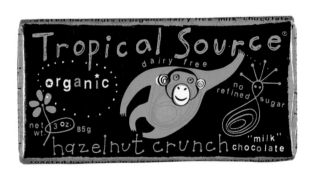

PACKAGING

DESIGN
 haley johnson
 minneapolis, minnesota

STUDIO
 haley johnson
 design company

CLIENT
 cloud nine inc.

PRINCIPAL TYPE
 helvetica

DIMENSIONS
 3 x 6 in.
 (7.6 x 15.2 cm)

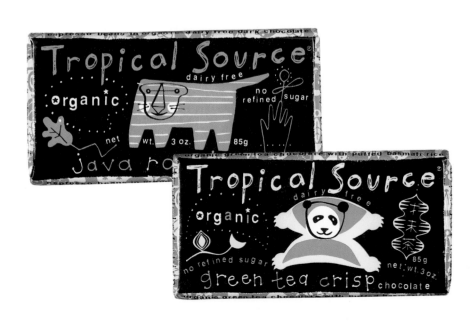

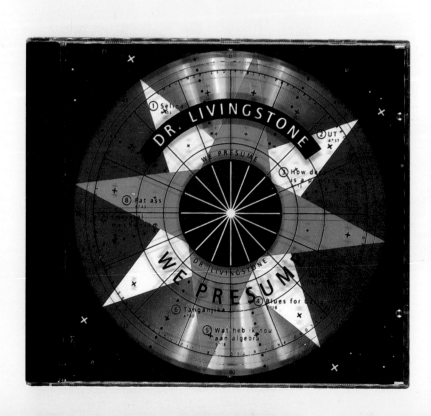

POSTER

DESIGN
michael rylander
san francisco, california

COPYWRITING
tom witt

AGENCY
witt/rylander
advertising

CLIENT
the new pickle
circus

PRINCIPAL TYPE
poplar, mesquite,
juniper, blackoak,
birch, and roycroft

DIMENSIONS
16 x 25 in.
(40.6 x 63.5 cm)

COMPACT DISC

DESIGN
huber jaspers
amsterdam, the netherlands

CREATIVE DIRECTION
doc visser

STUDIO
visser/poortman
design

CLIENT
dr. livingstone

PRINCIPAL TYPE
quay sans

DIMENSIONS
5 1/2 x 5 in.
(14 x 12.7 cm)

DESIGN
dara schminke
baltimore, maryland

STUDIO
envision

CLIENT
script magazine

PRINCIPAL TYPE
adobe garamond and
frutiger

DIMENSIONS
various

scr(i)pt

YES! I want the screenwriting industry delivered to my door!

○ Enclosed is my check payable to *script* ○ Visa ○ Mastercard

card # expiration date

signature

○ Please check here if you have a change of address and print the address on the reverse side

STATIONERY

DESIGN
laurie demartino
minneapolis, minnesota

LETTERING
laurie demartino

STUDIO
studio d design

CLIENT
jackie buck

PRINCIPAL TYPE
courier bold and
handlettering

DIMENSIONS
7 ¼ x 10 ½ in.
(18.4 x 26.7 cm)

915 Spring Garden Street Studio № 306
Third Floor Philadelphia Pa 19123

Buck

Illustrator │ Phone № 215 235 3440

Illustrator

Jackie Buck
915 Spring
Garden Street
Studio № 306
Third Floor
Philadelphia
Pa 19123

DESIGN
susan carlson
chicago, illinois

STUDIO
liska and
associates

CLIENT
heltzer inc.

PRINCIPAL TYPE
news gothic

DIMENSIONS
8 1/2 x 11 in.
(21.6 x 27.9 cm)

4853 NORTH RAVENSWOOD AVENUE
CHICAGO ILLINOIS 60640 4409
TEL 312 561 5612 FAX 312 561 5564

HELTZER incorporated

HELTZER INCORPORATED
4853 NORTH RAVENSWOOD AVENUE
CHICAGO ILLINOIS 60640 4409

93

DESIGN
haley johnson
minneapolis, minnesota

STUDIO
haley johnson
design company

CLIENT
paul irmiter, smart
photos llc

PRINCIPAL TYPE
franklin gothic
book, adobe
garamond semi bold
type 1, courier,
and bodoni

DIMENSIONS
8 ½ x 11 in.
(21.6 x 27.9 cm)

eek!

arol Wahler
TYPE DIRECTORS CLUB
60 East 42nd St., #721
New York
NY 10165

Ph.D

1524a cloverfield boule... **santa** monica ca 90404

DESIGN
clive piercy and
michael hodgson
santa monica, california

LETTERING
clive piercy and
michael hodgson

STUDIO
ph.d

PRINCIPAL TYPE
meta and
handlettering

DIMENSIONS
10 x 10 in.
(25.4 x 25.4 cm)

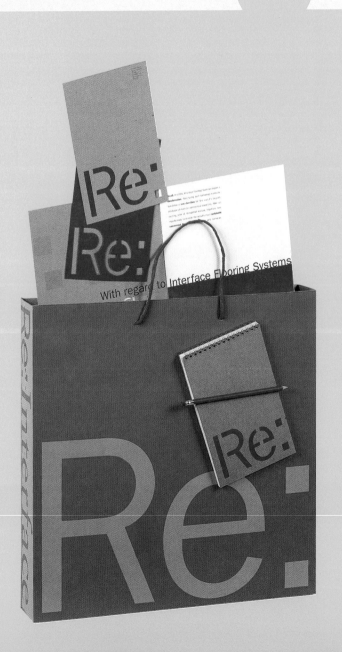

Re:
Re:

With regard to Interface Flooring Systems

Re:Interface

Re:

Re:

91
42"
17"

DESIGN
design!
dalton, georgia

ILLUSTRATION
randy commander
chattanooga, tennessee

CLIENT
interface flooring
systems

PRINCIPAL TYPE
franklin gothic

DIMENSIONS
various

BOOK

DESIGN
nan goggin and
karen cole
champaign, illinois, and
wanganui, new zealand

TYPE COMPOSITOR
joe elliot

PRESSMAN
corky nightlinger

WRITER
karen cole

STUDIO
office of
printing services
of the university
of illinois at
urbana-champaign

PRINCIPAL TYPE
futura, futura
bold, typewriter,
and typewriter
underline

DIMENSIONS
10 x 9 in.
(25.4 x 22.9 cm)

PROMOTION

DESIGN
guido heffels and
thomas walmrath
hamburg, germany

COPYWRITING
jim aitchison, fred
baader, rainer
baginski, e.
bardoul, matthias
berg, karel beyen,
thilo von büren,
veronika claßen,
brigitte fussnegger,
ola gatby, carsten
heintzsch, erik
heitmann, christoph
herold, guido
heffels, gepa
hinrichsen, judith
homoki, konstantin
jacoby, linus
karlsson, detmar
karpinski, andré
kemper, hartwig
keuntje, werner
knopf, uwe loesch,
bob moore, carlos
obers, olaf oldigs,
michael prieve,
thomas rempen,
wolfgang sasse,
michael schirner,
marcello serpa,
reinhard siemes,
and michael weigert

AGENCY
springer & jacoby
werbung gmbh

CLIENT
appel grafik gmbh

PRINCIPAL TYPE
at rotis semi sans
and serif

DIMENSIONS
5 5/8 x 8 1/16 in.
(14.4 x 20.5 cm)

PROMOTION

DESIGN
rüdiger götz and
johannes plass
hamburg, germany

STUDIO
factor design

PRINCIPAL TYPE
monospaced 821

DIMENSIONS
5 13/16 x 8 1/4 in.
(14.8 x 21 cm)

42"
17"

STATIONERY

DESIGN
koeweiden and
postma
amsterdam, the netherlands

STUDIO
koeweiden postma
associates

CLIENT
jaap stahlie

PRINCIPAL TYPE
push-tong (adapted)

DIMENSIONS
8 1/4 x 11 1/4 in.
(21 x 29.2 cm)

DESIGN
 jeffery fey
 hollywood, california

LETTERING
 hatch show print
 nashville, tennessee

STUDIO
 capitol records art
 department

PRINCIPAL TYPE
 ariston, engravers
 roman, and times
 roman

DIMENSIONS
 5 1/2 x 5 in.
 (14 x 12.7 cm)

PONY BONEPONY
BONEPONY
Y BONEPONY BON
NY BONEPONY BONE PO
LIVE FROM THE SOUTHERN BELT
DOUGLAS CORNER CAFE, 11/94

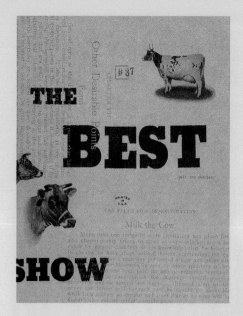

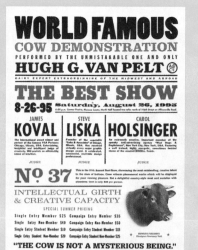

BROCHURE

DESIGN
eric kass
fishers, indiana

AGENCY
miller brooks, inc.

STUDIO
eric kass design

CLIENT
art directors club
of indiana

PRINCIPAL TYPE
clarendon and news
gothic

DIMENSIONS
11 x 17 in.
(27.9 x 43.2 cm)

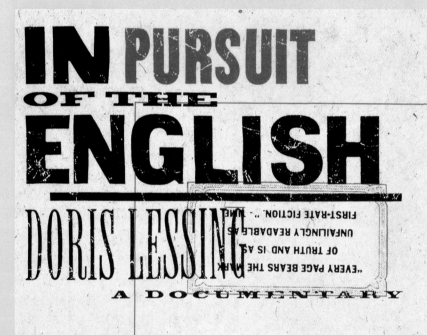

87
42ᵃᵃ
17ᵃᵃ

BOOK COVER

DESIGN
carin goldberg
new york, new york

STUDIO
carin goldberg
design

CLIENT
harpercollins
publishers

PRINCIPAL TYPE
paula wood, morgan
gothic, willow, and
blackoak

DIMENSIONS
5¼ x 8 in.
(13.3 x 20.3 cm)

DESIGN
steven baillie
new york, new york

ILLUSTRATION
kevin sykes

STUDIO
mtv: off-air
creative

CLIENT
mtv: music
television

PRINCIPAL TYPE
various

DIMENSIONS
8 ³/₄ x 6 ³/₄ in.
(22.2 x 17.1 cm)

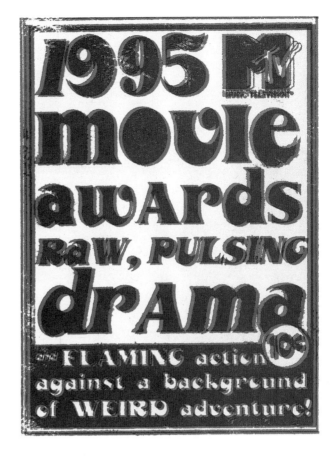

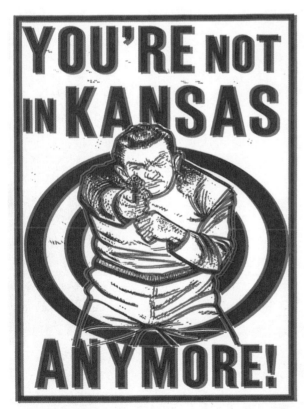

FLYER

DESIGN
george estrada
seattle, washington

LETTERING
george estrada

STUDIO
modern dog

CLIENT
tasty shows

PRINCIPAL TYPE
akzidenz, clarendon,
and handlettering

DIMENSIONS
11 x 17 in.
(27.9 x 43.2 cm)

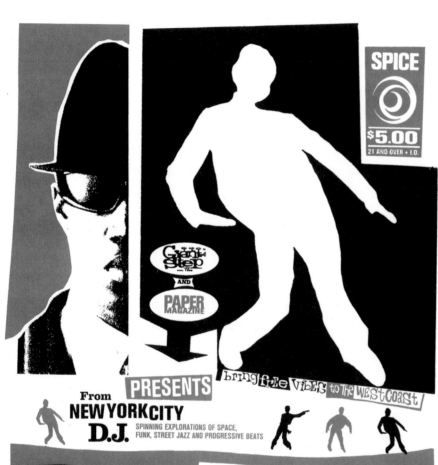

85

POSTER

DESIGN
michele melandri,
morgan thomas, and
stanley hainsworth
beaverton, oregon

STUDIO
nike, inc.

PRINCIPAL TYPE
franklin gothic
condensed and extra
condensed, and
univers extra black
extended oblique

DIMENSIONS
23 x 35 in.
(58.4 x 88.9 cm)

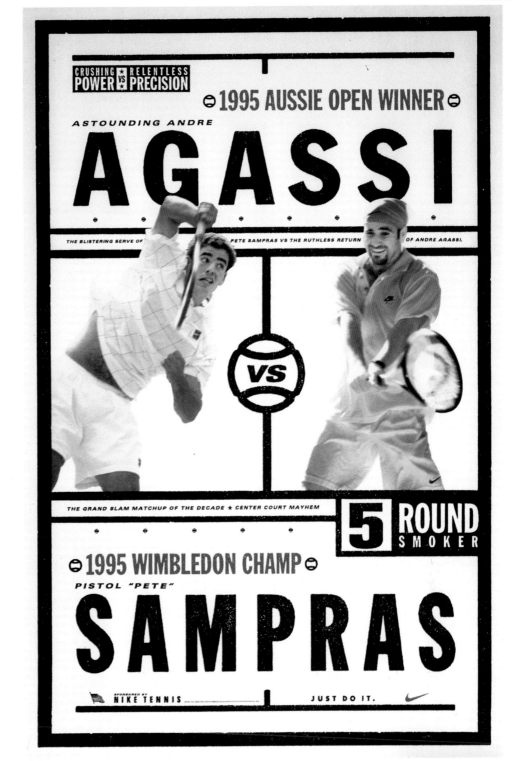

BROCHURE

DESIGN
 paula scher and
 lisa mazur
 new york, new york

PHOTOGRAPHY
 carol rosegg

STUDIO
 pentagram design

CLIENT
 the public theater

PRINCIPAL TYPE
 various sans serif
 american wood type
 styles

DIMENSIONS
 8 x 5¼ in.
 (20.3 x 13.3 cm)

83
17" / 42""

POSTER

DESIGN
 paula scher and
 lisa mazur
 new york, new york

STUDIO
 pentagram design

CLIENT
 the new york
 shakespeare festival

PRINCIPAL TYPE
 various sans serif
 american wood type
 styles

DIMENSIONS
 42 x 85 in.
 (106.6 x 215.9 cm)

POSTER/
ADVERTISEMENTS

DESIGN
paula scher and
lisa mazur
new york, new york

PHOTOGRAPHY
carol rosegg

STUDIO
pentagram design

CLIENT
the public theater

PRINCIPAL TYPE
various sans serif
american wood type
styles

DIMENSIONS
various

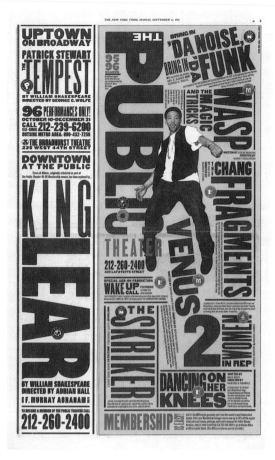

POSTER

DESIGN
paula scher and
lisa mazur
new york, new york

PHOTOGRAPHY
peter harrison

STUDIO
pentagram design

CLIENT
the public theater

PRINCIPAL TYPE
various sans serif
american wood type
styles

DIMENSIONS
30 x 45 in.
(76.2 x 114.3 cm)

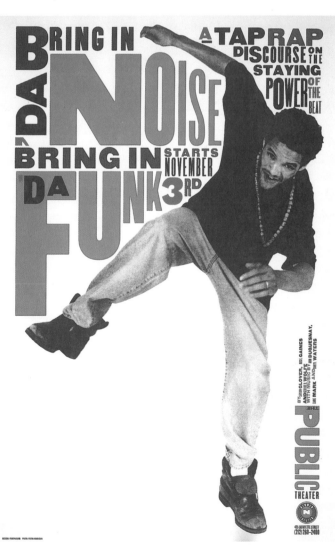

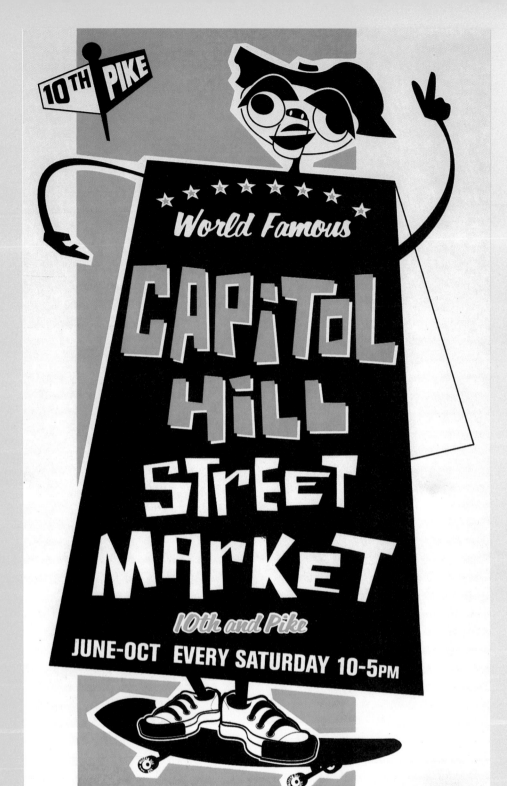

POSTER

DESIGN
george estrada
seattle, washington

LETTERING
george estrada

STUDIO
modern dog

CLIENT
capitol hill street
market association

PRINCIPAL TYPE
marker script,
akzidenz, and
handlettering

DIMENSIONS
16½ x 26 in.
(41.9 x 66 cm)

81

MAGAZINE

DESIGN
susan conley
new york, new york

CALLIGRAPHY
david coulson
pittsburgh, pennsylvania

DESIGN DIRECTION
robert newman

PHOTOGRAPHY
chris buck
new york, new york

STUDIO
entertainment weekly

PRINCIPAL TYPE
handlettering

DIMENSIONS
8 1/2 x 11 in.
(21.6 x 27.9 cm)

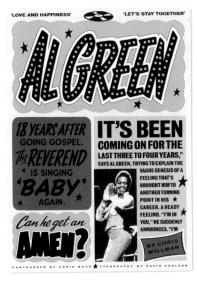

POSTERS

DESIGN
howard brown and
mike calkins
philadelphia, pennsylvania

STUDIO
urban outfitters

PRINCIPAL TYPE
univers, futura,
beton, block,
franklin gothic,
and polar

DIMENSIONS
12 x 19 in.
(30.5 x 48.3 cm)

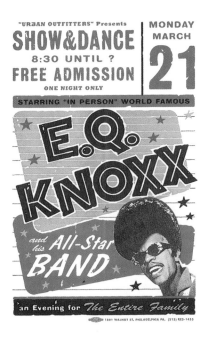

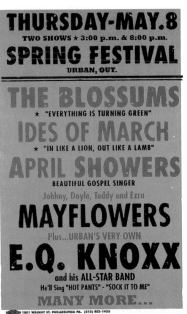

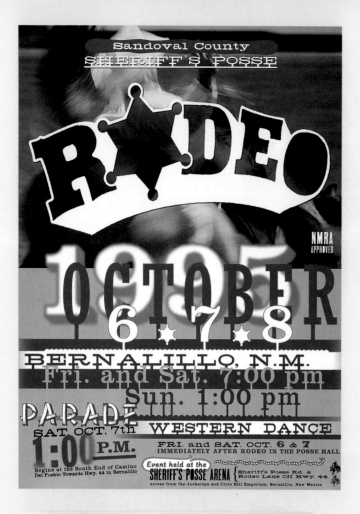

POSTER

DESIGN
greg lindy
los angeles, california

STUDIO
rey international

CLIENT
sandoval county
sheriff's posse

PRINCIPAL TYPE
rockwell, clarendon,
and hellenic

DIMENSIONS
14 x 19 in.
(35.6 x 48.3 cm)

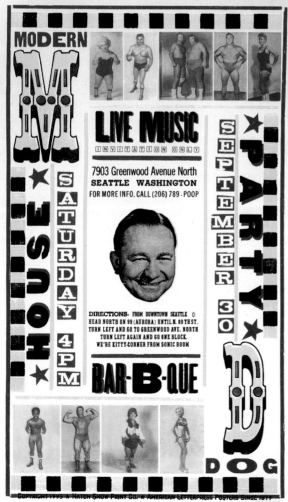

POSTER

DESIGN
kevin bradley
nashville, tennessee

LETTERING
kevin bradley

ART DIRECTION
michael strassburger
and robynne raye

STUDIO
modern dog

PRINCIPAL TYPE
wood block

DIMENSIONS
13 3/4 x 22 1/2 in.
(34.9 x 57.2 cm)

POSTER

DESIGN
greg lindy
los angeles, california

STUDIO
rey international

CLIENT
klon

PRINCIPAL TYPE
futura and wood
gothic

DIMENSIONS
11 x 19¼ in.
(27.9 x 48.9 cm)

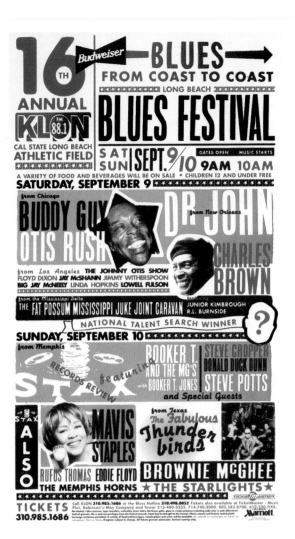

BROCHURE

DESIGN
greg lindy
los angeles, california

STUDIO
rey international

CLIENT
klon

PRINCIPAL TYPE
futura and wood
gothic

DIMENSIONS
23¾ x 11 in.
(60.3 x 27.9 cm)

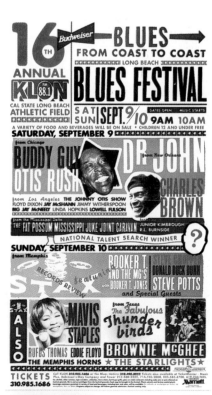

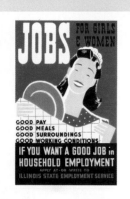

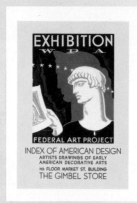

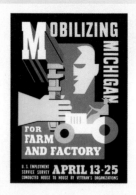

BOXED NOTECARDS

DESIGN
don sibley and
donna aldridge
dallas, texas

STUDIO
sibley/peteet design

CLIENT
weyerhaeuser paper
company

PRINCIPAL TYPE
futura and headline

DIMENSIONS
5 ½ x 7 ½ in.
(14 x 19.1 cm)

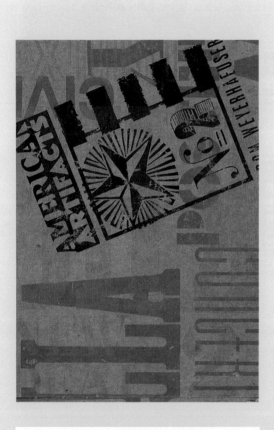

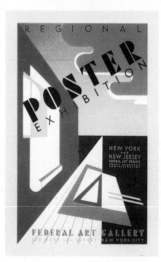

77

42

17

POSTER

DESIGN
coby schultz
seattle, washington

LETTERING
coby schultz

STUDIO
modern dog

CLIENT
american institute
of graphic arts,
portland chapter

PRINCIPAL TYPE
brush script,
headline, fleece,
clarendon, and
handlettering

DIMENSIONS
11½ x 30½ in.
(29.2 x 77.5 cm)

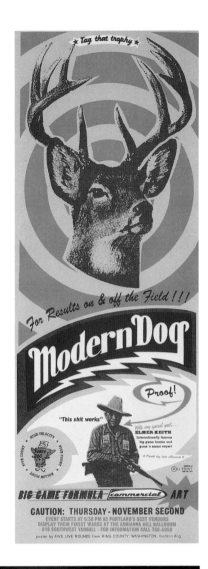

POSTER

DESIGN
don miller
union city, new jersey

WRITER
kevin mckeon

AGENCY
after midnight
advertising/usa

CLIENT
dixie brewing

PRINCIPAL TYPE
opti york script,
ff blur, and
handlettering

DIMENSIONS
19 x 27 in.
(48.3 x 68.6 cm)

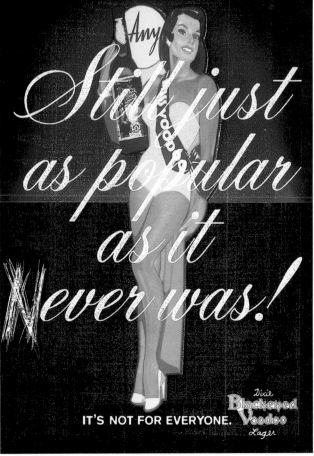

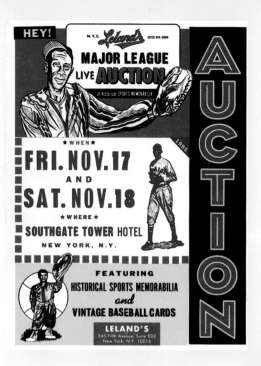

CATALOG

DESIGN
greg simpson and
eric baker
new york, new york

STUDIO
eric baker design
associates, inc.

CLIENT
leland's

PRINCIPAL TYPE
morgan gothic,
alternate gothic
no. 1, franklin
gothic, gothic 13,
grotesque, and
handlettering

DIMENSIONS
8 ¹/₂ x 11 in.
(21.6 x 27.9 cm)

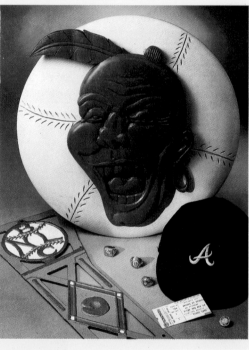

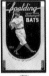
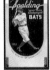

75

17 ¹ⁿ / 42 ⁿⁿ

POSTERS

DESIGN
howard brown and
mike calkins
philadelphia, pennsylvania

ILLUSTRATION
mike calkins

ART DIRECTION
howard brown

STUDIO
urban outfitters

PRINCIPAL TYPE
adastra royal,
trade gothic
condensed, and
futura condensed

DIMENSIONS
24 x 38 in.
(61 x 96.5 cm)

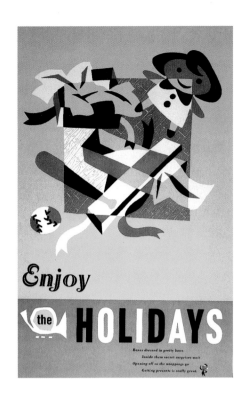

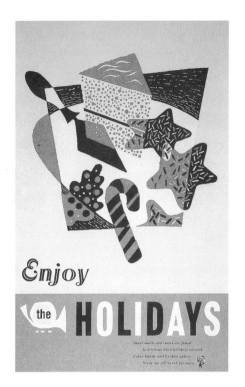

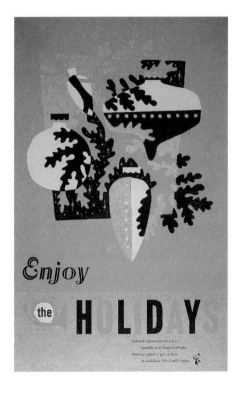

YES, it's
BEATNIK BOB

"POET"

"HIPSTER"

"ARTISTE"

"PIRATE"

It's FUN
for
BEATS

HE'S A "NON-CONFORMIST"

and FUN
for
SQUARES

DRAW WHISKERS, HAIR
AND SIDEBURNS
WITH THIS MAGIC WAND

Beat Culture and
the New America

FOR AGES 5 thru ADULT
SEE BACK OF CARD FOR COMPLETE INSTRUCTIONS

©
MCMXCV

PACKAGING

DESIGN
 scott stowell
 brooklyn, new york

LETTERING
 scott stowell

STUDIO
 scott stowell:
 design

CLIENT
 whitney museum of
 american art

PRINCIPAL TYPE
 metro, tempo heavy
 condensed, trade
 gothic, and
 handlettering

DIMENSIONS
 7 x 8¾ x ¼in.
 (17.8 x 22.2 x .6
 cm)

73
42"
17"

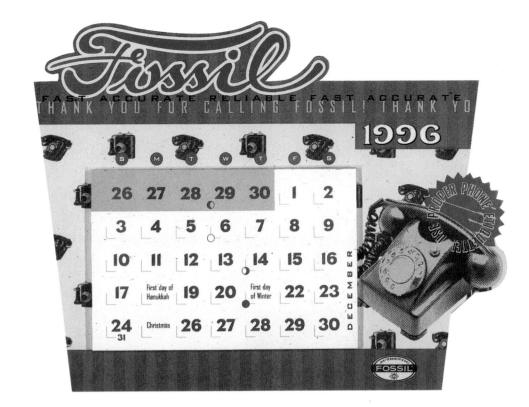

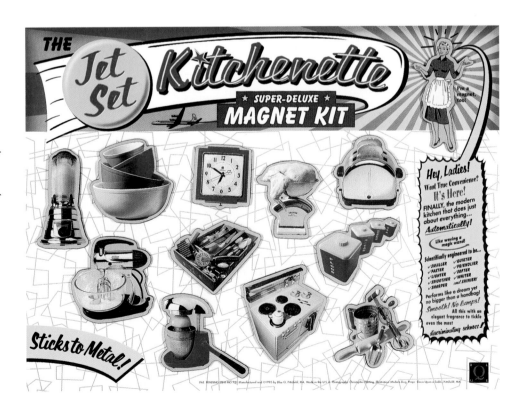

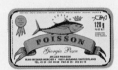

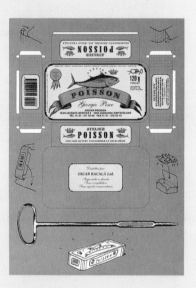

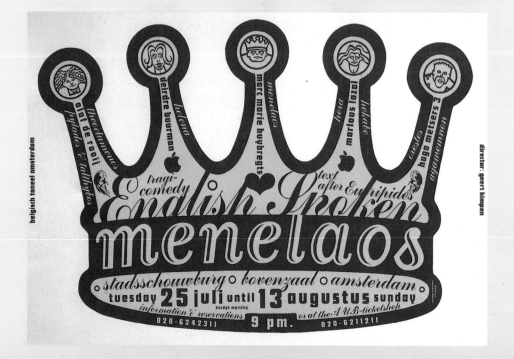

STATIONERY

DESIGN
 giorgio pesce
 lausanne, switzerland

LETTERING
 giorgio pesce

STUDIO
 atelier poisson

PRINCIPAL TYPE
 various

POSTER

DESIGN
 petra janssen and
 edwin vollebergh
 's-hertogenbosch, the
 netherlands

STUDIO
 studio boot

CLIENT
 beta/belgisch toneel
 amsterdam

PRINCIPAL TYPE
 matrix, author, and
 futura

DIMENSIONS
 16½ x 23⅝ in.
 (42 x 60 cm)

DESIGN
andy cruz, allen
mercer, and jeremy
dean
wilmington, delaware

LETTERING
allen mercer

COPYWRITING
rich roat

ILLUSTRATION
allen mercer

STUDIO
brand design/house
industries

CLIENT
custom papers group

PRINCIPAL TYPE
horatio and
handlettering

DIMENSIONS
22 x 34 in.
(55.9 x 86.4 cm)

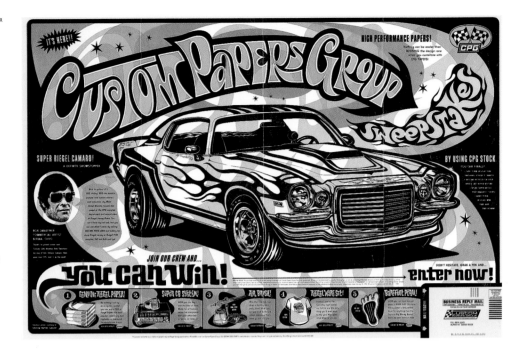

SWATCHBOOKS

DESIGN
andy cruz, allen
mercer, and rich
roat
wilmington, delaware

LETTERING
allen mercer

ILLUSTRATION
allen mercer

STUDIO
brand design/house
industries

CLIENT
custom papers group

PRINCIPAL TYPE
various

DIMENSIONS
8 3/4 x 5 3/4 in.
(22.2 x 14.6 cm)

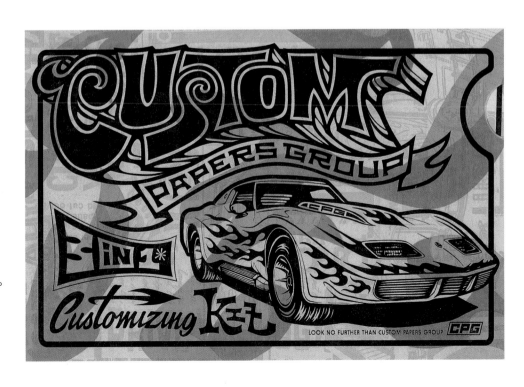

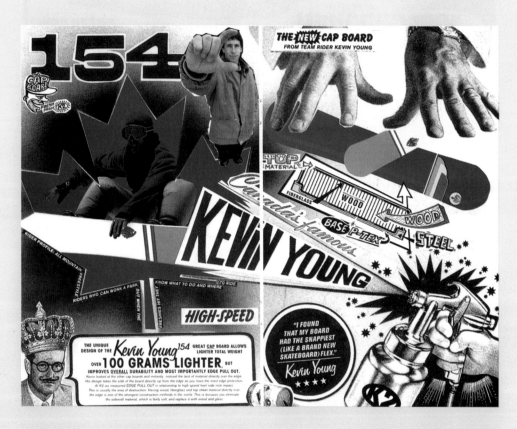

DESIGN
michael
strassburger,
robynne raye,
vittorio costarella,
and george estrada
seattle, washington

STUDIO
modern dog

CLIENT
k2 snowboards

PRINCIPAL TYPE
akzindenz, bauhaus,
american typewriter,
peignot, balloon,
free hand, cooper
black, and
handlettering

DIMENSIONS
5 3/8 x 8 3/8 in.
(13.6 x 21.1 cm)

DESIGN
jens gehlhaar
valencia, california

STUDIO
gaga design
bad ems, germany

PRINCIPAL TYPE
cornwall, copycat,
and capricorn

DIMENSIONS
5 5/16 x 4 in.
(14.8 x 10.5 cm)

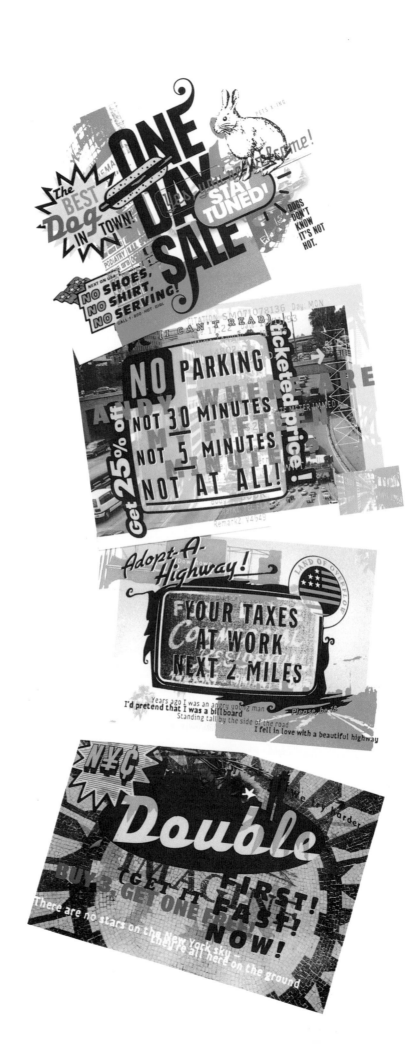

DESIGN
petra janssen and
edwin vollebergh
's-hertogenbosch, the
netherlands

STUDIO
studio boot

PRINCIPAL TYPE
letter gothic and
folio

DIMENSIONS
8¼ x 11¼ in.
(21 x 29.2 cm)

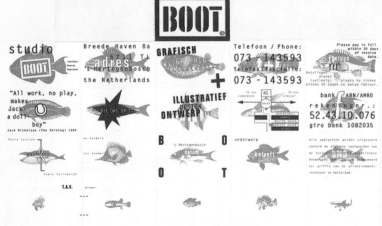

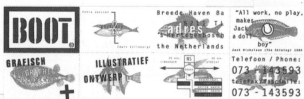

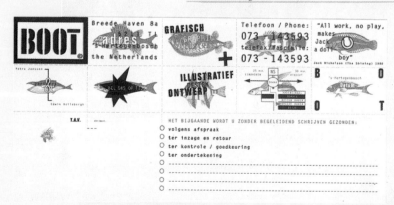

POSTER

DESIGN
mark fox
san rafael, california

STUDIO
blackdog

PRINCIPAL TYPE
futura

DIMENSIONS
24 x 24 in.
(61 x 61 cm)

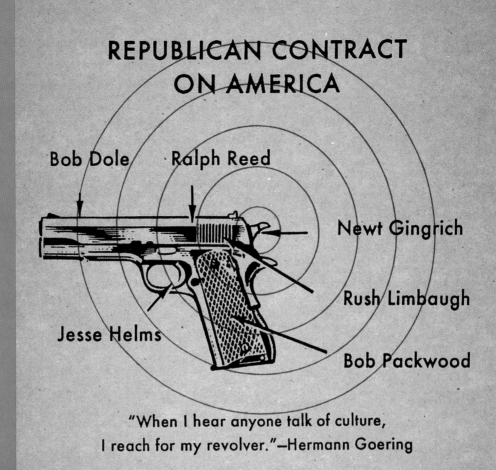

PACKAGING

DESIGN
 deborah norcross
 burbank, california

PHOTOGRAPHY
 chris bierne

CLIENT
 reprise records

PRINCIPAL TYPE
 futura and folio

DIMENSIONS
 5½ x 5 in.
 (14 x 12.7cm)

PACKAGING

DESIGN
 jack anderson and
 david bates
 seattle, washington

STUDIO
 hornall anderson
 design works, inc.

CLIENT
 smith sport optics,
 inc.

PRINCIPAL TYPE
 square slab 711 and
 futura bold
 condensed

DESIGN
mike calkins
philadelphia, pennsylvania

ART DIRECTION
howard brown

STUDIO
urban outfitters

PRINCIPAL TYPE
news gothic

DIMENSIONS
8 x 4¼ in.
(20.3 x 10.8 cm)

STATIONERY

DESIGN
christopher hadden
portland, maine

STUDIO
christopher hadden
design

PRINCIPAL TYPE
simoncini garamond
and helvetica 95
black

DIMENSIONS
8 1/2 x 11 in.
(21.6 x 27.9 cm)

63

17"" / 42""

STATIONERY

DESIGN
john sayles
des moines, iowa

LETTERING
john sayles

STUDIO
sayles graphic
design

CLIENT
the finishing touch

PRINCIPAL TYPE
handlettering

DIMENSIONS
8 1/2 x 11 in.
(21.6 x 27.9 cm)

DESIGN
 maria grillo and
 tim bruce
 chicago, illinois

STUDIO
 the grillo group,
 inc.

CLIENT
 florian architects

PRINCIPAL TYPE
 cooper modern

DIMENSIONS
 8 ½ x 11 in.
 (21.6 x 27.9 cm)

BUILDINGS INTERIORS STORES EXHIBITS PRODUCTS PLANNING
FLORIAN ARCHITECTS
432 NORTH CLARK STREET SUITE 200 CHICAGO ILLINOIS 60610
TELEPHONE 312 670 2220 FACSIMILE 2221

TRANSMITTAL

SERGIO GUARDIA

BUILDINGS INTERIORS STORES EXHIBITS PRODUCTS PLANNING
FLORIAN ARCHITECTS
432 NORTH CLARK STREET SUITE 200 CHICAGO ILLINOIS 60610
TELEPHONE 312 670 2220 FACSIMILE 2221

TO

FROM
DATE
JOB NAME
JOB NUMBER

WE ARE SENDING YOU ☐ ATTACHED ☐ UNDER SEPARATE COVER VIA _____ THE FOLLOWING ITEMS

☐ SHOP DRAWINGS ☐ SAMPLES ☐ CHANGE ORDER
☐ PRINTS ☐ SPECIFICATIONS
☐ PLANS ☐ COPY OF LETTER

BUILDINGS INTERIORS STORES EXHIBITS PRODUCTS PLANNING
FLORIAN ARCHITECTS
432 NORTH CLARK STREET SUITE 200 CHICAGO ILLINOIS 60610
TELEPHONE 312 670 2220 FACSIMILE 2221

COPIES	DATE	NUMBER	DESCRIPTION

☐ FOR APPROVAL ☐ APPROVED AS NO
☐ FOR YOUR USE ☐ RETURNED FOR
☐ AS REQUESTED ☐ RESUBMIT _____
☐ FOR REVIEW AND COMMENT ☐ SUBMIT _____ C
☐ APPROVED AS SUBMITTED ☐ RETURN _____ C

FLORIAN ARCHITECTS

COMMENTS

COPY TO

IF ENCLOSURES ARE NOT AS NOTED, KINDLY NOTIFY US AT ONC

BUILDINGS INTERIORS STORES EXHIBITS PRODUCTS PLANNING
FLORIAN ARCHITECTS
432 NORTH CLARK STREET SUITE 200 CHICAGO ILLINOIS 60610

REDEFIN-
ING **UTILITY.**
FUSION
from **DOMTAR**

BROCHURE

DESIGN
chad hagen
minneapolis, minnesota

DESIGN DIRECTOR
bill thorburn

COPYWRITER
matt elhardt

STUDIO
thorburn design

CLIENT
domtar paper
company

PRINCIPAL TYPE
trade gothic

DIMENSIONS
9 x 10 in.
(22.9 x 25.4 cm)

Definition #3:

Something or some service that is particularly useful to the public.

Lavender 67 lb. Vellum/Bristol

BOB'S BOLTS
& Cheese Shop
17083 Robyn Avenue North.
Toledo OH 40980-9097

Definition #3(b): Something or some service that is particularly useful to the public
because it comes in a variety of sizes, colors, weights and is available when you need it.

Tan 65 lb. Cover Opaque

BUILDING FORM 576-c

COMPANY _____ PHONE _____

INVOICE# _____

DATE _____

P.O.	Q.NTY.	JOB#	ITEM	COST

CATALOG

DESIGN
michael ian kaye
new york, new york

STUDIO
farrar, straus and
giroux

PRINCIPAL TYPE
old typewriter,
rubber stamps, and
handlettering

DIMENSIONS
7 1/5 x 10 in.
(19.1 x 25.4 cm)

STATIONERY

DESIGN
joel templin
minneapolis, minnesota

STUDIO
charles s. anderson
design company

PRINCIPAL TYPE
twentieth century,
garamond, and
alpine gothic

DIMENSIONS
8 1/2 x 11 in.
(21.6 x 27.9 cm)

DESIGN
tim bruce
chicago, illinois

PHOTOGRAPHY
tony armour

STUDIO
vsa partners

CLIENT
chicago volunteer
legal services

PRINCIPAL TYPE
akzidenz grotesk

DIMENSIONS
8 ½ x 13 in.
(21.6 x 33 cm)

59

STATIONERY

DESIGN
todd piper-hauswirth
minneapolis, minnesota

STUDIO
charles s. anderson
design company

CLIENT
eager photo

PRINCIPAL TYPE
trade gothic

DIMENSIONS
8 ½ x 11 in.
(21.6 x 27.9 cm)

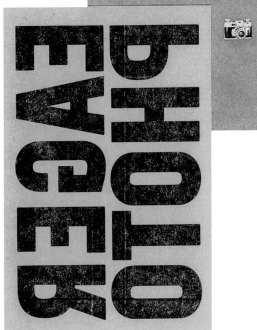

Maddocks & Company 2011 Pontius Avenue, Los Angeles, CA 90025

GREETING CARD

DESIGN
paul farris and
winnie li
los angeles, california

LETTERING
winnie li

STUDIO
maddocks & company

PRINCIPAL TYPE
ocr-b and cut
lettering

DIMENSIONS
18 x 18 x 7 in.
(45.7 x 45.7 x 17.8
cm)

57

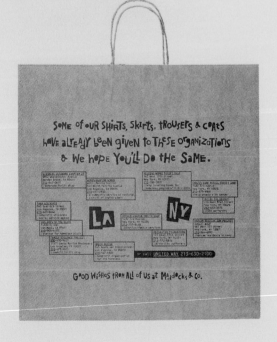

DESIGN
stefan sagmeister
and eric zim
new york, new york

CALLIGRAPHY
eric zim, stefan
sagmeister, and
patrick daily

PHOTOGRAPHY
tom schierlitz

AGENCY
sagmeister inc.

CLIENT
stephan schertler

PRINCIPAL TYPE
alternate gothic
and futura

DIMENSIONS
8 x 7½ in.
(20.3 x 19.1 cm)

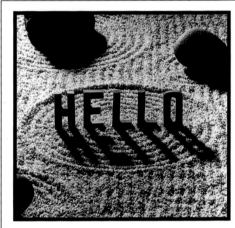

DESIGN
clive piercy
santa monica, california

LETTERING
clive piercy

STUDIO
ph.d

CLIENT
virgin interactive
entertainment

PRINCIPAL TYPE
gill sans and
handlettering

DIMENSIONS
9 x 12 in.
(22.9 x 30.5 cm)

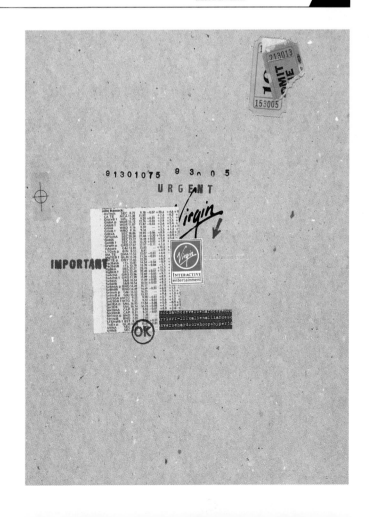

DESIGN
josé serrano
san diego, california

STUDIO
mires design, inc.

PRINCIPAL TYPE
futura, helvetica
neue, and franklin
gothic

DIMENSIONS
7 x 7 in.
(17.8 x 17.8 cm)

MIRES DESIGN INC.
PACKAGING CERTIFICATE
THIS
DESIGN STUDIO
MEETS ALL CREATIVE AND
PRODUCTION REQUIREMENTS OF
APPLICABLE PACKAGING PROJECTS

BURSTING TEST	204	PROJECTS PER QUARTER
MIN COMB EXPERIENCE	93	YEARS IN DESIGN
SIZE LIMIT	NONE	PER PROJECT
GROSS DESIGNS	0	PER YEAR

SAN DIEGO, CA. 619-234-6631

55
17 in. 42 cm

BORDEAUX PRINTERS | CLIENT GIFT & SELF PROMOTION

TO CREATE A MEMORABLE PROMOTION FOR A COMMERCIAL PRINTER, WE
GAVE THIS BOTTLE OF PREMIUM BORDEAUX WINE A UNIQUE INDUSTRIAL
LABEL. THEN WE DESIGNED GIFT WRAP AND HANG-TAGS TO MATCH. THE
RESULT? A FINE WINE THAT'S APPROPRIATE WITH ANY PRINT JOB.

DIRECT MAIL

DESIGN
 alex tylevich and
 bill thorburn
 minneapolis, minnesota

DESIGN DIRECTOR
 bill thorburn

COPYWRITER
 matt elhardt

STUDIO
 thorburn design

CLIENT
 concerts for the
 environment

PRINCIPAL TYPE
 helix (subtopia)
 and justin lefthand

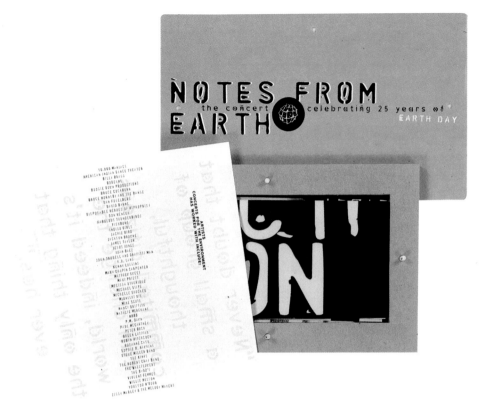

POSTCARDS

DESIGN
 steven guarnaccia
 montclair, new jersey

ILLUSTRATION
 steven guarnaccia

CLIENT
 l'affiche gallery

PRINCIPAL TYPE
 handlettering

DIMENSIONS
 4 x 6 in.
 (10.2 x 15.2 cm)

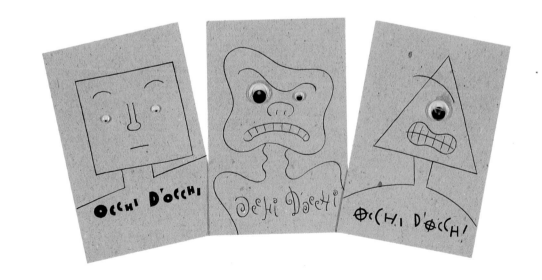

THE SECRETS OF

Business Success

CAN BE *yours!*

WITH

12

INSPIRATIONAL &

MOTIVATIONAL

MESSAGES FOR

1995

Warning: USE ONLY IN WELL VENTILATED AREA – MAY INDUCE NAUSEA.

Concrete

PHONE (416) 534-9960 FACSIMILE (416) 534-2184 MODEM (416) 534-9707

Where slogans are a core business!

CALENDAR

DESIGN
john pylypczak and
diti katona
toronto, canada

ILLUSTRATION
ross macdonald
new york, new york

STUDIO
concrete design
communications inc.

PRINCIPAL TYPE
bembo, bodoni, and
chancery

DIMENSIONS
5 7/8 x 9 1/2 in.
(14.9 x 24.1 cm)

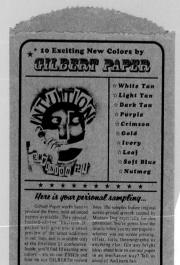

PROMOTION

DESIGN
michael
strassburger,
robynne raye,
vittorio costarella,
and george estrada
seattle, washington

ART DIRECTION
michael strassburger

STUDIO
modern dog

CLIENT
gilbert paper
company

PRINCIPAL TYPE
cooper black,
estro, times,
akzidenz, marker
script, fiedler,
clarendon,
handlettering, and
many others

DIMENSIONS
4 x 6 in.
(10.6 x 15.2 cm)

DESIGN
steven guarnaccia
montclair, new jersey

ILLUSTRATION
steven guarnaccia

CLIENT
l'affiche gallery

PRINCIPAL TYPE
handlettering

DIMENSIONS
6 1/16 x 4 in.
(15.4 x 10.2 cm)

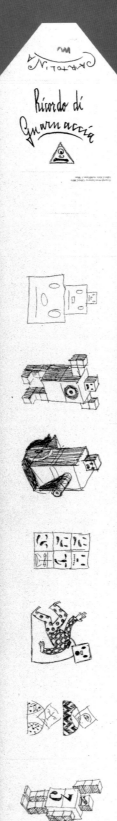
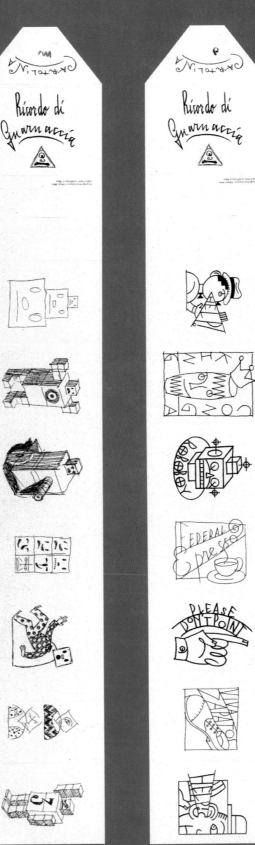
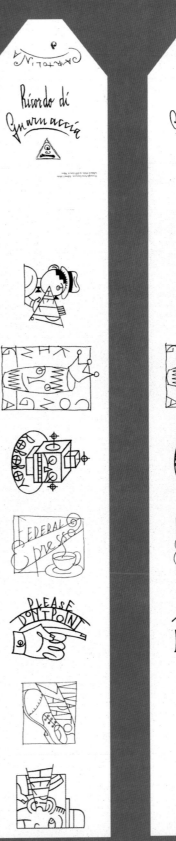

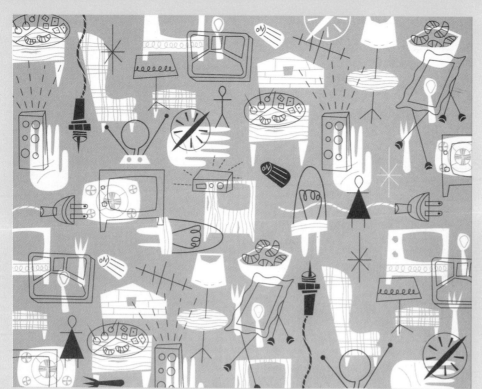

STATIONERY

DESIGN
melinda beck
brooklyn, new york

ILLUSTRATION
melinda beck

STUDIO
melinda beck studio

CLIENT
nick at nite

DIMENSIONS
8 ½ x 11 in.
(21.6 x 27.9 cm)

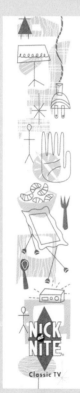

51
42"ND
17"TH

BROCHURE

DESIGN
brent wirth
des moines, iowa

STUDIO
cmf&z

CLIENT
hansen printing
inc.

PRINCIPAL TYPE
courier

DIMENSIONS
10 x 10 in.
(25.4 x 25.4 cm)

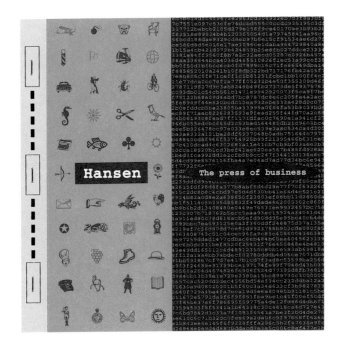

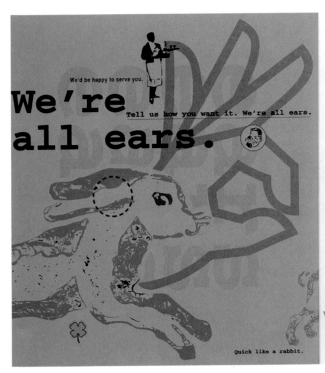

INTERNET SITE

DESIGN
 alan colvin and
 kevin flatt
 minneapolis, minnesota

STUDIO
 duffy design

PRINCIPAL TYPE
 trade gothic and
 letter gothic

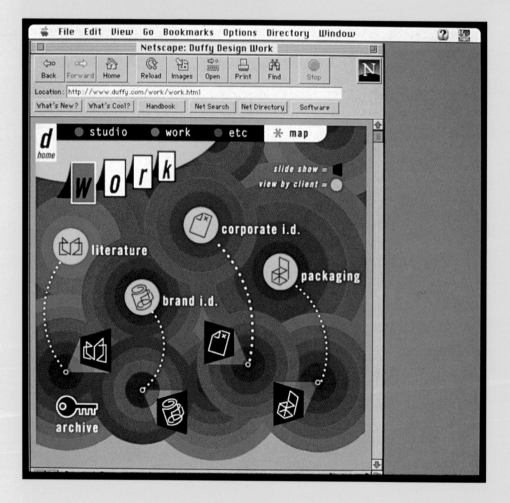

49
42"x67"

DESIGN
alan colvin and
kevin flatt
minneapolis, minnesota

STUDIO
duffy design

PRINCIPAL TYPE
trade gothic and
letter gothic

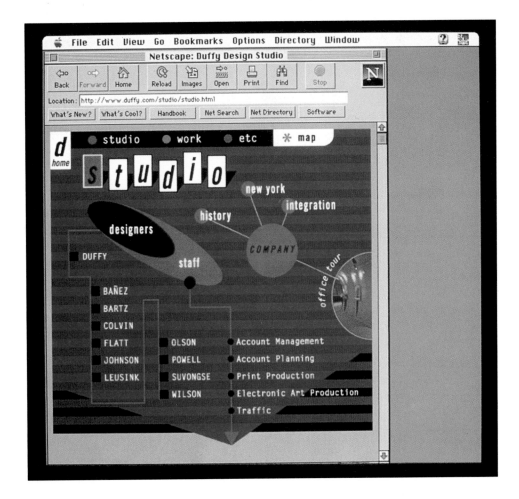

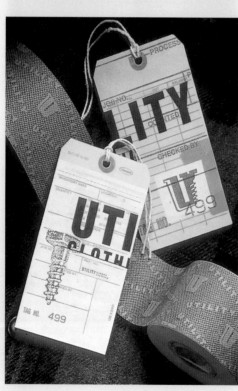

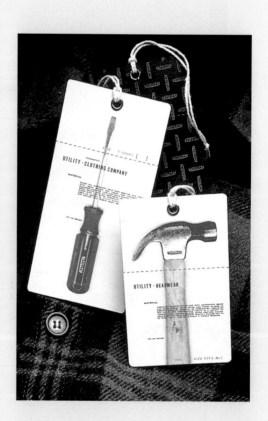

DESIGN
jason schulte, todd
piper-hauswirth, and
joel templin
minneapolis, minnesota

ART DIRECTION
charles s. anderson

STUDIO
charles s. anderson
design company

CLIENT
target

PRINCIPAL TYPE
trade gothic,
gothic 13, memphis,
and opti alternate

CAMPAIGN

DESIGN
howard brown and
mike calkins
philadelphia, pennsylvania

ART DIRECTION
howard brown

STUDIO
urban outfitters

PRINCIPAL TYPE
profil, trade
gothic, and doric
italic

DIMENSIONS
24 x 38 in.
(61 x 96.5 cm)

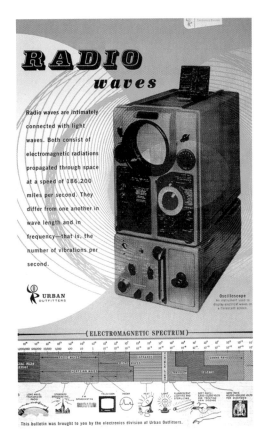

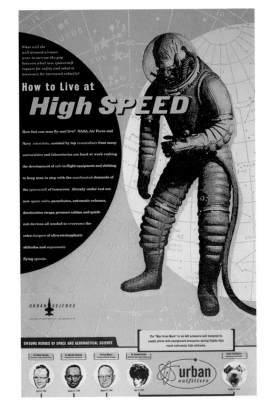

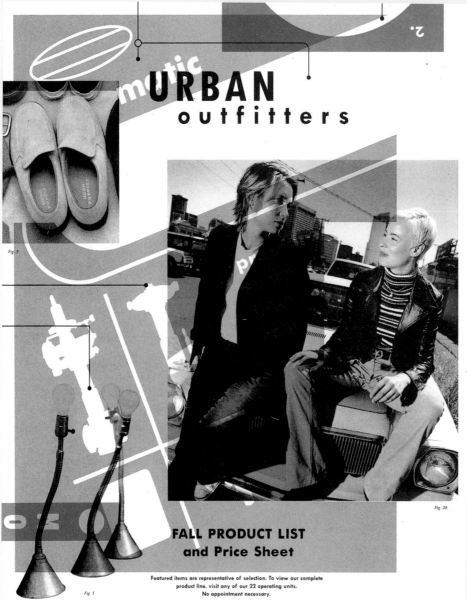

URBAN outfitters

FALL PRODUCT LIST
and Price Sheet

Featured items are representative of selection. To view our complete
product line, visit any of our 22 operating units.
No appointment necessary.

Fig 5

Fig. 28

45

ANNUAL REPORT

DESIGN
 howard brown, mike
 calkins, and
 anthony arnold
 philadelphia, pennsylvania

ART DIRECTION
 howard brown

STUDIO
 urban outfitters

PRINCIPAL TYPE
 clarendon, univers,
 and news gothic

DIMENSIONS
 10 1/2 x 9 1/2 in.
 (26.7 x 24.1 cm)

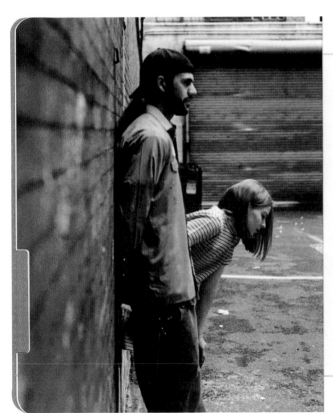

SELECTED FINANCIAL DATA

Fiscal Year Ended January 31.
(In thousands, except share and per share data)

	1991	1992	1993	1994	1995	% Change '95 - '94
Income Statement Data:						
Net sales	$37,426	$43,891	$59,135	$84,486	$110,121	30%
Gross profit	17,895	21,674	30,165	43,989	57,334	30%
Income from operations	3,501	3,971	7,004	13,302	17,576	32%
Net income	$ 1,755	$ 2,296	$ 4,078	$ 7,806	$ 10,817	39%
Net income per common share	$.24	$.30	$.52	$.97	$ 1.23	27%
Weighted average common shares outstanding	7,395,885	7,577,402	7,859,927	8,032,186	8,787,804	9%
Balance Sheet Data:						
Working capital	$ 3,528	$ 5,143	$ 8,744	$28,285	$ 26,872	(5%)
Total assets	11,471	14,720	20,913	43,400	56,766	31%
Total liabilities	5,968	6,527	7,883	7,902	10,015	27%
Long-term debt, excluding current maturities	1,687	755	898	–	–	N/A
Total shareholders' equity	5,503	8,193	13,030	35,498	46,751	32%

5

DESIGN
erik johnson
minneapolis, minnesota

ART DIRECTION
charles s. anderson

STUDIO
charles s. anderson
design company

CLIENT
french paper
company

PRINCIPAL TYPE
trade gothic,
franklin gothic,
and twentieth
century

DIMENSIONS
4 x 3 x 2 in.
(10 x 7.6 x 5.1 cm)

DESIGN
 joel templin and
 charles s. anderson
 minneapolis, minnesota

ART DIRECTION
 charles s. anderson

STUDIO
 charles s. anderson
 design company

CLIENT
 french paper
 company

PRINCIPAL TYPE
 prestige and
 twentieth century

DIMENSIONS
 16 ¹/₂ x 25 in.
 (41.9 x 63.5 cm)

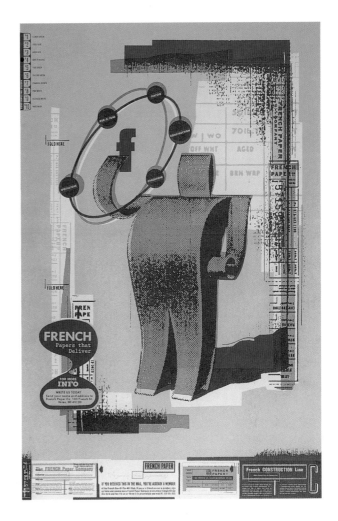

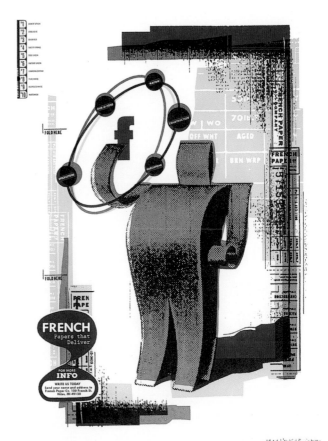

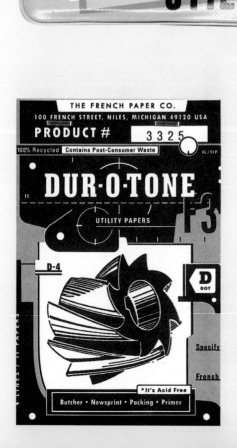

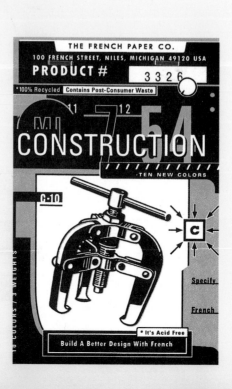

PROMOTION

DESIGN
erik johnson
minneapolis, minnesota

ART DIRECTION
charles s. anderson

STUDIO
charles s. anderson
design company

CLIENT
french paper
company

PRINCIPAL TYPE
gothic 13 and
twentieth century

DIMENSIONS
3¼ x 5¼ in.
(8.3 x 13.3 cm)

41

SWATCHBOOKS

DESIGN
charles s. anderson
and paul howalt
minneapolis, minnesota

STUDIO
charles s. anderson
design company

CLIENT
french paper
company

PRINCIPAL TYPE
stymie, condensed
universe 57, and
twentieth century

BROCHURE

DESIGN
 todd piper-hauswirth
 minneapolis, minnesota

ART DIRECTION
 charles s. anderson
 and todd piper-
 hauswirth

PHOTOGRAPHY
 darrell eager

STUDIO
 charles s. anderson
 design company

CLIENT
 how magazine

PRINCIPAL TYPE
 trade gothic and
 twentieth century

DIMENSIONS
 6 3/4 x 9 in.
 (17.1 x 22.9 cm)

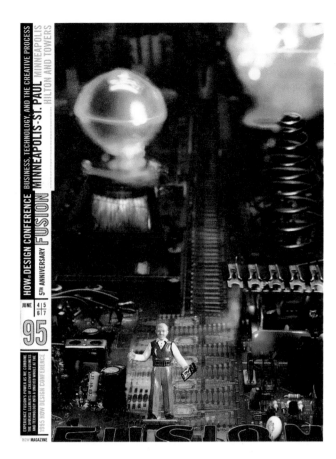

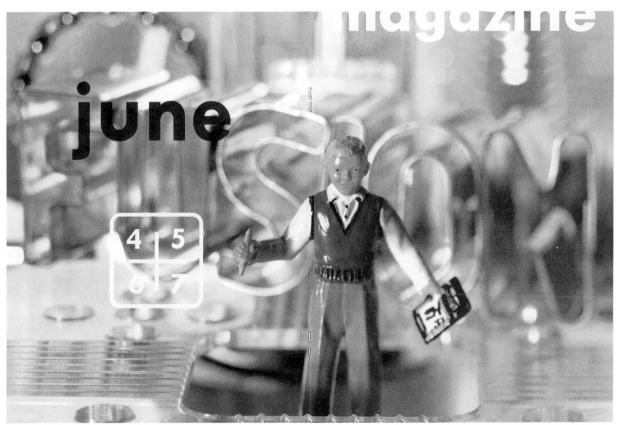

VIDEO

DESIGN
todd piper-hauswirth
and charles s.
anderson
minneapolis, minnesota

ART DIRECTION
todd piper-hauswirth

STUDIO
charles s. anderson
design company

PRINCIPAL TYPE
trade gothic,
twentieth century,
news gothic, opti
alternate, and hobo

39
42"
17"

MULTIMEDIA

DESIGN
 charles s.
 anderson, paul
 howalt, brian
 smith, and tom
 esslinger
 minneapolis, minnesota

STUDIO
 charles s. anderson
 design company

PRINCIPAL TYPE
 twentieth century

PACKAGING

DESIGN
 joel templin
 minneapolis, minnesota

ART DIRECTION
 charles s. anderson

STUDIO
 charles s. anderson
 design company

PRINCIPAL TYPE
 american typewriter,
 prestige elite, and
 alpine gothic

DIMENSIONS
 5 in. (12.7 cm)
 diameter

37
42ND
17

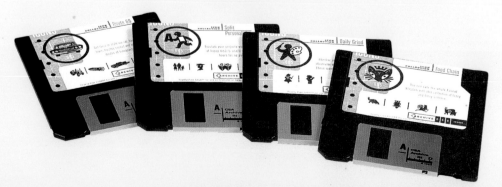

PACKAGING

DESIGN
 joel templin
 minneapolis, minnesota

ART DIRECTION
 charles s. anderson

STUDIO
 charles s. anderson
 design company

PRINCIPAL TYPE
 alpine gothic,
 clarendon, and
 optivenus

DESIGN
 charles s.
 anderson, todd
 piper-hauswirth, and
 joel templin
 minneapolis, minnesota

STUDIO
 charles s. anderson
 design company

PRINCIPAL TYPE
 twentieth century
 and garamond

DIMENSIONS
 5 ¹⁄₂ x 8 ³⁄₄ in.
 (14 x 22.2 cm)

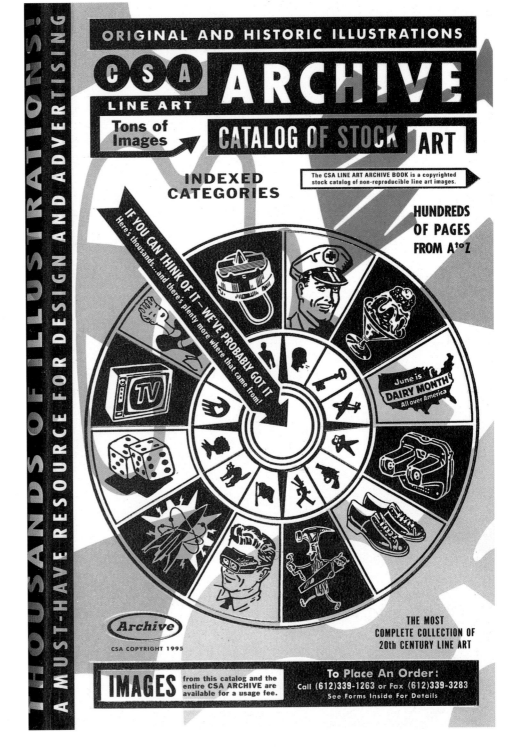

THOUSANDS OF ILLUSTRATIONS!
A MUST-HAVE RESOURCE FOR DESIGN AND ADVERTISING

ORIGINAL AND HISTORIC ILLUSTRATIONS

CSA LINE ART
Tons of Images

ARCHIVE
CATALOG OF STOCK ART

INDEXED CATEGORIES

The CSA LINE ART ARCHIVE BOOK is a copyrighted stock catalog of non-reproducible line art images.

HUNDREDS OF PAGES FROM A to Z

IF YOU CAN THINK OF IT — WE'VE PROBABLY GOT IT
Here's thousands...and there's plenty more where that came from!

June is DAIRY MONTH All over America

Archive
CSA COPYRIGHT 1995

THE MOST COMPLETE COLLECTION OF 20th CENTURY LINE ART

IMAGES from this catalog and the entire CSA ARCHIVE are available for a usage fee.

To Place An Order:
Call (612)339-1263 or Fax (612)339-3283
See Forms Inside For Details

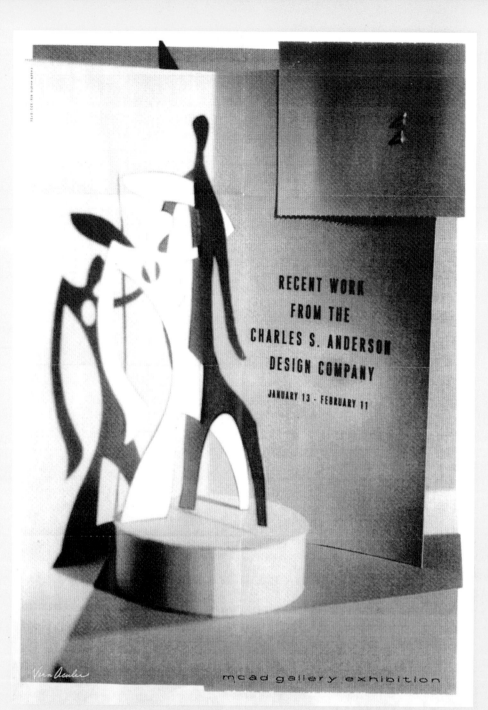

POSTER

DESIGN
 todd piper-hauswirth
 and erik johnson
 minneapolis, minnesota

ILLUSTRATION
 erik johnson

ART DIRECTION
 charles s. anderson

PHOTOGRAPHY
 darrell eager

STUDIO
 charles s. anderson
 design company

CLIENT
 minneapolis college
 of art & design

PRINCIPAL TYPE
 optivenus, vern
 extended, and
 todder stencil

DIMENSIONS
 36 x 52 in.
 (91.4 x 132.1 cm)

35

17" 42"

DESIGN
george gabriel
niles, illinois

INSTRUCTOR
associate professor
philip burton
chicago, illinois

PRINCIPAL TYPE
maze

ABCDEFGHIJKL
MNOPQRSTUVW
XYZ
abcdefghijklm
nopqrstuvwxyz

TYPEFACE

DESIGN
zuzana licko
sacramento, california

STUDIO
emigre

PRINCIPAL TYPE
dogma extra outline

33 / 17" / 42"

ABCDE
FGHIJK
LMNOP
QRSTU
VWXYZ

MARK CROSS
NEW YORK

E

TYPEFACE

DESIGN
frances ullenberg
new york, new york

AGENCY
desgrippes gobé &
associates

CLIENT
mark cross

PRINCIPAL TYPE
mark cross

TYPEFACE

DESIGN
sibylle hagmann
pasadena, california

STUDIO
typo *studious*

PRINCIPAL TYPE
postfound normal

ABCDEFGHIJKL
MNOPQRSTUV
WXYZ
abcdefghijklmn
opqrstuvwxyz

ABCDEFGHIJKLMN
OPQRSTUVWXYZ
abcdefghijklmnopqr
stuvwxyz

TYPEFACE

DESIGN
fabian nicolay
darmstadt, germany

STUDIO
azur design

PRINCIPAL TYPE
moira

[selected for typographic excellence]

ENTRIES

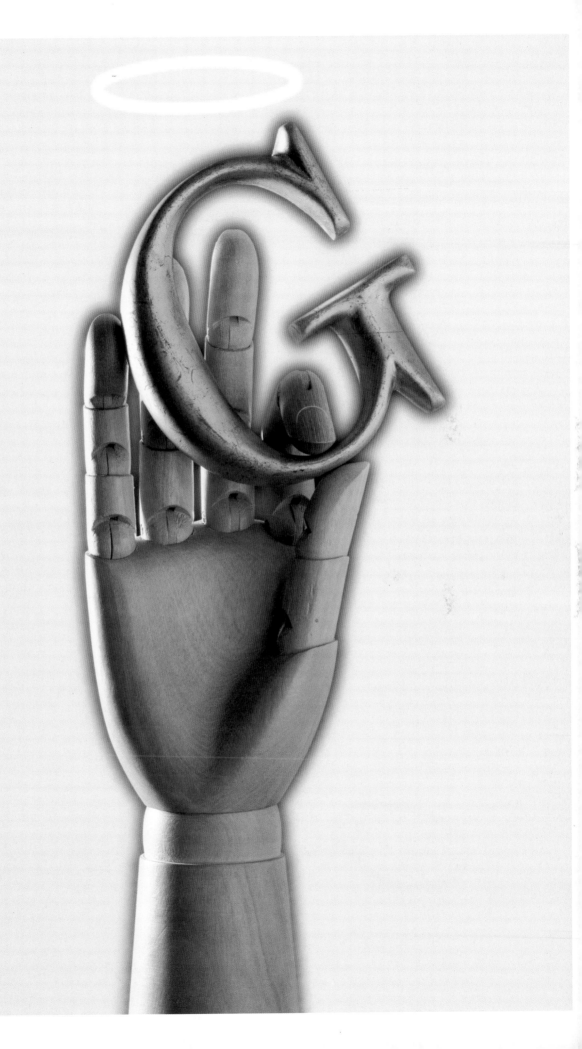

FOR MANY YEARS, THE GOLDEN RULE AT PROGRES-
SIVE HAS BEEN TO RESPECT PEOPLE, VALUE THE
DIFFERENCES AMONG THEM, AND DEAL WITH INDI-
VIDUALS THE WAY WE WOULD LIKE THEM TO DEAL
WITH US. IT IS THIS GOLDEN RULE THAT LED TO
THE THEME OF *DIVERSITY* FOR THE 1994 ANNUAL
REPORT. DIVERSITY (AS DEFINED BY PROGRESSIVE)
IS NOT JUST ABOUT THE RISKS OR EMOTIONAL AND
FINANCIAL COMMITMENTS REQUIRED TO FORGE A
MULTI-EVERYTHING-EVERYBODY WORK FORCE THAT
ATTEMPTS TO MIRROR THE REAL WORLD. DIVERSITY
IS ALSO ABOUT CHANGE AND VALUING DIFFERENCES
IN WAYS THAT ENHANCE AND, IN FACT, ENRICH
THEIR SYSTEMS. FOR PROGRESSIVE, DIVERSITY IS
ABOUT EMBRACING AND NURTURING THE EVER-CHANG-
ING COLLAGE OF ITS PEOPLE, CUSTOMERS, STRATE-
GIES, IDEAS, CULTURE, AND FUTURE. PROGRESSIVE
ASKED THEIR PEOPLE, CUSTOMERS, AND INDEPEN-
DENT AGENTS TO PROVIDE THEIR THOUGHTS ON THIS
THEME. A SELECTION OF THEIR COMMENTS APPEARS
THROUGHOUT THE REPORT.
WE COMMISSIONED ARTIST CARTER KUSTERA TO
RESPOND VISUALLY TO *DIVERSITY*. HE CREATED A
SERIES OF SILHOUETTE DRAWINGS WITH TEXT THAT
IS INFLUENCED BY NUMEROUS TV TALK SHOWS. BY
ISOLATING AND RECOGNIZING THE INDIVIDUAL AND
THE ABSTRACTION CREATED WHEN HUNDREDS OF DIF-
FERENT PERSONALITIES ARE REPRESENTED AS A
WHOLE, HE CONNECTS THE VIEWER AS A PARTICI-
PANT IN THIS COLLAGE OF COLORFUL IDENTITIES.

SHARON WERNER

Throughout the day of judging, I saw an astonishing amount of smart, innovative, and great work. When I first saw the cover of *Bob Is Normal,* the Progressive annual report, my immediate thought was: "Damn, I wish I had done that."

The images are playful and provocative, and the names and personality traits appear so "Normal" that they inspire a variety of emotions: there's laughter (MayMay, who hides candy in her corporate files) and pity (Alfred: the only thing he hates more than his name is his job). I came away with the feeling that Progressive knows its clients and employees, treats them as individuals, and cares about how they serve them.

The piece is thoughtful in its attention to detail on each page. The typography, a beautiful, closely leaded, loosely kerned, multicolored serif face is a nice contrast to the variety of human (not electronic) hand-scrawled type.

The designers Nesnadny, Moehler, and Schwartz and the client Progressive should be congratulated for having the vision and courage to produce an annual report that is not only beautiful and informative but thought-provoking.

I'm sure next year we'll be seeing several pieces that imitate this direction—but it'll be a tough act to follow.

29
17" 42"

Diversity
reminds me
of the art
of pointillism:
perfect
individual dots
up close;
blurred images
from five
paces back;
remarkable
clarity
of each point's
purpose
and
value from the
intended
perspective.

Progressive's
Golden Rule Core Value requires
us to respect all people, value the differ-
ences among them and deal with them in the
way we want to be dealt with. To build on this Core
Value, "Diversity" is the theme of our 1994 Annual
Report. For Progressive, "Diversity" is about changing
in ways that enhance and enrich our systems, and about
embracing and nurturing our changing mosaic of peo-
ple, customers, strategies, culture and environment.
Reactions to this theme from our people, customers
and agents appear as statements throughout this re-
port. Artist Carter Kustera responded to "Diversity"
by creating a large series of silhouette drawings with
text inspired by his interest in daytime TV talk shows,
and is not intended to represent any Progressive
person. Kustera isolates and recognizes the in-
dividual and the abstraction created when
hundreds of different personalities are
represented as a whole, which makes
the viewer a participant in this collage of
colorful identities. Kustera's drawings
will be a part of Progressive's
growing collection of
contemporary art

Adapt to the
changes
in the industry
caused by
competition,
risk,
investments, and
government
rules and
regulations.
Being prepared
in advance,
to accept
changes and
being able to adapt,
makes you
the leader and
not a follower.

and ten percent of total 1994 volume. Consumers prefer different ways to buy, so we offer choices—with an in-dependent agent, over the telephone, at a Progressive location or by mail. Many independent agents, who were threatened by multi-distribution and lower commissions, realize that by concentrating on explaining the con-sumers' choices at the point of sale, they can make good money on Pro-gressive's new low-cost auto insur-ance, while regaining lost private passenger auto market share. Other agents use our commission options to match the different levels of service provided to different insureds. Inde-pendent agents accounted for over 90 percent of 1994 volume.

Consumers want to do business when it's convenient for them, so we are available 24 hours a day, 7 days a week, to deliver any service and/or answer any question.

Progressive's unique approach to management continues to evolve along with its business strategy. In 1994, we were pleased to be recog-nized by management scholars and writers, as well as by USA Today and Fortune, for the success of our "man-agement re-engineering," which in-cludes the following:

Total Quality Management dovetails with our Excellence Core Value—doing better than we did before—and empowers Progressive people to change how they function if the change measurably improves cus-tomer service or reduces costs, and if it does not disrupt others in the work chain. Because measurement is es-sential to TQM, we have dramatically improved our ability to measure per-formance and to control quality.

Teamwork has replaced intense inter-nal competition as the way we work. We continue to improve the ways in which we motivate, manage and reward teams. Steady Cost Reduction has been, and continues to be, critical to our strat-egy, and, along with profit and growth, is the basis for our people's Gainsharing awards. Underwriting expenses were 24 percent of premi-ums in 1994, compared to 26 percent in 1993 and 31 percent in 1989.

Process Management has been added to senior line managers' profit and loss responsibilities, eliminating much staff line friction and fostering cooperation among divisions and departments.

Through Testing of new ideas has re-placed our former propensity to seize perceived opportunities and grow them as fast as possible.

Performance-based Compensation pays our people very well for excep-tional performance, makes contin-gent pay significant to everyone and fosters the achievement of our de-manding objectives.

Progressive's Diversified Businesses

Diversified divisions provide combinations of service and indemnity to businesses. In 1994, Diversified divisions' net premiums written and underwriting profits were $115 mil-lion and 21 percent, respectively, compared to $118 million and 14 percent in 1993. The Diversified divisions produced service revenue and pretax profits of $41.9 million and $10.0 million, respectively, in 1994, compared to $45.7 million and $6.8 million in 1993.

ANNUAL REPORT

DESIGN
joyce nesnadny,
michelle moehler,
and mark schwartz
cleveland, ohio

ILLUSTRATION
carter kustera
new york, new york

STUDIO
nesnadny + schwartz

CLIENT
the progressive
corporation

PRINCIPAL TYPE
simoncini garamond

DIMENSIONS
8 1/2 x 11 in.
(21.6 x 27.9 cm)

BILLIE
SAYS BEING RICH IS ONLY A STATE
OF MIND

TUSHI
CLUB KID

DARRYL
SAYS THERE IS 100 WAYS TO SPELL
HIS NAME

RANDY
IS A MEMBER OF THE MILE HIGH
CLUB

BILL
DOES NOT BELIEVE IN
MARRIAGE

SUE
HOPES EVERYONE BAD WILL
JUST GO AWAY

ABE
OWNS A FAX, PC, MODEM,
CELLULAR PHONE & CB RADIO

SANDY
PROUD TO BE LARGE

This publication, based in the English Department at East Carolina University, seeks to combine the best attributes of an academic journal with a contemporary magazine for serious readers. The design is a framework, consisting of a grid and a typographic system, that unifies eclectic subject matter with interpretive typographic treatments. Writing may be nonfiction, fiction, or poetry. This is a text that is meant to be read, and we strive to maintain readability. But the typographic design allows each article to make a distinctive contribution to the whole. The design process is an ongoing evolution—working with pages on the computer screen, and developing new typographic treatments as new kinds of written materials join the mix. Each issue is a bit of a surprise.

MICHAEL VANDERBYL

I found this piece to be both compelling and poetic. Each article is given its own voice visually but maintains an accessibility to the content. Publications in this category are usually boring and anonymous in their graphic treatment; this is a welcome exception. In a time when much of typography is used to confound the reader, this piece invites you to extract information, perspective, and delight from its pages through its ever-changing grid and its interesting crops of photography. The fact that this publication exists is a tribute not only to the designer but to the client also—a client with vision and the ability to see beyond the words, who allowed the designer to translate those words graphically with the same passion with which they written.

27

42″
—
17″

MAGAZINE

DESIGN
eva roberts and
stanton blakeslee
greenville, north carolina

EDITOR
alex albright

CLIENT
east carolina
university english
department

PRINCIPAL TYPE
stone serif and
stone sans

DIMENSIONS
7 5/8 x 10 in.
(19.4 x 25.4 cm)

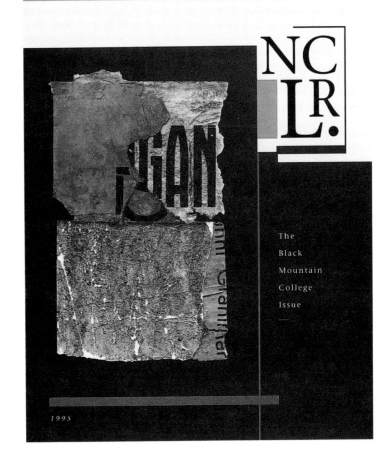

I don't remember any dark faces in the town of Black Mountain either. In western North Carolina, white people worried about Indians: *Indians to the back of the bus*. Over in the Maggie Valley, where the Cherokee reservation is, they had three water fountains in the public squares. Indians obsessed Black Mountain College, too, but quite the other way. People who were involved in anthropology used the term "Amerindians" – and almost everyone read Jaime d'Angelo, knew something about Catlin and Bodmer and trickster stories and the Iroquois false-face societies and, especially, the transformation that took place as eastern tribes were squeezed west and found the HORSE. Harvey Harmon could talk for hours about it. And Wess Huss spoke eloquently about cultural rape – the Indian schools where kids were stripped of their language – and the squalor of reservation life where he'd done Quaker fieldwork.

No, it wasn't until I was in New York City a few years later on that the door opened and I found LeRoi Jones and A.B. Spellman and Bob Thompson and Archie Shep on and on and on. People, people who were the actual grandchildren of commanding African-American women like those who had ruled my grandmothers' kitchens and brooked no sass from me or any other child I knew. These grandchildren remembered their grandmothers the same way I did. It's a funny bond. I imagine Roman matrons, in the days of the Republic, might have had as firm a concept of right and wrong as those women. But I doubt their laps were as soft. *Gracie. Viola. Pearl*.

* * *

Martha King was born in Charlottesville, Virginia, in 1937. She attended Black Mountain College during summer 1955 and moved to New York after her marriage to Basil King in 1958. She is the author of four collections of poetry. She edited the magazine Giants Play Well in the Drizzle *from 1983-93, and she now publishes* Northern Lights International Poetry/Brooklyn Series, *single-author pamphlets. She is director of publications for the National Multiple Sclerosis Society.*

THE RETURN
to

BLACK

MOUNTAIN:

May

Day

1992

by Fielding Dawson

It had been almost 39 years.
I was smart enough to know, as we drove along the highway looking for the turnoff (spotting the sign, stopped the car, got out, and took the photographs) that no matter all the renovation and rebuilding on school property, which I expected, I had some surprises ahead and looked forward to my reactions.
All of it would be authentic.
Hadn't I walked in dreams the path to the bridge over the creek on the way to the farm? Didn't I still have an occasional dream? Sure. So I knew, and did in this way just the right thing: opened up to it. All walls down. We turned from the highway onto Lake Eden Road (in writing this I'm confused in memory: am I writing about my return, or about . . . the feel of the road on the way . . .) I gave focus to what was coming, stepped out of my ego, into an open mind.
Maybe other students go back to their schools, like those John Ford movies, we hear music as the actor gets closer, and the hallowed buildings and campus appear from between trees and tall bushes . . . eyes

THE FALL ISSUE OF *DANCE INK* MAGAZINE FEATURED
A NUMBER OF STORIES THAT TOUCHED UPON DIF-
FERENT GENRES AND CONVENTIONS OF NEWSPAPERS:
A STORY ON ATHLETES AS DANCERS (SPORTS SEC-
TION), A PIECE ON AN OFFBEAT HORROR FILM
(MOVIE PAGES), AN ESSAY ON STREET PHOTOGRA-
PHY (METRO SECTION), A GRAINY BARBARA KRUGER
PHOTOMONTAGE, AND EVEN A STORY ON A COMIC
STRIP. I WAS INTERESTED IN EXPLORING THESE
THEMATIC RELATIONSHIPS WITH A TYPOGRAPHIC
PALETTE AND SHIFTS IN PAPER STOCK THAT EVOKED
THE LANGUAGES OF MASS MEDIA. PERHAPS THE
CLEAREST EXPRESSION OF THE IDEA IS THE TABLE
OF CONTENTS, WHICH CAPTURES THE VISUAL CHAT-
TER ONE FINDS IN THE EDITORIAL SECTIONS AND
CLASSIFIED ADS OF SMALL-SCALE NEWSPAPERS FROM
MORE DISTANT TIMES.

LAURIE ROSENWALD

My choice is *Dance Ink* magazine, designed by Abbott
Miller.

"Writing about painting is like dancing about architec-
ture"— did you ever hear that one? This one is design-
ing about dancing. I'd rather dance than read about it;
but until we can finally design frozen-dinner packaging
with this much intelligence and smart typography,
Dance Ink will be an outlet for everything that is fine. I
especially love the Robert Wilson title page and the
type-specimen book style of the "testimonials." And the
paper is so heavy and the ink is so black! I'm sure it's just
the way the designer wanted it to be. How often does
that happen?

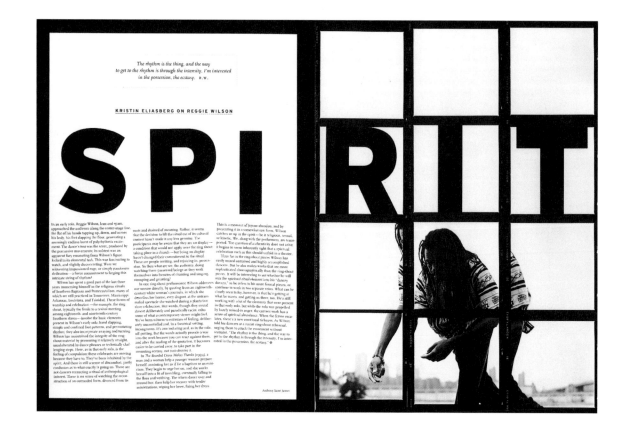

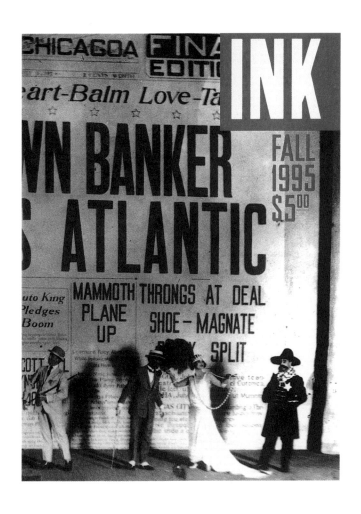

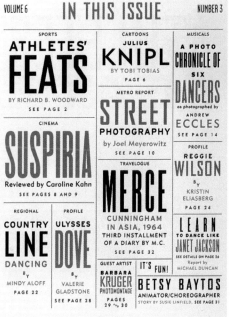

MAGAZINE

DESIGN
j. abbott miller
new york, new york

STUDIO
design/writing/
research

CLIENT
dance ink, inc.

PRINCIPAL TYPE
scala, bureau
agency, and bank
gothic

DIMENSIONS
10 7/8 x 14 1/4 in.
(27.6 x 36.2 cm)

THE *MTV UNPLUGGED* BOOK HAD A COMPLEX YET SPE-
CIFIC DESIGN PROBLEM: HOW DO YOU INFUSE THE
EMOTION AND CONTENT OF A POPULAR TELEVISION
PROGRAM WITH OVER 70 UNIQUE ARTISTS BETWEEN
THE PAGES OF A COFFEE TABLE BOOK *SUCCESSFUL-
LY*?

PARADOXICALLY, I WAS STUCK WITH ONLY TWO
DESIGN PLATFORMS. FIRST, THE RUDIMENTS OF
ART-MAKING: TEXTURE, LINE, FORM, AND COLOR.
AND SECOND, THE PRE-BUILT AESTHETIC OF THE
UNPLUGGED SHOW, WHICH HAS BECOME VERNACULAR.
PEOPLE WERE USING "UN" AS A SLANG PREFIX TO
MEAN EVERYTHING NOT UPTIGHT, NOT HIGH-TECH,
AND NOT PRETENTIOUS.

INITIAL SOLUTIONS INVOLVED DISCOVERING SEMI-
OTIC MEANINGS AND ASCRIBING THEM LITERALLY
WITH UNIQUE SHAPES, TYPEFACES, MATERIALS,
COLORS, AND VISUAL TEXTURES WHILE REMAINING
TRUE TO THE POPULAR NOTION OF WHAT "UN"
MEANS. OF COURSE, LIBERTIES WERE TAKEN WITH
THE STYLE OF DELIVERY.

JACKIE MERRI MEYER

When I was judging the show, the *MTV Unplugged*
entry really stood out.

Because of the content of *MTV Unplugged*—what rests
between the front and back cover—the overall package
has to communicate a high level of creativity, form, and
function. And while the book could have taken the
familiar road, it didn't, opting instead for an enlivened
use of type, design, texture, and manufacturing.

The cover treatment is the first clue to what lies ahead.
It subtly suggests the hollow opening of a guitar and a
record label, and I particularly liked the retro invoice
and the spelling out of the first edition.

When it comes to typography, I am a purist, and I
believe in legibility. And although the type is uncon-
ventional it succeeds; it is inviting to the reader and
compatible to the art. When a type layout becomes art,
it breaks as poetry. *MTV Unplugged* has cadence and
sings to the audience.

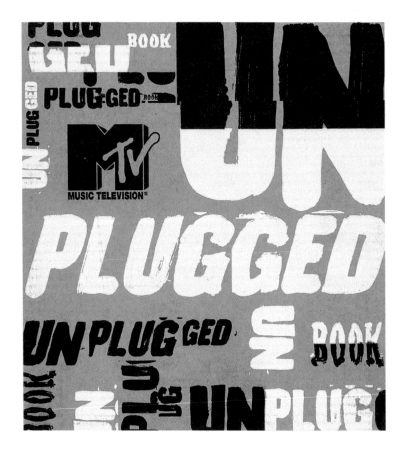

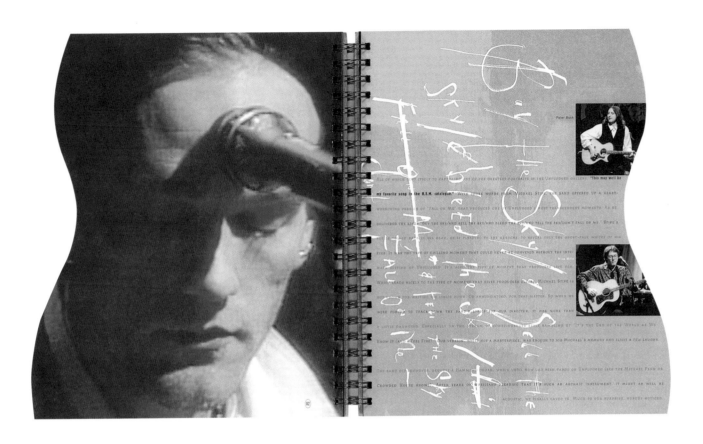

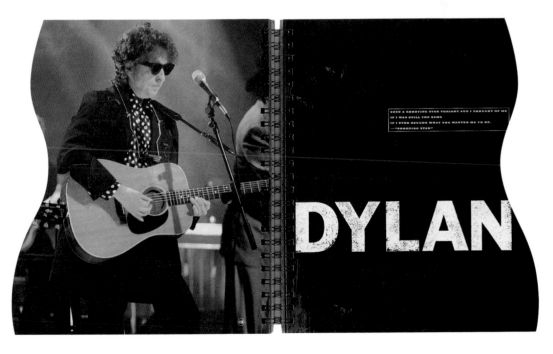

BOOK

DESIGN
christopher davis
new york, new york

CREATIVE DIRECTION
jeffrey keyton

AGENCY
mtv off-air
creative

CLIENT
mtv: music
television

PRINCIPAL TYPE
ag old face,
glypha, champion,
and eg woodblock

DIMENSIONS
11 x 12 in.
(27.9 x 30.5 cm)

BAVARIAN MOTOR WORKS WANTED TO CREATE A BILINGUAL WORLDWIDE MOTOR-SHOW MAGAZINE THAT WOULD PRESENT THE BMW ENTERPRISE IN A YET UNSEEN WAY. THEY TOOK NOTICE OF MUTABOR THROUGH A PRESS ARTICLE, AND SOON GAVE US—THREE YOUNG DESIGNERS, PLUS STUDENTS, AT THE MUTHESIUS-HOCHSCHULE KIEL—THE CHANCE TO REALIZE OUR VIEWS ON GRAPHIC DESIGN FOR THIS TRADITIONAL GERMAN ENTERPRISE. THE CONCEPT STARTED OUT VERY RIGID, BUT SOON THE WAY WAS FREE FOR A VIVACITY BEYOND THE BMW-CI AND GOOD OLD HELVETICA: WE NAMED IT *FAHRWERK*.

IN THE PRESENTATIONS WE TRIED TO COMBINE A KIND OF STRAIGHT JOURNALISM WITH IMAGES THAT WERE OF A COMPLETELY NEW IMPACT CONCERNING THE REPRESENTATION OF AUTOMOBILES. THAT'S WHY WE WORKED WITH PHOTOGRAPHERS WHO SHARED OUR POINTS OF VIEW, AMONG THEM HOLGER WILD, WHO IS ALSO A MEMBER OF MUTABOR. BESIDES OUR TYPOGRAPHIC APPROACHES, WE SET A HIGH VALUE UPON COLORS, PAPER QUALITY, AND WORKMANSHIP, WHICH ARE NOT OFTEN GIVEN ENOUGH CONSIDERATION IN GERMANY THESE DAYS.

LOUIS FISHAUF

Inevitably, in the blur of the judging process, it's difficult to give each entry the consideration that it may deserve. Those quieter pieces that might reveal their subtle charms when seen in a normal (that is, one-on-one) viewing situation can get lost in the sensory overload and the time pressure involved in reviewing thousands of entries.

It's equally difficult to choose a favorite among those thousands and walk away with any certainty that you've made a good—or even defensible—choice.

It was a great relief, therefore, when I received those two issues of *fahrWerk* a couple of months after the judging and realized that they were even better than my hasty evaluation (and hazy memory) had led me to believe.

The designers of these large-format BMW "magazines" for the Frankfurt and Tokyo motor shows have used many elements of the postmodern lexicon—deconstructed typography, layered imagery, soft-focus "art" photography, xerography—but in a very controlled, almost engineered way. Accessibility and readability are never sacrificed. Maps and charts are exuberantly designed, but crystal clear. And despite a variety of layout approaches for the various articles, there is an overriding unity of vision. It's like *Ray Gun* designed by Mies van der Rohe.

Part of *fahrWerk*'s appeal lies in the fact that it is so completely different from the glossy brochures full of beauty shots that North Americans have come to expect from the makers of high-priced luxury automobiles. It positions BMW as a forward-thinking company with a commitment to excellence. Totally unexpected, yet totally appropriate.

That *fahrWerk* was designed by a trio of students is truly astonishing. If they continue to produce work of this caliber, we'll no doubt be seeing a lot more of Mutabor.

series

the new five 5
der neue er

fahrWerk

ファーヴェルク

メッセ新聞

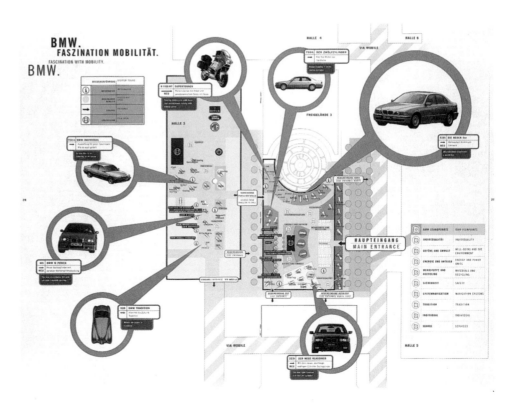

BMW.
FASZINATION MOBILITÄT.
FASCINATION WITH MOBILITY.

BMW.

BROCHURES

DESIGN
 pepe lange,
 heinrich paravicini,
 and johannes plass
 kiel, germany

PHOTOGRAPHY
 holger wild and
 wilbert weigend

STUDIO
 mutabor, forum für
 kunst und
 gestaltung

CLIENT
 bmw

PRINCIPAL TYPE
 trade gothic and
 letter gothic

DIMENSIONS
 10 5/8 x 15 3/4 in.
 (27 x 40 cm)

THE PRINTING HOUSE KOTEVA'S 50TH ANNIVERSARY
PACKAGE HAS BEEN SUCCESSFULLY USED TO ENHANCE
THE CORPORATE IMAGE OF THE COMPANY IN A VERY
PERSONAL, TOUCHING, AND DOCUMENTARY FASHION.
AN 80-PAGE BOOK DESCRIBING NOT ONLY KOTEVA'S
BUT ALSO FINLAND'S AND THE WORLD'S "FIVE COL-
ORFUL DECADES" FROM 1945 TO 1995 WAS THE CEN-
TRAL ELEMENT IN THE ANNIVERSARY PACKAGE. THE
IDEA WAS TO PRESENT THE ENTERPRISE IN A WIDER
HISTORICAL CONTEXT BY PROVIDING THE BROWSER
A FEELING OF REAL PARTICIPATION THROUGH VIVID
REMEMBRANCES OF THE PAST DECADES. THE ROLE OF
THE GRAPHIC DESIGN WAS TO CREATE THIS BY CON-
VEYING SOME KEY CHARACTERISTICS OF EACH PERI-
OD.

THE WHOLE ANNIVERSARY PACKAGE WAS DELIVERED
TO THE PRIMARY TARGET GROUP IN A WOODEN AMMU-
NITION CARTRIDGE BOX THAT LOOKS VERY MUCH
LIKE THE REAL THING. THIS IS A REFERENCE TO
THE DRAMATIC STARTING POINT OF KOTEVA'S HIS-
TORY DURING THE SECOND WORLD WAR, WHEN THE
STALIN-LED SOVIET UNION TRIED TO CONQUER FIN-
LAND. BOMBING RAIDS BY RUSSIAN PLANES AGAINST
SEVERAL FINNISH CITIES, INCLUDING THE
NATION'S SECOND LARGEST, TURKU, WERE PART OF
THIS AGGRESSION. ONE RAID WAS DIRECTED
AGAINST TURKU'S HARBOR, BUT FINNISH ANTI-AIR-
CRAFT FIRE CONTAINED IT, AND THE ATTACKERS
HAD TO DROP THEIR BOMBS ABOVE ANOTHER SECTION
OF THE CITY, WHICH WAS DESTROYED. IT HAPPENED
TO BE THE NEIGHBORHOOD WHERE KOTEVA'S FACIL-
ITIES WERE TO BE BUILT ON AN EMPTY LOT, DUR-
ING THE WAR, USING BRICKS PRODUCED BY RUSSIAN
POWs. THE PRINTING HOUSE KOTEVA REMAINS TODAY
AT THE SAME ADDRESS.

ALONG WITH THE RICHLY ILLUSTRATED 80-PAGE
ANNIVERSARY BOOK, A RECIPIENT OF THE BOX
FINDS A RANDOM SAMPLE OF ACTUAL BLANK CAR-
TRIDGES AND METAL PRINTING TYPES. THERE IS
ALSO AN ARCHIVE FOLDER CONTAINING REPRODUCED
PRINTS OF OLD DOCUMENTS FROM THE EARLIEST
DECADES OF KOTEVA'S HISTORY. THESE LOOK AND
FEEL SO REAL THAT SOME RECIPIENTS DECIDED TO
RETURN "THE ORIGINALS" TO THE ARCHIVE OF THE
PRINTING HOUSE!

DIKKO FAUST

I've been let out of Purgatory for twelve hours to judge 3,700 entries. In the middle of the sifting, my eyes are grabbed by a small pine crate, title burned onto the top. Crumpled facsimiles of used receipts from the 1950s float in wood shavings, artillery shells, and a dozen pieces of metal type (Erbar!). A 1960 postcard of the company van, zigzag catalogs of their cardboard boxes, a menu from a company dinner: Finnish Piet Swart is at work here! But—the centerpiece? A hardbound corporate annual report indistinguishable from countless others in this vast pile (*why* letterspace lowercase Bernhard Modern for text?). I am jolted back into Virtual Design Reality.

19
17 42

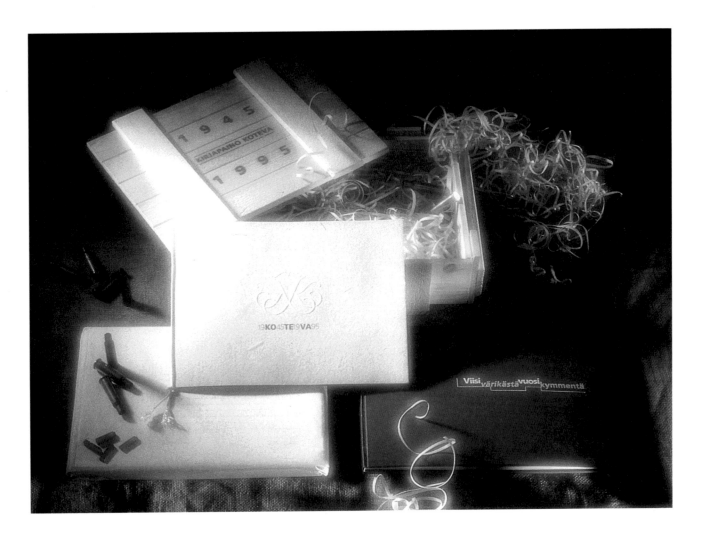

PACKAGING AND BOX

DESIGN
erkki ruuhinen, pia
pirhonen, tarja
mattila, and timo
keinänen
helsinki, finland

WRITER
reijo mäki,
turku, finland

STUDIO
errki ruuhinen
design

CLIENT
printing house
koteva

PRINCIPAL TYPE
frutiger black,
bernhard modern,
shelley allegro
script

DIMENSIONS
13 3/4 x 9 5/8 x 3 15/16 in.
(35 x 24.5 x 10 cm)

CREATING A HOUSE INDUSTRIES CATALOG IS ALWAYS A CHALLENGE BECAUSE WE WANT TO SHOW OUR FONTS IN AN ORDERLY MANNER WHILE MAINTAINING THE UNIQUE FLAVOR OF OUR MAILINGS. MULTIPLE METALLIC INKS, STRONG BLACK ARTWORK, AND COLORED PAPER GRAB THE RECIPIENTS' ATTENTION AND ENTICE THEM TO FURTHER EXPLORE THE CATALOG. THE MAILER OPENS UP TO A CLEAN LISTING OF THE FONTS WITH A MINIMUM OF CLUTTER.

MARGO CHASE

Judging the TDC show was a challenge. All kinds of great work was submitted, but after hours of looking at piece after piece, I went numb. Many pieces started to look alike. I began to categorize them in my mind: "There's another traditional Swiss-style thing," "another Charles Spencer Anderson knockoff," "another David Carson-style thing. . . ." Many of these were strong design pieces, even great examples of their kind, but I longed for something fresh.

Then along comes House Street Van Font Kit. It's COOL. It's WITTY. And it's DIFFERENT. There's no better way to describe this eye-catching mix of 1970s-style lettering and Pep Boys graphics used to promote House Industries' unusual fonts.

It's rare to find design that stands apart stylistically, has an original approach to marketing, and still functions. This House Industries piece does all these things well.

At first glance, and if you're old enough to remember the 1970s, you might think this flyer was just a rehash of '70s lettering and auto-parts catalogs. But if you were to go back to the original examples of these genres, you would be disappointed. In most nostalgic experiences, memory enhances the facts and nasty details fade, until what you remember is better than the actual experience. Good nostalgic design works the same way. It reminds you of the real thing, but it's much better.

Let's be honest: Most 1970s type was ugly, and auto-parts catalogs are a snore, but the House Industries Font Catalog is neither. Its thoroughly modern use of metallic inks, layered imagery, and colored paper results in a rich, fresh, and *totally cool* piece of design.

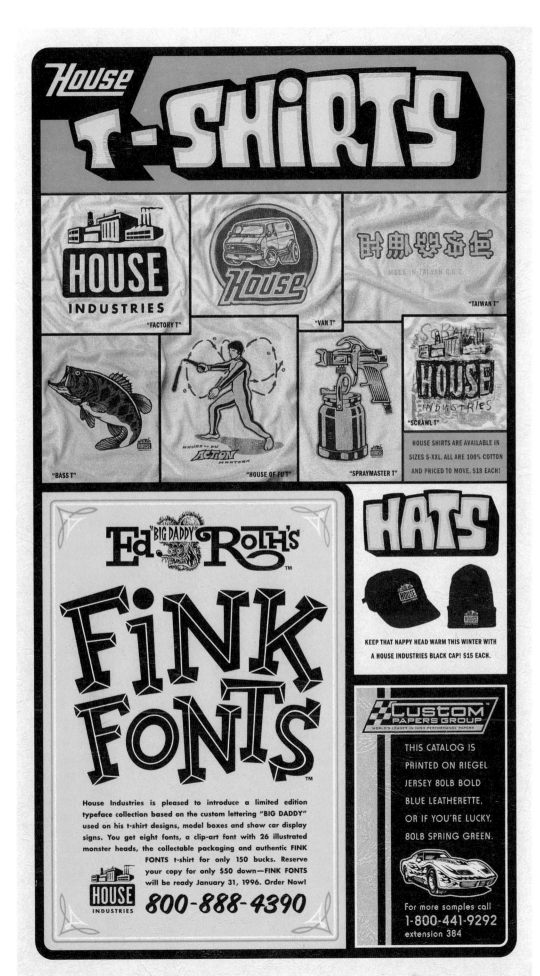

CATALOG

DESIGN
andy cruz and allen
mercer
wilmington, delaware

STUDIO
brand design/house
industries

PRINCIPAL TYPE
various

DIMENSIONS
30 x 10.5 in.
(76.2 x 26.7 cm)

JUDGES

[c h o i c e s]

sharon WERNER

Sharon Werner is the principal of Werner Design Werks Inc. Previous to starting her business, she was a senior designer with the Duffy Design Group. Since starting Werner Design Werks Inc. in 1992, she has developed a diverse client list: Bloomingdale's, Nick at Nite—MTV Network, VH-1 Network, fX Cable Network, Musicland Stores Corp., Target Stores, Comedy Central, Chronicle Books, Anatomy, Levi's, Minnesota Public Radio, and the College of Visual Arts. She has been recognized with awards and honors from the American Center for Design, AR100, New York Art Directors Club, Type Directors Club, and British Design and Art Direction. She was recently chosen for inclusion in 100 World's Best Posters. Her work is included as part of the permanent collection of the Library of Congress, the Cooper-Hewitt Museum, and the Victoria and Albert Museum, London.

About her design for *A Good Day for Soup*, Werner writes:

"In keeping with the spirit of the writing and with the idea of soup as a comfort food, we wanted this cookbook to look warm, inviting, and friendly. The use of the tomato-red color band and script type on the cover plays off a famous canned soup and allows the book to be identified from across the store. We considered how we as cooks use recipes and tried to make the soup recipes easy to read and use and kept the playfulness to the more nonessential divider and intro pages."

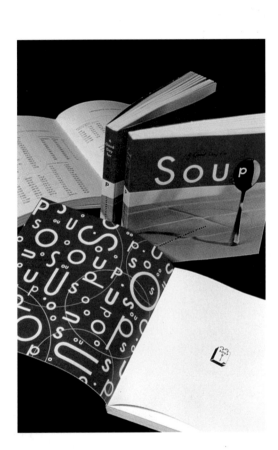

michael VANDERBYL

Michael Vanderbyl received a Bachelor of Fine Arts degree in graphic design from the California College of Arts and Crafts in 1968. Today, he is the dean of the School of Design at his alma mater. Since its founding in 1973, in San Francisco, Vanderbyl Design has evolved into a multi-disciplined firm with expertise in graphics, packaging, signage, interiors, showrooms, furniture, and textiles. A partial client list includes Amoco, American Institute of Architects, Bedford Properties, Bernhardt Furniture Company, Esprit, HBF, IBM, Keilhauer Industries, Polaroid, The Robert Talbott Company, Simpson Paper Company, Mead Paper Company, San Francisco Museum of Modern Art, The Oakland Museum, Catellus Corporation, Sun Microsystems, Port of Oakland, and Bentley Mills. He has gained international prominence in the design field as a practitioner, educator, critic, and advocate. For the United States government, he chaired the presidential jury for the 1992 National Endowment for the Arts Presidential Design Awards. He is a member of the Alliance Graphique Internationale.

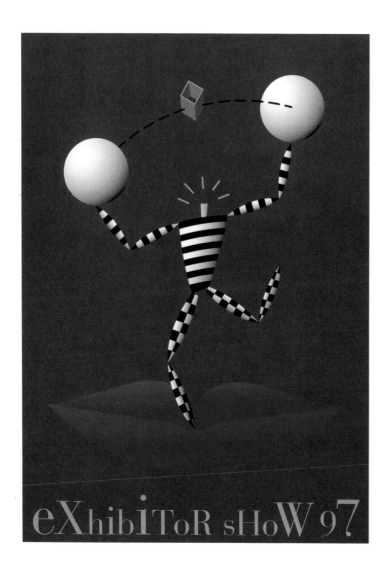

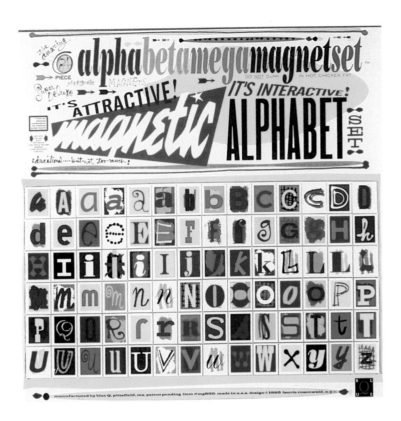

laurie ROSENWALD

Laurie Rosenwald has been a principal in Rosenworld, a design studio, since 1990. The studio's area of expertise includes packaging, publication design, corporate identity, illustration, interactive media design, film and video animation, writing, type design, and lettering. She has worked extensively in Japan, France, Holland, Sweden, Italy, and Germany—although she prefers Iceland, where the only notable industry is fishing. Some of her recent projects include consulting as art director for on-air graphics for Nick at Nite (1996); design of a comprehensive stationery and school supply line for the Swedish Postal System; home screen designs for America Online and Prodigy; book jacket design for Knopf, Chronicle, and Carol Publishing; video packet concept and design for Comedy Central's *Upfront at a Distance*; and product design for Morozoff Chocolates, Osaka, Japan. She also works as an illustrator for *The New Yorker, New York* magazine, *The New York Times,* and many other publications.

Rosenworld has been featured in the October 1994 issue of *Print* magazine; in the 1993 *Communication Arts* design annual; *Print*'s regional design annual and *50 Years of Graphic Design; Graphis Poster 1993;* AIGA's *A Decade of Entertainment Graphics 1982-92; I.D.* magazine's annual *New and Notable Graphic Design;* and many more. She was featured in a recent *Communication Arts* and in several books, including *American Typeplay* by Steven Heller and Gail Anderson, *This Face You Got* by Jim Mullen, and *The Savage Mirror* by Steven Heller and Gail Anderson.

Rosenwald recently designed the magnetic refrigerator alphabet, shown here, for Blue Q. It appeared on the market in the spring of 1996.

jackie MERRI MEYER

Jackie Merri Meyer is currently the vice president and publisher of Warner Treasures, a gift-book imprint of Warner Books, and creative director of Warner Books, where she is responsible for the jackets of 350 books a year. Previously, having started out in the art department of *Vogue* Promotion, she was an art director at Macmillan, McGraw-Hill, and Abraham & Straus. In the 1970s, she was a professional photojournalist, and her work was exhibited in a group show with Warhol, Steinberg, and others. A photograph she took of John Belushi was used last year in a television commercial for The Partnership for a Drug-Free America, which won a bronze medal at the Cannes Film Festival in 1995. A graduate of The Cooper Union, she is an active member of the school's alumni council. She taught at Parsons School of Design in the undergraduate program and has lectured widely at the Society of Illustrators, Fashion Institute of Technology, American Illustration Graphic Arts Weekend, Baltimore Publishers Association, New York University Publishing Institute, School of Visual Arts, the Art Directors Club of New York, and The Cooper Union. In 1982, she co-authored a book with her husband, Scot Carouge.

Concerning her design of the jacket for a mass-market hardcover book, Ed McBain's current 87th Precinct novel, *Romance* (illustration by Phil Rose), Meyer says: "I like to think it's mass with class—that's our trademark at Warner Books."

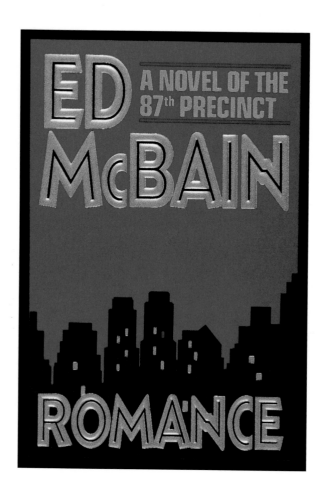

louis FISHAUF

Louis Fishauf is creative director of Reactor Art & Design Ltd., in Toronto. A graduate of Ontario College of Art, he spent ten years as a magazine designer and art director at such publications as *City Woman, T.O.,* and *Saturday Night* before co-founding Reactor in 1982. Since 1986, when he was introduced to the Macintosh computer, he has been an enthusiastic advocate and practitioner of electronic technology in design. He now works almost exclusively in the digital environment, dividing his time between design projects and illustration commissions. His work has won numerous awards in Canada and abroad and has been featured in many design publications, including *Communication Arts, Print, Adobe, How, I.D., Step-by-Step, Studio, Applied Arts Quarterly, Novum Gebrauchgraphik, Bat, IdN, MdN,* and *Idea.* He has served on the CAPIC Digital Technology Committee, the design advisory board of George Brown College, and the boards of the Art Directors Club of Toronto and the Worldwide Publishing Consortium. An example of Fishauf's fine work is this graphic illustration for an advertising campaign introducing the release of Adobe Illustrator 6.0 software by FCB Technology Group.

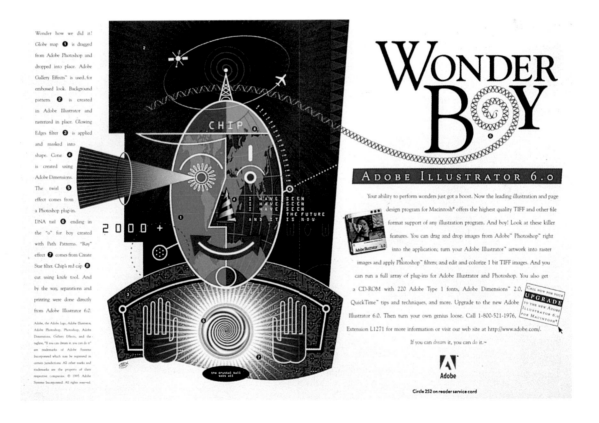

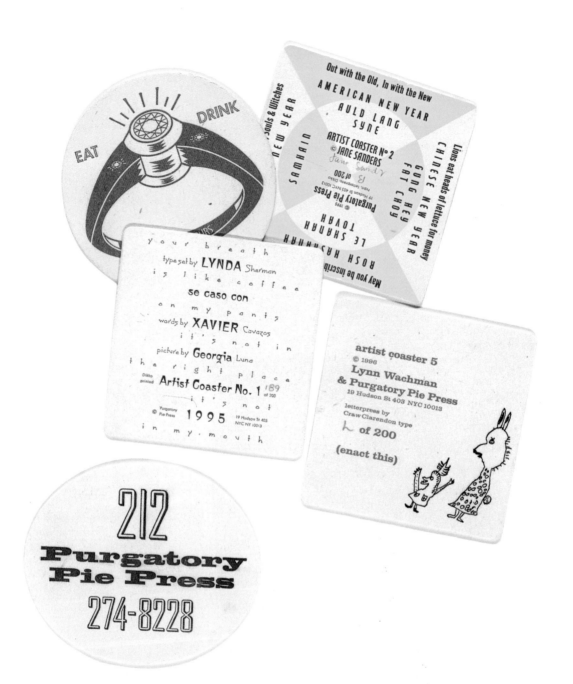

dikko FAUST

Typographer and letterpress printmaker Dikko Faust has collaborated with over one hundred artists, writers, and others since founding Purgatory Pie Press in 1977. With designer-editor Esther K. Smith he has created artist books, postcards, coasters, tracts, and other projects, which can be found in collections around the globe. The Press has had retrospectives at the Victoria and Albert Museum, London, and

Metropolitan Museum of Art, New York. He is a founding member of the Willard T. Sniffin and Morris Fuller Benton fan clubs and prefers real (wood and metal) type to "this virtual stuff." His assorted Purgatory Pie Press letterpress coasters, for example, were handset and printed using moveable metal type.

margo CHASE

Margo Chase's education in biology and medical illustration and her love of medieval iconography may explain the organic and often unusual nature of her design. Her eclectic style has been seen on compact disk covers for Madonna, Prince, Bonnie Raitt, and Crowded House, as well as on the poster for Francis Ford Coppola's movie *Dracula*. Her newly launched digital font foundry and current projects, such as motion graphics work for Turner Pictures and identity design for Kemper's Snowboards, keep her on the cutting edge of technology and style.

Of the work illustrated here Chase has written: "Germs: digital + organic is a presentation of images that explore the visual origin of ideas. What do renaissance tapestries and twisted metal have in common? How are organic sources like hand-drawn calligraphy and cracked mud affected by digital technology? How does random visual input mutate into a recognizable visual style? William Burroughs says: 'Ideas are viruses of the mind.' Watch Germs and learn how to catch the disease."

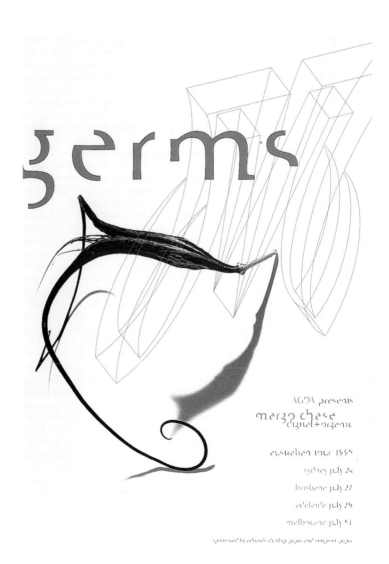

JUDGES

DANIEL PELAVIN IS A TYPOGRAPHIC DESIGN-

ER AND ILLUSTRATOR WHO HAS DONE

REVISIONS FOR ADVERTISING, CORPO-

RATE, AND PUBLISHING CLIENTS

SINCE 1970. HE HAS COLLEGE

DEGREES, HONORS, AND AWARDS

CERTIFICATES UP THE YIN YANG,

BUT CREDITS APPRENTICESHIP

IN THE ART STUDIOS OF

DETROIT, MICHIGAN, AS HIS

GREATEST SOURCE OF TRAINING

AND INSPIRATION. HE HAS MADE A

CONSCIENTIOUS EFFORT TO FORGET

THE NAMES OF AS MANY TYPEFACES AS

POSSIBLE AND TO CONCENTRATE,

INSTEAD, ON USING THEM EFFECTIVELY.

CHAIRMANS

You may wonder just what exactly is involved in being the chairman of TDC42. Here's pretty much how it goes: First, you must compile a list of seven designers prominent enough to attract good entries, who still possess enough of their ideals to care about this sort of thing. Then you must work up the chutzpah to call these people, ask them to take time away from their families and studios to spend a grueling twelve-hour day locked up in New York City to do the judging. This year, they were not even allowed to stack the entries with their own work!

The next few months are spent hoping and praying that you've made good decisions and that designers who have been fooled for years into entering bogus competitions will make a leap of faith, believing that they've got a fair shot with this one. When the day of judging comes and you have nearly 50 percent more entries than in any previous year, you make yourself crazy worrying that each and every entry gets the attention it deserves. The whole thing goes by so fast—it's sort of like your wedding day without the hors d'oeuvres—and the real work is done by the judges and dozens of dedicated TDC members and student helpers.

There was so much excellent work that we put more of it into this book than in any of the previous sixteen volumes. The year 1995 was quite a good one for typography.

daniel PELAVIN

CONTENTS

ACKNOWLEDGMENTS

The Type Directors Club gratefully acknowledges
the following for their enthusiastic support
and contributions to the success of TDC42:
Design: Michael Vanderbyl, Vanderbyl Design
Exhibition facilities: The Arthur A. Houghton
 Jr. Gallery at The Cooper Union
Judging facilities: School of Visual Arts
Paper: S. D. Warren
Printer (call for Entries): Quality House of
 Graphics
Calligrapher: Robert Boyajian
Daniel Pelavin's photograph by Preston Lyons

For Watson-Guptill Publications:
Senior Editor: Marian Appellof
Design Coordinator: Jay Anning
Production Manager: Ellen Greene
The principal typefaces used in the
composition of *Typography 17* were OCR-B and
Adobe Garamond.

TYPO
GRAP
HY17

THE ANNUAL OF THE
TYPE DIRECTORS CLUB
42ND EXHIBITION

WATSON-GUPTILL PUBLICATIONS

NEW YORK

ANNUAL OF THE TYPE DIRECTORS CLUB

17TH

42ND

EXHIBITION

PERHAPS ONLY THE PERSPECTIVE
AFFORDED BY TIME WILL PROVE
IF PARADISE WAS AGAIN LOST IN
THIS DECADE, ALONG WITH THE
MODERN IDEAL OF A PURIFIED
VISUAL LANGUAGE AND THE
PRINCIPLES OF [GOOD]
TYPOGRAPHY. YET, AS THE
CLASSICAL DOGMAS OF
LEGIBILITY, CLARITY, AND
SIMPLICITY ARE BROKEN, CULTURAL
MYTHS ARE STRIPPED NAKED AND
OUR EYES ARE OPENED. YOU ARE
INVITED TO ENTER YOUR MOST
POETIC WORK IN THE 1995 TYPE
DIRECTORS CLUB 42ND EXHIBITION.

TDC No 42